Van Gogh's Table

Van Gogh's Table

AT THE AUBERGE RAVOUX

ALEXANDRA LEAF
FRED LEEMAN

DESIGN BY BIRGITTA RALSTON
PHOTOGRAPHS BY FREDÉRIC LEBAIN

ARTISAN

NEW YORK

PUBLISHED BY ARTISAN
A Division of Workman Publishing Company, Inc.
708 Broadway
New York, New York 10003-9555
www.artisanbooks.com

LIBRARY OF CONGRESS CATALOGING-IN-PUBLICATION DATA
Leaf, Alexandra
 Van Gogh's Table at the Auberge Ravoux / Alexandra Leaf, Fred Leeman ;
 photographs by Frédéric Lebain.
 p. cm.
 Includes bibliographical references and index.
 ISBN 1-57965-182-8
 1. Gastronomy—History. 2. Food Habits—France. 3. Food in art. I. Leeman, Fred. II. Title.

 TX637 .L393 2001
 394.1'0944'09034—dc21

 2001034312

PRINTED IN ITALY BY MONDADORI PRINTING

FIRST EDITION

10 9 8 7 6 5 4 3 2 1

ART DIRECTION AND BOOK DESIGN BY BIRGITTA RALSTON

Contents

Van Gogh's Last Home

IN THE WORLD THERE ARE A FEW UNIQUE PLACES that in their essential nature embody all of the emotions of an epoch. The Auberge Ravoux is one such place. For Vincent van Gogh, it was the last café in a lifetime spent searching for what cafés offered. In them he could find the replacement for the family he never had. He could find a place filled with life in the shadow of his own isolation. In his short thirty-seven years, he lived in at least thirty-eight different places in four different countries. Not surprisingly, in 1888 he wrote to his brother Theo, "I feel that I am always a traveler, going somewhere to a destination."

The Auberge Ravoux, a typical French inn, is located in Auvers-sur-Oise, a small artists' village twenty-two miles northwest of Paris. The village had already welcomed Daubigny, Corot, Daumier, Cézanne, Pissarro, and Dr. Gachet by the time Van Gogh arrived. And it was due to Van Gogh's work and tragic death that Auvers and the Auberge Ravoux achieved worldwide fame.

Van Gogh arrived in Auvers on May 20, 1890. He took Room 5, with full board, in the Auberge Ravoux for three and a half French francs per day. This room was his last. His stay was characterized by a burst of creativity, resulting in more than seventy masterpieces,

studies, a large number of drawings and letters, and the only etching he ever made. A little over two months later, on July 29, he died. Because of French superstitions about suicide, it is unlikely that the room was ever rented again. And since the inn was never renovated, the room and the Auberge Ravoux itself were declared historical landmarks.

WHEN BY ACCIDENT I DISCOVERED AUVERS-SUR-OISE, in 1985, I found everything that had attracted nineteenth-century painters and that, for outsiders, is typical of the charm of the Île-de-France region. Auvers remains a little village with its church, its cemetery, its châteaux, its tiny town hall, its wheat fields, and, of course, the Auberge Ravoux. At that time, visitors to the auberge consisted of scholars, art historians, and Van Gogh followers. It had a restaurant where one could see the work of local artists as well as an art gallery upstairs.

The year 1987 was a turning point of my life. I was able to buy the Auberge Ravoux and set about realizing what had become a dream: to preserve the soul of Van Gogh's last home and open it to those who care about the artist. I sought to create a spiritual refuge where people could connect on an emotional plane with his art and feelings. It was to be a place where those who visited could step back in time. There, they would find Van Gogh's room, a small intimate space, empty except for memories. Visitors could furnish it with their own feelings or experiences. No mass tourism would trample through the tranquility of the place. It would be preserved as a refuge of silence from the frenzy of the external world.

THE AUBERGE was part of a small neighborhood in the center of the village. It, and the surrounding houses, would need to be restored together, with simplicity, aesthetics, and harmony as our guides. Every detail had to match the powerful impression made by the artist's bedroom without overshadowing it.

For seven years we gathered together the best craftsmen who, with a combination of skill and heart, worked tirelessly to bring this vision to life. Finally, despite bureaucratic challenges, the project was completed in 1993. Today, the Maison de Van Gogh welcomes one hundred thousand pilgrims yearly. Its uniqueness is confirmed both by the visitors and the media from around the world. The café is thriving as in Van Gogh's day. Popular food guides extol the virtues of the cuisine. Van Gogh's room is preserved. The cultural activities continue. The naysayers and skeptics take credit for their silent support.

BUT STILL ONE CHALLENGE REMAINS: to bring back an original Van Gogh to live permanently in the artist's last home. On June 10, 1890, Vincent wrote to his brother Theo from the auberge, "Some day or other, I believe I will find a way of having an exhibition of my own in a café." The history of bringing the Maison de Van Gogh back to life has been one of having dreams and realizing them. This has been a great adventure for everyone involved. Achieving Van Gogh's wish will bring our efforts to fulfillment.

More than seven hundred thousand guests from all over the world have enjoyed the special combination of nourishment for the body and the soul offered at the auberge. The idea for this book came from their questions and comments. With our guests in mind, we

3

endeavor to take the reader into the world of Van Gogh in his time, and the Auberge Ravoux as it was then and is now.

Dr. Fred Leeman, the former chief curator of the Van Gogh Museum in Amsterdam, has written Part One of the book, "A Private Life in Public Places." His essays explore the world of cafés, restaurants, and auberges and their influence on Van Gogh's life and work. Unlike his more famous still life paintings, such as the *Sunflowers* and *Wheat Fields* series, Van Gogh's café paintings, included here, allow us entree into his real life. Dr. Leeman guides us to the more emotional side of this complicated and misunderstood artist.

Dr. Julia Galosy, who has been with me through the entire project, describes the development and restoration of the inn from 1855 to 2001, giving life to a vision that was complex and multilayered.

Part Two, "Recipes from Van Gogh's Table," was written by Alexandra Leaf, an American culinary historian and authority on nineteenth-century French cuisine. With chef Christophe Bony, she presents the food of the region and the cuisine of the Auberge Ravoux. The original Ravoux recipes are published here for the first time.

More than one hundred years later, there is still room at the inn. For those who care about Van Gogh, we have reserved a seat for you at his table.

I dedicate my work, and this book, to Françoise, Alexandre, and Philippine, my family, and to Alain, my Theo, whose faith and belief in me never wavered, even in the darkest moments. To all of the people whose negativity and skepticism challenged me and made me stronger. To all those who believed and showered me with their letters and good wishes, for giving me a reason to go on.

Dominique-Charles Janssens
President, Institut Van Gogh

A Private Life in Public Places

ON THE AFTERNOON OF TUESDAY, JULY 29, 1890, the body of Vincent van Gogh, who had died that morning at 1:30 A.M. in his attic room in the Auberge Ravoux in Auvers-sur-Oise, was put in a coffin, made by the carpenter Levert who lived next door. A few weeks before, Van Gogh had painted a portrait of Levert's two-year-old son, holding an orange in his hands. The coffin was carried down the stairs to the so-called artists' room on the ground floor, behind the dining room. It was the room where Van Gogh had painted and stacked his canvases during his seventy-day stay in Auvers. There the coffin was put on trestles, lent by the carpenter. A simple white cloth was used as a drapery. The room was transformed into a *chapelle ardente*. Tom Hirschig, a Dutch painter who rented a room next to Van Gogh's, went out to pick some greenery to decorate the room. Masses of yellow flowers were brought in, yellow dahlias and a large bunch of sunflowers by Dr. Gachet, who had made a drawing of Van Gogh on his deathbed. Theo, who had arrived and been with his brother before he died, thanks to Hirschig, nailed the canvases that were in the

Portrait of Vincent van Gogh
in the Café du Tambourin
by Toulouse-Lautrec, Paris, 1887.
Pastel on cardboard, 22⅜ x 18¼"
Van Gogh Museum, Amsterdam

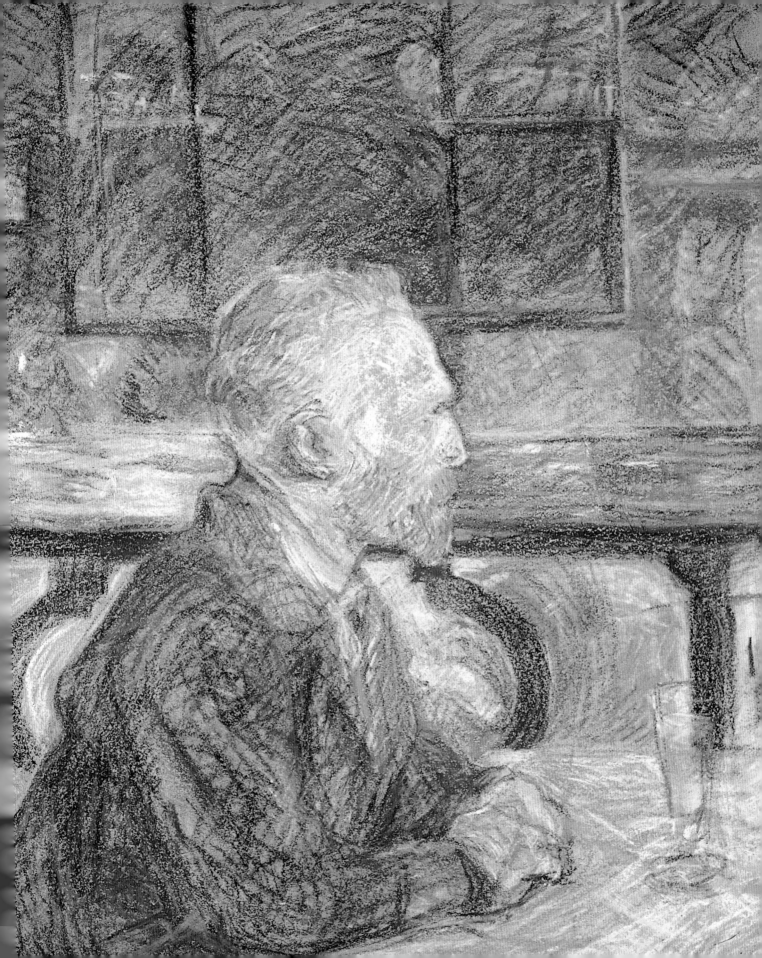

room on the walls around the coffin. Among them were *The Church in Auvers, Irises, The Garden of Daubigny, Levert's Son with an Orange, The Pietà after Delacroix, The Prisoner's Round after Doré, A Portrait of Adeline Ravoux, The Town Hall of Auvers, 14 of July*.

THE NEXT MORNING, VAN GOGH'S FRIENDS began to arrive at the Auberge Ravoux. Père Tanguy, his paint dealer, was early, at nine o'clock; Andries Bonger came, Theo's best friend; the Dutch painter Maurits van der Valk, with his girlfriend; Auguste Lauzet, the lithographer; Lucien Pissarro, Camille's son; perhaps Maurice Denis. Charles Laval, the follower of Paul Gauguin, came with Van Gogh's young friend, the artist Émile Bernard. After the funeral, Bernard wrote a letter to the critic Albert Aurier: "[The canvases] formed a kind of halo around him and rendering—through the brilliance of the genius that shone from them—his death even more painful for us artists. . . . Near him also his easel, his folding stool, and his brushes had been placed in front of the casket." Tom Hirschig, however, was more down-to-earth: "From his coffin, which was badly made, there escaped a stinking liquid . . . they had to sprinkle carbolic acid, the temperature still being so hot." To him, this was a sign that "everything was terrible about this man," and he concluded, "I think he suffered a great deal in this world."

This confrontation of the sordid and the sublime sums up the miracle of Van Gogh's achievement. His capacity to create art of the highest quality with so little conventional talent from such relatively miserable circumstances will never cease to fascinate. Of these circumstances, we are well informed by his letters. Van Gogh may well be the best documented artist—at least of his time.

VAN GOGH'S DEATH IN THE AUBERGE RAVOUX can be seen as the final consequence of the life that he had been leading. Since leaving his family home at the age of eleven, he had pretty much led the life of a wanderer. At least thirty-eight different addresses in Holland, Great Britain, Belgium, and France can be counted, most of them in cheap pensions, inns, auberges, or rooms above *restaurants populaires*. Seldom did he have a room of his own, and when he did, such as the "yellow house," it attained mythical proportions in both his own imagination and that of posterity. We are able to follow his path through these semipublic places, not only because he wrote about them but also because they often figure in his work, either as the subject or as the place where he painted. As such, these works offer us clues to his working method, his style, his artistic ambitions, and finally, to his state of mind.

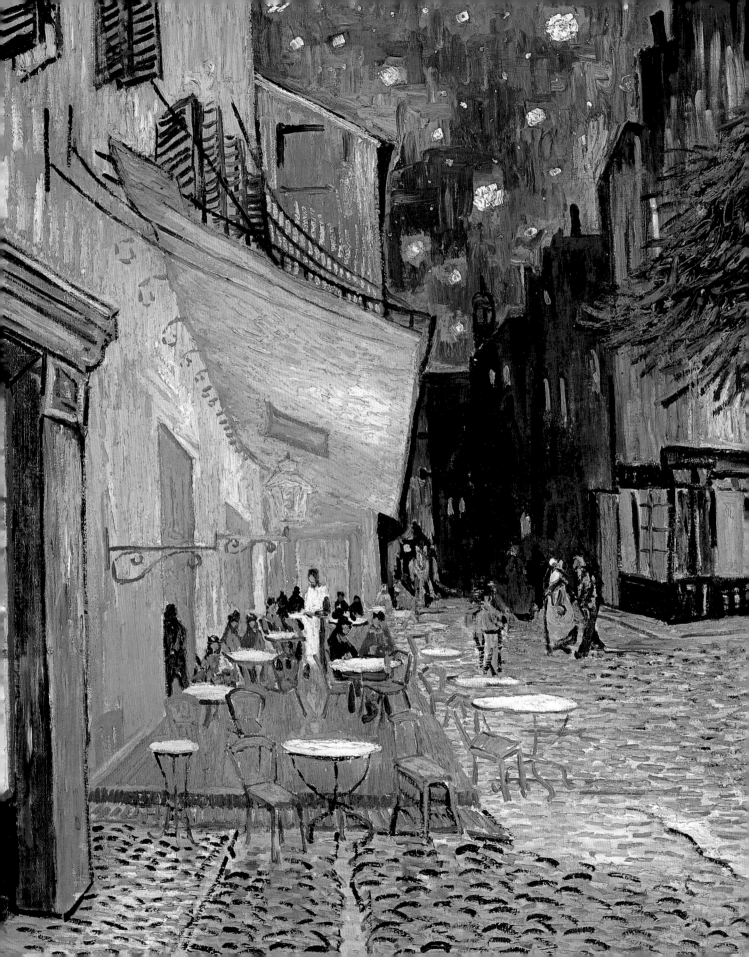

A Place to Live, a Place to Work

IN THE HAGUE IN 1882, VAN GOGH SAW HIS DREAM of a "room of one's own" realized for a short while. To his great joy, he was able to rent a brand-new house where he could install a studio: "I have a love for this studio as a skipper has for his ship." He even had company that assumed the appearance of a family. One of his models, Sien Hoornik, a former prostitute, came to live with him. She had a daughter and was pregnant. She frequently posed for him, as did her mother and sister. After the baby was born, the new house was even busier. Van Gogh enthused in a letter to his brother: "Well, boy, if you come here to a home full of life and activity and know that you are the founder of it, won't that give you a real feeling of satisfaction—much more than if I were a bachelor living in bars?"

In starting a liaison with the destitute Sien, Van Gogh entered into a life not unlike that depicted in the realistic prints he collected. As was his models' wont, he frequented the most humble places that served food, the soup kitchens run by The Hague municipality. As an aspiring artist, he saw these places as possible venues for painting from life. Early in 1883 he began work on this subject. Struck by the gloomy holes-in-the-wall where poor people begged for food, he made a quick sketch of one of them that he wanted to work out later in a large drawing, a watercolor, and, perhaps, in a salable painting.

Café Terrace at Night, F467
Arles, 1888.
Oil on canvas, 31⅞ x 26"
Museum Kröller-Müller, Otterlo

FOR A BEGINNING ARTIST, a many-figured composition was very complicated. Because he could make only quick sketches working on the spot, Van Gogh decided to re-create the soup kitchen in his studio. By means of shutters he imitated the light fall from right above, drew the black hole on a piece of paper, and had Sien and her family members pose for him in characteristic clothes. Every person holds a jar, a mug, or some receptacle. Sien's mother holds the baby, Sien's daughter is returning with the precious food; a bigger girl, perhaps Sien's sister, has just handed over a big jar, and Sien, in profile, is resigned to wait her turn. This drawing embodies something essential of Van Gogh's feelings about the function of art. He has adapted a subject from one of the wood engravings he collected—an "image of the people"—and connected it with his own personal experience. He shows life stripped to its bare essentials. He did the drawing in natural black chalk, a coarse material appropriate for the subject, since it had "a real gypsy soul."

Though living with Sien Hoornik and her two children had isolated him socially from The Hague art world, Van Gogh had hoped to marry her. Sien, however, was considering resuming her more profitable profession. Theo disapproved of his brother's dream to marry Sien but kept on sending him money regularly. Finally, the situation became untenable, and Van Gogh took the train to Drenthe in order to forget his hopeless liaison and to find new meaning in the land that had inspired his teacher Anton Mauve and Jules Dupré, whom he very much admired.

The overriding sense he had in this desolate environment was "that particular torture, loneliness . . . that loneliness—which a painter has to bear, whom everyone in some isolated place regards as a lunatic, a murderer, a tramp, etc., etc." In the colony Nieuw-Amsterdam he made his lodging in the local inn, where he stayed for two months in a "pretty large room . . . which happens to have a small balcony, from which I can see the heath with the huts. Moreover I see a very curious drawbridge." From this view, he made a large, subtle watercolor that so well expresses the dreariness of a bleak and wet autumn day. Its schoolbook perspective, which copies the desolate landscape so precisely, must be due to the confines of his balcony window.

The attitude of the local population toward him was one of wariness: ". . . one must expect to be distrusted at every inn—like any poor peddler (for that is what they take one for). Often one has to pay the money for board and lodging in advance." He did, however, win the trust of Hendrik Scholte,

The Public Soup Kitchen, F102a
The Hague, 1883.
Black mountain chalk, 22½ x 17½"
Van Gogh Museum, Amsterdam

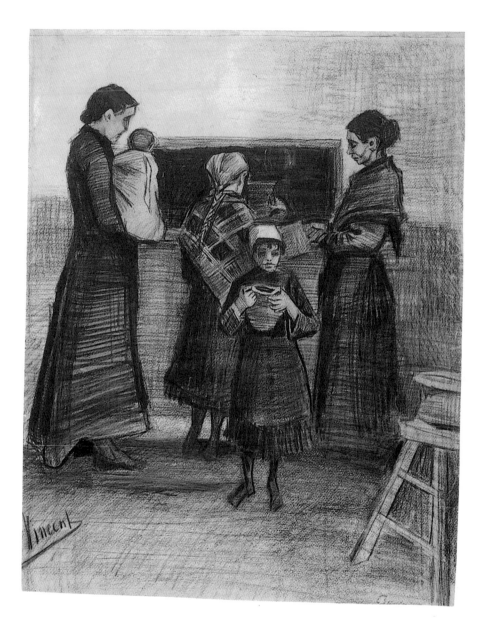

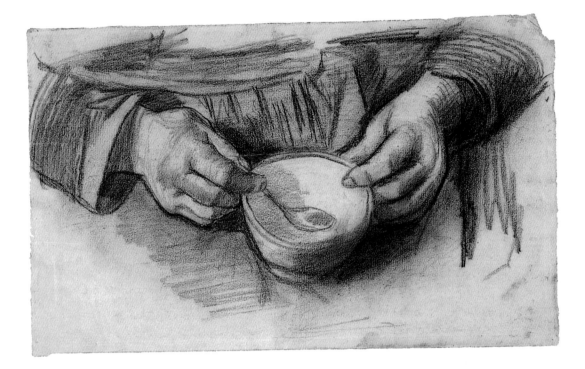

An Image of the People

his innkeeper in Hoogeveen. Every once in a while he went downstairs to warm himself by the fire and spend time among the family: "Downstairs there is the inn, and a farmer's kitchen with a peat fire on the hearth, very cosy in the evening. Such a fireplace with a cradle beside it is an excellent place for meditation. When I am feeling melancholy or worried about something, I just run downstairs for a while." In the end, the loneliness became unbearable, and because of the "suspicion of the people at the inn," he had to ask his father for financial support. The thirty-year-old aspiring artist had to go back to his parents' home in Nuenen.

THERE HE SET OUT on his most ambitious project to date. Again it was to depict an "image of the people," and again it was to show people and nourishment. To achieve a complicated multifigure composition like this with the figures having appropriate expressions, he realized he had to study heads and hands from life. Then an oil sketch had to be made to work out the whole composition, balancing poses and lighting. The final work could then be done by heart. This was all usual academic practice, but extraordinarily

Hands Holding a Bowl, F1165
Nuenen, 1885.
Oil on canvas, 8¼ x 13¾"
Van Gogh Museum, Amsterdam

The Potato Eaters, F1661
Nuenen, 1885.
Lithograph, 10⅜ x 13⅜"
Van Gogh Museum, Amsterdam

ambitious for an artist with so little practice. "I am always doing *what I can't do yet* in order to learn how to do it," Van Gogh wrote. He knew he needed to study hard, so in December 1884 he started painting and drawing heads and hands, the carriers of human emotion. How the final work would look was still uncertain. Many studies preserved from this period cannot be directly linked to the completed painting, but were intended as practice, as an extension of his repertoire. One of them, however, shows the hands of a woman holding a bowl as seen in *The Potato Eaters*. Her hands, swollen by hard manual labor, hold a dish and a fragile-looking spoon in her lap—a vignette of nourishment as the reward for hard work and as fuel for renewed toiling.

After months of practice, Van Gogh felt confident enough to tackle a large composition. Sketches and preparatory drawings resulted in a first oil sketch, done from life, and a painted version (now at the Museum Kröller-Müller). Fully secure that he was on the right track, he made a lithograph based on his first version as an advertisement of the full-scale work that was yet to come. When it was finally done—in the studio as the academic practice required—the simple composition with its strange artificial lighting coming from a single paraffin lamp and

the clumsily drawn figures with their caricature-like faces met with skepticism and contempt. His friend Anthon van Rappard was convinced that Van Gogh had overreached himself. In defense of his painting, Van Gogh revealed something of his motivation and his objectives: "I have tried to emphasize that those people, eating their potatoes in the lamplight, have dug the earth with those very hands they put in the dish, and so it speaks of manual labor, and how they have honestly *earned* their food." He took pride in realizing that he had achieved something that overstepped the boundaries of conventional beauty and that

15

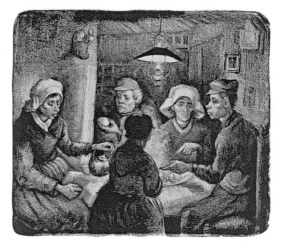

reserved for his masterpiece "a certain life of its own and raison d'être of its own that will hurl the errors into the shade—in the eyes of those who appreciate character and who allow themselves to be moved." In April 1885, he sent the painting to Theo, who acted as his art dealer in Paris.

Van Gogh realized that an artistic career would not only deprive him of family life, but also put him on the fringe of polite society. He was far from scared to leave the protection of his family, the preachers, art dealers, and admirals he had grown up among. As a preacher in the Borinage (1879), he had been used to subjecting himself to, even indulging himself in, physical hardship and mingling with his social inferiors. His sitters for *The Potato Eaters,* for instance, lead "a way of life quite different from that of civilized people" but were in his view "in many respects so much better than the civilized world." Moreover, there would always be the lifeline of regular payments from Theo, not unlike a credit card in the backpack of a modern traveler to India. Just the same, he now came to depend on a life in semipublic places, where the basic comforts were offered as long as they were paid for. Staying with his family would lead only to unbearable tension in the long run, because it reminded him of his inability to earn a living. So, as a thirty-year-old "problem child," he had to settle for the purgatory of the semipublic life in cafés, restaurants, inns, and brothels.

Inspiration in Paris

WILLING TO IMPROVE HIMSELF, he went to the Antwerp École des Beaux Arts and took drawing classes in the winter of 1885–86 and from there went on to Paris, where he arrived without notice in the beginning of March. In Paris he moved in with his brother on the rue Laval (now rue Victor Massé). He started to attend the drawing classes at the atelier of Fernand Cormon. In June, they moved to a more spacious apartment in Montmartre at 54 rue Lepic in order to provide Van Gogh with a studio. Living not far from the still rural section of Montmartre permitted Van Gogh access to places of amusement around the mills that still dominated the hill. The Moulin de la Galette, for example, which was just a short walk up the street, comprised a dancing hall, a café, and the mill Le Radet. (The mill was later named after the wafers that were sold there.) Also there was a *guinguette,* a small dining terrace with a trellis.

In the winter of 1886–87, Van Gogh made an elaborate drawing there, *Terrace of a Café* (1886, F1407). At the left of the drawing, the stairs leading up to the mill can be seen; the dance hall, which was to become the stage for Toulouse-Lautrec's famous *Bal du Moulin de la Galette* (in the Chicago Art Institute), dominates the background. The terrace

Terrace of a Café
(La Guinguette), F1407
Paris, 1886.
Pen, pencil, heightened with white, 15 x 20½"
Van Gogh Museum, Amsterdam

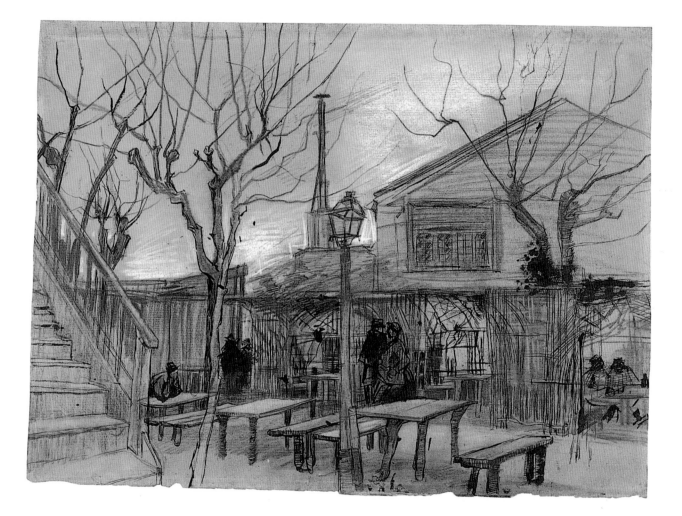

itself was a simple setting with rough wooden benches and tables, no tablecloths or napkins. Despite the late season—the bare trees indicate that the drawing was done in winter—there are still some guests, thickly clothed against the cold. Two are sitting under the canopy with a bottle of wine, which was about the only thing that was served there. The place was also frequented by Van Gogh's fellow student and friend at the atelier Cormon, Henri de Toulouse-Lautrec. In style, the drawing is very much like the more elaborate drawings Van Gogh had made in Holland: a pencil drawing, its outlines reinforced with ink and given tonality with watercolor and heightened with white chalk. The blue Ingres paper has faded to beige.

The Neighborhood Restaurant

THE TWO BROTHERS took their meals either together or with Theo's best friend, Andries Bonger, in a small neighborhood restaurant run by Mme. Bataille on the rue des Abbesses. The structure, dating from 1850, was an accumulation of narrow rooms with low ceilings. Service was quick and one was not supposed to eat at one's leisure; it was good food and inexpensive. Toulouse-Lautrec, who lived around the corner, was among the regulars. Later, after Van Gogh and Theo moved

to the rue Lepic, Van Gogh drew the view from the restaurant window with a coat and hat—his own—hanging beside it. As if to stress that the empty chair and bottle were his, he signed, inscribed, and dated the drawing *"La fenêtre chez Bataille Vincent 87,"* something he rarely did. The drawing is executed in the Impressionist technique he was trying to master at the moment. The darkness inside is suggested by cross-hatching in blue pencil, while the window shutter and chair are enlivened with touches of orange and white. Ultimately, Van Gogh redrew the main outlines in pen and brown ink, added the street scene with the two figures, and drew a transparent bottle on the table. Significantly, though he went to the restaurant nearly every day, he didn't paint the interior, but chose instead the view from the window.

The flower paintings he had been doing had considerably brightened Van Gogh's palette. His meeting with Paul Signac in the early months of 1887 bolstered his desire to experiment with Impressionist colors, and he indulged in the latest technique—*pointillé*. Although Van Gogh was too impetuous to adhere to the strict principles of Signac's Neo-Impressionism, he loosely adopted the technique to create the effect of bright summer sunshine. In the spring of 1887, he often worked with Signac and his young friend Émile Bernard.

View from a Window
(Restaurant Chez Bataille), F1392
Paris, 1886.
Pen, colored chalk, 21¼ x 15¾"
Van Gogh Museum, Amsterdam

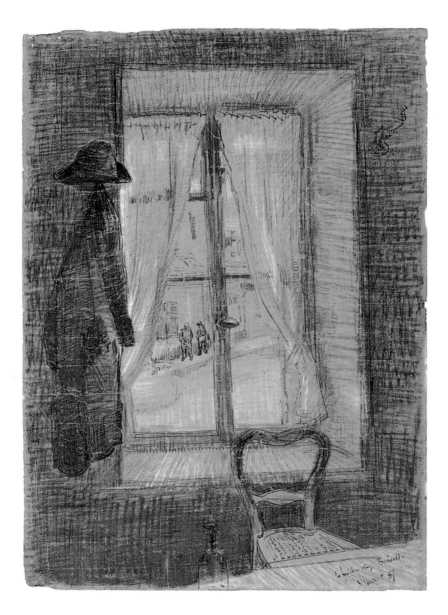

Both painters lived in Asnières, a community not yet swallowed up by the metropolis, that was a favorite Parisian destination for day trips. Just across the Asnières rail or road bridge, it was a short walk to a series of establishments on the bank of the Seine, now vanished. Le Restaurant de la Sirène, 7 boulevard de la Seine, comprised a "Salon pour noces" and "Salons et Cabinets de Société," inscriptions that Van Gogh faithfully rendered in his painting. In steep perspective, he portrayed the somewhat makeshift assembly of buildings and terraces, held together by ubiquitous climbing roses. The whole structure is bathed in bright yellow and blue brushstrokes, vibrant color keys suggesting a festive summer atmosphere. Roses, flags, and people in summer clothes add more spots of bright color within this sunlit scene. In the immediate foreground on the right, three men seem to be having a good time. The one wearing the blue workman's shirt—*"la cotte bleue de zingueur,"* as Signac would remember—and emblematic yellow straw hat was most likely the painter.

That same summer, Van Gogh painted the carefully composed *Interior of a Restaurant* (June–July 1887, F342). It is a room with a dark red faux paneling. The tables seem to be specially dressed up for the occasion: Tablecloths are laid, plates and wineglasses await the customers. A vase with a large bunch of flowers has been set on each table. Their decorative presence must have been purely for the occasion, since they would severely hamper any meal or conversation. Again, the artist makes his presence felt in the painting: Between the doors, a painting that decorates the wall is identifiable as one of Van Gogh's—*Lane in Voyer d'Argenson Park at Asnières* (Paris, 1887, F276). Although at first glance this painting seems to be dominated by dots, Van Gogh applied this technique selectively, in fact only on the floor and walls. All the concrete objects—the chairs, tables, lamp, and the hat that is hanging out of reach—are executed with strokes, sometimes even with drawn outlines.

The identification of this restaurant has invited much speculation. It has been suggested that it was the Grand Bouillon Restaurant du Chalet on the avenue de Clichy where Van Gogh was to organize a group exhibition a few months later. Detailed descriptions given by those who were familiar with the huge *établissement* ("walls ten meters high, thirty wide"; "the room was immense"), however, are incompatible with the real dimensions of this restaurant. Moreover, the place can hardly be called *populaire* in the French meaning of the word, given its bourgeois appearance. A likely candidate is the restaurant of M. Perruchot, located on the left

Restaurant de la Sirène
at Asnières, F313
Paris, 1887.
Oil on canvas, 22½ x 26¾"
Musée d'Orsay, Paris

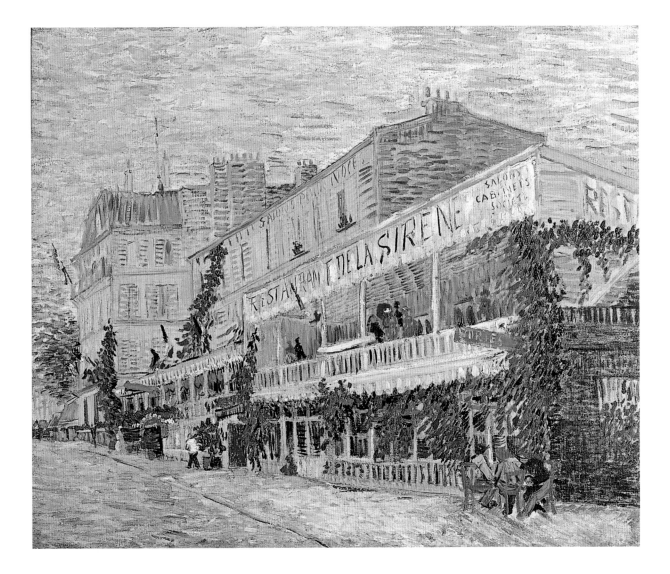

across the Pont de Clichy. Van Gogh frequently visited that restaurant, where one could have a rough wine from Suresnes at a modest price. There was another pretext for him to frequent the place, since he was friendly with the Comtesse de Boissières, who rented an apartment upstairs. Perhaps the man in *Portrait of a Man in Skullcap,* who was described very early on as a *"patron de restaurant,"* represents the owner, Père Perruchot.

Even more ambitious was Van Gogh's rendering of another restaurant, *Interior of a Restaurant* (Paris, 1887, F549), this one clearly a *restaurant populaire*. Diners have to crowd together at long tables in order to eat or even drink. The artist has positioned himself as far away from the other guests as possible, which gives him a wide enough angle to encompass much of the interior. Although perspective is generally not Van Gogh's strength, the complicated succession of ever smaller tables and chairs convincingly creates the sensation of a spacious interior. Against the wall, several larger and smaller paintings are hung. The interior is cheered up by large flowerpots, set somewhat haphazardly among the tables. Three waitresses in blue-black, with white aprons, attend to the customers. By implication, Van Gogh has again made his presence felt. In the immediate foreground, a place setting has been laid for a

regular customer. His napkin has been put in a ring, and he has been given his bottle of wine, left over from the previous day. He has helped himself to a glass of wine and to some water from the full carafe as well.

There is no mention of this painting in Van Gogh's letters, so it has been subject to a lot of speculation as to its place and time, from Paris in the summer of 1887 to Arles in the summer of 1888. The very fact that it is not mentioned in the letters from Arles would imply this is not an Arles restaurant, as has often been thought. After all, Van Gogh was on consignment there from his art dealer brother and faithfully reported to him what he had made. With the coats and hats in it, it was most likely painted during the winter, placing it somewhere in the winter of 1887–88. In February, Van Gogh had gone to Arles, where he took lodgings in some rooms over a small restaurant. Somehow the painting's spacious interior does not fit these modest premises. (Another point against Arles.) How about Paris in 1887? We know that in the autumn of 1887 Van Gogh frequented the vast Grand Bouillon Restaurant du Chalet, 43 avenue de Clichy. A Dutch painter and friend of Van Gogh, Edzard Koning, remembered a "kind of hall with a glass roof like the Central Station, where it was good

Interior of a Restaurant, F342
Paris, 1887.
Oil on canvas, 18⅛ x 22½"
Museum Kröller-Müller, Otterlo

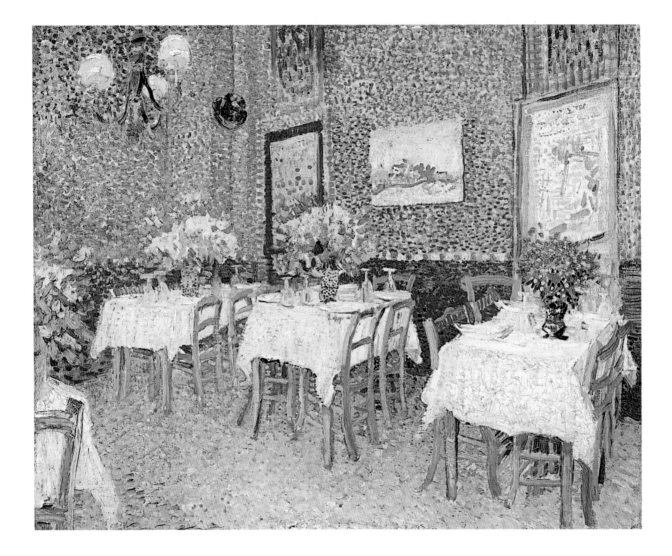

and cheap . . . It was a restaurant with female servants, about thirty of them, for whom Vincent invented typical nicknames, which they could not pronounce. One of them was a giantess, very white and thick, as if she was made of margarine. V. used to call her the 'invertebrate.'"

In November of the same year, Van Gogh had the ambitious plan to use the Grand Bouillon as an exhibition space for paintings by him and his friends. As Émile Bernard, one of the participants, later wrote: "Two years ago, Vincent van Gogh undertook a kind of exhibition of impressionism in a large popular restaurant on the avenue de Clichy. The room was immense and had enough space to hang more than a thousand paintings. Vincent turned to his friends and was joined by Louis Anquetin, Koning (who has returned to Holland since), and Émile Bernard." A glass roof accounts for the extraordinary clarity of the space, where none of the objects seems to cast a shadow. And these bright paintings on the walls with their simple white frames look like the work produced in those days by Van Gogh and his friends.

Four menus of the Grand Bouillon, 43 avenue de Clichy, have been preserved, which show sketches the artist later used as studies: a design for his portrait of Père Tanguy, his art dealer, a couple of musicians, a man and a woman strolling beside sunflowers, a prostitute washing herself. The menus themselves were relatively simple, preprinted and to be used as the bill, delivered at the cash register near the exit.

Soon after the exhibition closed, Van Gogh began to feel exhausted by the pressure of living in Paris. Spending so much time in the cafés had taken its toll, and Van Gogh realized he had a drinking problem. Moreover, living with his brother had its own complications and tensions. Van Gogh wanted to work in peace in the mild climate of the South of France. There he hoped to find a studio where artists could work together. For the time being, however, he was restricted to living in a simple inn.

After his arrival in Arles, on Monday, February 20, 1888, Van Gogh rented some rooms above the Restaurant Carrel at 30 rue de la Cavalerie. To his great surprise, sixty centimeters of snow had fallen. But that didn't prevent him from making three studies during the first week of his stay, among them "a view with a bit of pavement with a pork-butcher's shop." On the front, one can read "Reboul Charcutier." Reboul had his shop opposite the restaurant at number 61. As Van Gogh had done in Paris, he used the window where he took his meals as an observation point. But the differences are telling. Here he has allowed

Interior of a Restaurant, F549
Arles, 1888.
Oil on canvas, 21¼ x 25⅜"
Collection Murray S. Danforth, Jr.,
Providence, Rhode Island

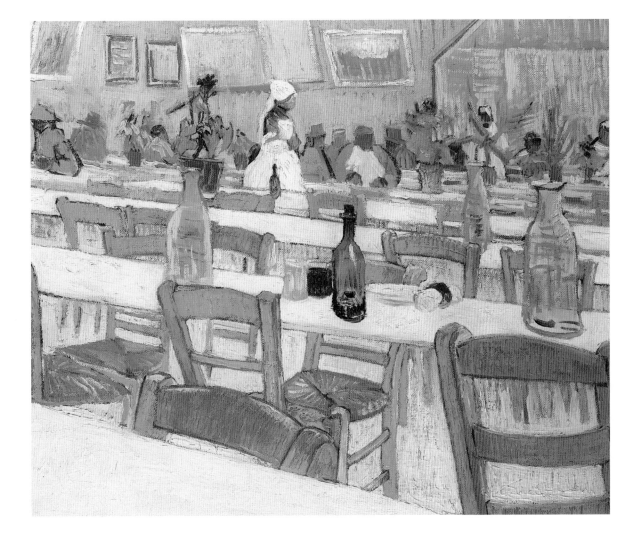

Arlésienne is hurrying in heavy winter clothes, lifting her skirt slightly in order to prevent the snow and mud from soiling it.

With its geometric rigor, the small painting is a showcase for the color contrasts that Van Gogh had recently mastered in Paris. His favored orange-green and blue-yellow are put to the test against the bright light that he hoped to find in the south. Even if the winter snow would curb his dreams of luminosity, his palette did not fail him in creating a moment of light. Twenty-five years later, the woman who ran the restaurant in 1888 gave a description of the atmosphere that reigned in her place: "It was frequented above all by shepherds from the Camargue, a bunch of familiar scoundrels . . . they often took their dogs with them, and their bells."

After an argument over the bill in May, the owner wanted to keep Van Gogh's luggage. They went to the *juge de paix,* who decided partly in Van Gogh's favor. Since the yellow house that he had rented was still inhabitable on May 7, he made his lodgings in the Café de la Gare at 30 place Lamartine, run by Joseph-Michel and Marie Ginoux, and had his meals next door in the restaurant at number 28, owned by Mme. Venissac. He felt that his health was wanting, and was prepared to pay 1 franc per meal to improve it.

the cast-iron window partitions to dominate the formal composition. Nothing of the interior can be seen other than a curtain that has been pulled aside in order to allow an unobstructed view. The façade of the *charcuterie* is exactly in the center and forms a sort of geometrical interplay with the window partitions. In the narrow space between, a "bit of pavement" can be seen, over which an

A Pork Butcher's Shop
Seen from a Window, F389
Arles, 1888.
Canvas on cardboard, 15¾ x 13"
Van Gogh Museum, Amsterdam

The Language of Color

ON AUGUST 6 HE WROTE: "Today I am going to start on the interior of the café where I stay, by gaslight in the evening. It is what they call here a 'café de nuit' (they are fairly common here), staying open all night. Night prowlers can take refuge there when they have no money to pay for a lodging or are too drunk to be admitted." Apparently, however, Van Gogh had not begun the new painting. When his departure from the Café de la Gare was imminent, bills had to be settled, and again he quarreled with an owner, this time, M. Ginoux, "who after all isn't a bad fellow." This dispute was settled in a friendlier and more original way. As Van Gogh described sarcastically: "[I] told him that to revenge myself for paying him so much money for nothing, I would paint the whole of his rotten joint so as to repay myself . . . For three nights running I sat up to paint and went to bed during the day." As a compromise between him and his landlord the picture failed, since "the picture is one of the ugliest [un des plus laids] I have done. It is the equivalent, though different, of *The Potato Eaters*." As used here, *laid* is intended ironically. In *The Potato Eaters*, Van Gogh had defended the ugliness of the painting as being the crude but

appropriate expression of the daily hardship and natural honesty of its protagonists. This time, Van Gogh worked in a much higher color key. For some time, he had already been searching for a "symbolic language through color alone." This meant that he was leaving the use of color as suggestive of light and atmosphere: "It is color not locally true from the point of view of the delusive realist, but color suggesting some emotion of an ardent temperament." In this case, these emotions were of a violent nature, so violent color contrasts were necessary: "I have tried to express the terrible passions of humanity by means of red and green. The room is blood-red and dark yellow with a green billiard table in the middle; four citron-yellow lamps glow with orange and green. Everywhere there is a clash and contrast of the most disparate greens and reds in the figures of little sleeping bums, in the empty, dreary room, in violet and blue." The blood-red and the yellow-green of the billiard table, for instance, contrast with the soft tender Louis XV green of the counter, on which there is a pink nosegay. The white coat of the landlord (seen awake in a corner by the furnace) turns citron-yellow, or pale luminous green. He promised to send Theo a watercolor in order to clarify what he had made. After having explained the color scheme as a violent contrast

that echoed through all corners of the painting, he further described these contrasts and gave them a personal twist, not without literary allusions: "I have tried to express the idea that the café is a place where one can ruin oneself, go mad or commit a crime." This could all happen in "an atmosphere like a devil's furnace, of pale sulphur" in order to "express, as it were, the powers of darkness in a pub." Zola's *L'Assommoir* is alluded to, as well as Tolstoy's play *The Power of Darkness*, both of which he and Theo knew.

Not only the color contrasts and the literary associations, but also the emphatic schoolbook perspective conspire to achieve this oppressive effect. It is ten minutes past midnight. Except for five people, most of the guests have left, some tables still have bottles and glasses, and the patron, in his white outfit, is standing under the gaslight over the billiard table. The gaslight, which outshines the three visible paraffin lamps, creates the conspicuous shadow under the billiard table. The two sleepy bums at the right seem to be engaged in weary conversation; it is possible that in one of them Van Gogh has made his own presence felt, also in a literal sense. The man seated behind the stove has turned in, but the couple in the back is engaged in urgent conversation. Behind them, a *portière* partly covers the entrance to a kitchen,

and possibly to the room that Van Gogh rented. It is likely that he had to cross this "rotten joint" every night. Each time he was reminded of his desolate situation: "The painter of the future . . . I can't image him living in little cafés, working away with a lot of false teeth and going to the Zouaves' brothels, as I do." He made the painting in three nights, from September 5 to 8. On the last day he received a letter from Theo enclosing 300 francs, part of an inheritance. At last he was able to furnish the yellow house that had remained uninhabitable for four months. He could leave the unworthy café life behind. He sensed that with pictures like this one, he was testing new waters for his art. He ranked them under the description "exalted studies." Normally, he found these both ugly and poor, but after reading "this little article on Dostojevsky, these are the only ones which appear to me to have any deep meaning."

Van Gogh had described his night café to Bernard, who had assumed that it was a brothel. Van Gogh insisted that this was not the case: "I have written you a thousand times that my night café isn't a brothel. But going in one evening I came upon a pimp and a whore making up after a fight. The woman pretended to be indifferent and haughty, the man was wheedling." Van Gogh,

The Night Café, F463
Arles, 1888.
Oil on canvas, 27⅞ x 35"
Yale University Art Gallery, New Haven, Conn.

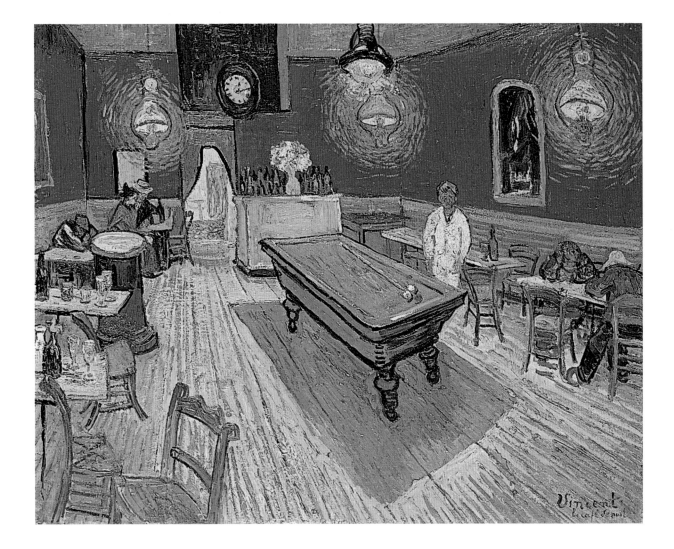

satisfied with a series of drawings that Bernard sent him, was inspired to tackle a similar subject: "I got busy painting it for you from memory on a little canvas. . . . I won't sign this study, for I never work from memory. There is some color in it that will please you, but once again, I have painted a study for you which I should have preferred not to paint." However, this is not *The Night Café*, so it cannot be identified with the sketch he promised to Bernard. In a letter to Theo, dated nearly a month later, around the 12th of November, Van Gogh again mentions that he has "done a rough sketch of the brothel," and that he "quite intend[s] to do a brothel picture."

This small painting has the appearance of having been made very quickly. In a gloomy, greenish room with erotic decoration on the walls, sparsely lit by a paraffin lamp, three doll-like women who are clad in loud orange, pink, and vermilion dresses, are being addressed by a man wearing a bowler hat, holding a glass in his hand. In the background, seated at another table, a second lieutenant of the Zouaves is engaged in conversation with a woman, while on the right a woman in red is being embraced by a man. The three stages of mock courtship are thus depicted: surveying the scene; preliminary negotiations; execution of the transaction. The figures are

outlined in Prussian blue, and the colors are in the same red and green hues that had been so capable of expressing "the terrible human passions" in *The Night Café*. The drawing, which is rough and clumsy, might be due to Van Gogh's inexperience in figure drawing. But as with *The Potato Eaters*, this roughness could also be seen as an advantage. After all, we are at the bottom of human life here, where lack of inhibition, cunning, and greed are most manifest. Another explanation for the clumsy aspect of the painting may have been a result of its having been done from memory. Van Gogh always needed live models to work from, and in his view he was "not sufficiently attractive to make them pose for nothing," so it would cost him a lot of money.

After Gauguin arrived in Arles on October 23, he tried to persuade Van Gogh to work more from imagination. He and Van Gogh then made several expeditions to the brothels "in order to study them." The actual paintings were made in the studio. The brothel sketch by Van Gogh seems to be the fruit of one of these expeditions. It also resulted in Gauguin's own version of *The Night Café*. Madame Ginoux is sitting in the foreground, while the supernumeraries in the background are "figures seen in the brothels." Gauguin enumerated them in a letter to Bernard: "Above, red wallpaper,

three whores, one with her head bristling with *papillotes,* the second with a green shawl. The third with a vermilion shawl. A sleeper at the left. A billiard. In the white foreground the well-finished figure of an Arlésienne with a black shawl. Marble table." Van Gogh, although praised by Gauguin, was less satisfied: "garish local colors don't suit me" and "the figure on the foreground is far too much *comme il faut."*

Of course, we can recognize three figures, who have all been immortalized by Van Gogh in numerous portraits: Madame Ginoux, the owner of the night café, the Zouave on the left, and the postman Roulin, whom Gauguin omitted from his description and who seems an afterthought. The marble table is occupied by a still life of alcohol, emblematic by its relative size. The seltzer bottle and sugar cubes conspire to prepare a glass of absinthe. Stylized smoke that hangs frozen in the air seems to tie the figures to a pernicious life cycle conditioned by alcohol and prostitution. And Madame Ginoux's knowing smile seems to indicate that it is she who is in control.

Enchantments of the Night

AFTER FINISHING *his* version of *The Night Café,* which almost seemed a deed of exorcism, Van Gogh could continue his exploration of night effects in a far more detached way. The painting was immediately followed by *The Café Terrace on the Place du Forum* (Arles, 1888, F467), a painting that has become almost symbolic of the enchantment of night life under southern skies. The terrace is situated on the place du Forum in Arles, a place Van Gogh would visit together with his friend, the painter and poet Eugène Boch. It is Van Gogh's first starry night painting, in which he tried to catch the striking artificial light effect of a gas lantern under a night sky by means of the most forceful contrast of his palette, blue and yellow. He prided himself on having wrought a night effect without having once resorted to black. Above all, it was an expansion of the night effect that he had seen with his colleague Louis Anquetin in Paris. Anquetin had painted an evening on the avenue de Clichy with a palette almost exclusively restricted to yellow and blue. Van Gogh strove for far richer contrasts, which he described at length in a letter to his sister Wilhelmina: "An enormous yellow lantern sheds its light on the terrace, the house front and the sidewalk, and even casts a certain brightness on the pavement of the street, which takes a pinkish violet tone. The fronts of the houses in a street stretching away under a blue sky spangled with stars are dark blue or violet and there is a green tree. Here you have a night picture

without any black in it, done with nothing but beautiful blue and violet and green, and in these surroundings the lighted square acquires a pale sulphur and greenish citron-yellow color. It amuses me enormously to paint at night right on the spot. They used to draw and paint the picture in the daytime after the rough sketch. But I find satisfaction in painting things immediately. . . . In the dark I may indeed mistake a blue for a green, a blue-lilac for a pink-lilac, for you cannot rightly distinguish the quality of a hue. But it is the only way to get rid of the conventional night scenes with their poor sallow whitish light, whereas a simple candle already gives us the richest yellows and orange tints."

Supposedly, Van Gogh painted this picture with candles affixed to the rim of his hat; whether the story is apochryphal remains uncertain, but writers and filmmakers love it.

This great work is the last of Van Gogh's café paintings. The tragic sequence of events that culminated in the famous ear incident on December 23 of that year finally led to his voluntary confinement in an asylum for the insane in nearby Saint-Rémy-de-Provence in the beginning of May 1889. Feeling cured and longing for the north, Van Gogh traveled to Paris on May 17 to meet up with Theo and his family, and some friends. Theo wrote him a letter of introduction to Dr. Gachet, a homeopathic practitioner who lived in Auvers-sur-Oise. Dr. Gachet had supported artists such as Cézanne and Pissarro and could keep an eye on Van Gogh. Moreover, Auvers was a country village that would undoubtedly offer the artist any number of subjects ideal for his work.

An Easy Customer

FOLLOWING HIS ARRIVAL in Auvers, on Tuesday, May 20, 1890, Van Gogh went to see Dr. Gachet with the letter from Theo. Gachet recommended that he stay at the Auberge Saint-Aubin, but he considered the 6 francs he had to pay too much, so he was fortunate to discover, all by himself, an attic room at the Auberge Ravoux, place de la Mairie, that cost him only 3 francs 50. The patron was Arthur-Gustave Ravoux, a wine dealer who had recently taken over the business. Eager to start working, Van Gogh wrote the next day to Theo, begging him to send him twenty sheets of Ingres paper. On one of them, he drew an interior with two tables with benches and chairs. At the bottom, there is a small sketch of Van Gogh's famous Arles bedroom painting. Because of this, the drawing used to be assigned to Arles. The sketch differs in essential ways with the painting, however, implying that Van Gogh

did not have the painting at hand but that he made the sketch from memory. Thus we can conclude that the drawing was not made in Arles. Moreover, the view from the window, where a thatched roof and some trees can be seen, also seems typical of Auvers. The rear of a cart or carriage can be seen through the left window, and a man is glancing through the window. We wish it were a representation of the Auberge Ravoux, of course, but the windows are different. The Auberge Ravoux has large windows that are divided by narrow strips. Another sketch confirms this. It is a small drawing, made in a sketchbook that Van Gogh used in Auvers. A woman is standing behind the bar serving two drinkers. Here, nothing contradicts the interpretation that this is the zinc of the Auberge Ravoux.

According to Adeline Ravoux, thirteen years old at that time, and whose features we would love to recognize in the woman behind the bar, Van Gogh was an easy customer. She described him in detail from recollection: "He was a man of good size, his shoulders lightly bent to the side of his wounded ear, his look very bright, soft, and calm, but hardly of a communicative nature. When we spoke to him, he always answered with an agreeable smile. He spoke French very correctly, groping little for words. He never drank alcohol. I insist on this point. The day of his suicide, he was in no way drunk, as some people allege."

Van Gogh seemed to have found a new equilibrium in the north. In his letters he even spoke of "consolation" and "serenity." Nothing seemed to prophesy that he would allow himself only a few weeks of that regained mental and physical health.

Art in the Café

FOR AN ARTIST WHO HAS neither family nor a home he can call his own, the café or auberge is where he sleeps, takes his meals, drinks, dreams, and drinks again. It is where he meets friends, artists like himself, and engages in discussions

33

Interior of a Restaurant, F1508v
Arles, 1888.
Pencil, 10¼ x 17⅜"
Van Gogh Museum, Amsterdam

on art and life. It is a public place that assumes the face of privacy. In 1880, Van Gogh made a pilgrimage to Courrières in Artois, the homeland of Jules Breton, the painter of rural life whom he very much admired and whom he considered to b e the worthy successor of the venerated Millet. The trip ended in total failure: The exterior of Breton's brick atelier seemed so forbidding to Van Gogh that he retreated. In Courrières, the Café des Beaux Arts seemed to repulse him as well, "also built of new bricks, equally inhospitable, chilly and repellent." The inside was as appalling as the outside. The walls, intended to justify the name of the café, were decorated with murals that represented the life of Don Quixote: "Those frescoes seemed to me a poor consolation, as they were of a rather inferior quality." Nonetheless, the idea of doing something in that genre himself captivated Van Gogh.

IN 1884, DURING A STAY with his parents in Nuenen, he received a commission from an amateur to decorate his dining room. Van Gogh chose the four seasons. He did not feel himself above working on decorations. On the contrary, he saw a niche for himself from a business point of view. When he was trying to refine his drawing education at the Antwerp École des Beaux Arts, he was astonished that the local art trade neglected what seemed to be a ready source of income: "One sees no pictures in the cafés, restaurants, café-chantants, at least hardly any. And how contrary this is to nature. Why don't they hang still lifes there, like . . . in times of old? Why, if they want girls at all cost, why not portraits of them?" In Paris he always hoped to get an exhibition in a café, which he eventually did at the Café du Tambourin. The display of his flower paintings and Japanese prints ended in disaster. As he later wrote, "The exhibition of prints that I had at the Tambourin influenced Anquetin and Bernard a good deal, but what a disaster that was!"

In November 1887 Van Gogh embarked on trying to have a second exhibition after the show of Japanese prints in the Café du Tambourin that summer. This time the enterprise was far more idealistic. He did not want to find just a showcase for his own work, he wanted to achieve a kind of unified presentation of the most advanced painters of that moment. By its sheer size, the presentation would attract the attention of dealers and buyers, or so he hoped. As the accepted Impressionists had dealers such as Durand-Ruel, Bernheim-Jeune, Georges Petit, and Boussod & Valadon on the *grands boulevards,* near the Opéra, the aspiring new generation gathered in the more modest quarters

Men in Front of the Counter in a Café, F1654
Auvers, 1890.
Pencil, 3⅛ x 5⅛"
Van Gogh Museum, Amsterdam

Sketch of a Hen, F1731
Auvers, 1890.
Pencil, black chalk, 3⅛ x 5⅛"
Van Gogh Museum, Amsterdam

around the boulevard de Clichy. Moreover, they had all worked in the atelier of Fernand Cormon in the same neighborhood. Van Gogh was already dreaming of a fraternity of artists. He tried to persuade Camille Pissarro to exhibit, and it is not known for what reasons he and the other Pointillists, like Signac, did not join in. But in the end only Van Gogh, Bernard, Anquetin, Toulouse-Lautrec, the Dutch painter Edzard Koning, and perhaps Armand Guillaumin participated.

The vast walls of the Restaurant du Chalet on the avenue de Clichy were "inundated" with studies, and the spectacle was "by far the most advanced thing in Paris," as Bernard later recalled. Van Gogh even likened the café to "a méthodiste chapel," and its walls seem to have been ten meters high and thirty meters wide. Bernard later wrote: "Two years ago, Vincent van Gogh undertook a kind of exhibition of impressionism in a vast popular restaurant at the avenue de Clichy. The room was immense and had space where one could have hung more than a thousand paintings: therefore Vincent asked for help; and he was joined by Louis Anquetin, Koning (who has returned to Holland since) and Émile Bernard. The regular customers . . . continued to take their meals, not without being a little upset by the repellent appearance

of the paintings and the painters amidst these polychromies. A certain number of artists came by from which we mention haphazardly, Pissarro, Gauguin, Guillaumin, Seurat, and so forth, and some dealers that were in those days well disposed towards the revolutionaries bought several things there. Just to quote among others Mr. Georges Thomas (of the Boulevard Malesherbes) who was then on the right way . . . About a hundred canvasses of Vincent were hanging from those walls. Thus, the general impression of the room was due to him, and a gay, vibrating, harmonious impression it was." So the organizing artist was by far the most prolific participant: "fifty or hundred paintings," Bernard remembered afterward, "violent still lives, flaming faces." The other artists present at the exhibition did not spill out their works as generously as Van Gogh.

There is some evidence that Van Gogh succeeded in tempting some of his colleagues to exhibit as well; Gauguin, Pissarro, and Guillaumin may have been on the verge of submitting. But suddenly the whole enterprise collapsed over a political-artistic issue: Père Martin, the *propriétaire*, wanted to hang patriotic shields between the paintings, which offended the artists. Van Gogh loaded his pile of works back on the same wheel cart he had used to bring them. In hindsight, this

second café exhibition was not as great a disaster as the first. Again, Van Gogh writes: "Bernard sold his first picture there, and Anquetin sold a study, and I made an exchange with Gauguin; we all got something out of it."

LATER IN ARLES, he kept toying with the idea of decorating cafés as a way of expanding business. Just as the old Dutch painters had decorated the stately home of the burghers, "here in the South paintings would offer a wonderful spectacle hanging on the white walls." Soon he would be able to do this in his yellow house, with sunflowers, portraits, and gardens. But the cafés remained an option; "maybe there will be something hanging there later." In 1889, during the Exposition Universelle Internationale, an excellent opportunity seemed to present itself. Gauguin's friend, the painter Émile Schuffenecker, succeeded in convincing café owner M. Volpini to hang some paintings in lieu of the mirrors the owner had ordered. Émile Bernard, Charles Laval, and others participated, but Theo, who operated as his brother's impresario in Paris, had second thoughts about participating. First of all, his brother was in a major crisis after the fight with Gauguin. And there were artistic politics involved. According to Theo, it would seem as if the artists who had not been invited to participate in the official exhibition "were going to the Universal Exhibition by the back stairs." Van Gogh agreed with his brother's decision and even seemed to deny his former dream of exhibiting in a café: "You cause a stir by exhibiting in cafés; I do not say it is not bad taste to do it, but I myself have this crime on my conscience twice over, as I exhibited at the Tambourin and at the Avenue de Clichy. . . ." That he was sarcastic becomes clear when he continues in one breath about the trouble he has caused during his madness to "81 worthy anthropophagi of the good town of Arles and their excellent mayor." In reality, the dream of exhibiting in a café was never given up. Less than three weeks before his death at the Auberge Ravoux, he was still making plans in this vein: "I think," he wrote to Theo, "I shall find a way to have an exhibition of my own in a café."

True Friends

BY A FORTUITOUS PROCESS, SOME OF THE PEOPLE VAN GOGH MET have become well known throughout the world. Ordinarily, the names and faces of café owners and regulars have a very limited notoriety within their community. Within one or two generations, all traces of them have vanished, all memories been erased. Instead, some of these people look at us from the walls of venerable institutions because, unknowingly, they became part of a project in which no one believed apart from the painter who wrote: "What impassions me most . . . is the portrait, the modern portrait. I seek it in color, and surely I am not the only one to seek it in this direction. I should like—mind you, far be it from me to say that I shall be able to do it, although this is what I am aiming at—I should like to paint portraits which would appear after a century to the people living then as apparitions. By which I mean that I do not endeavor to achieve this by a photographic resemblance, but by means of our impassioned expressions."

Joseph Roulin, F439
Arles, 1889.
Oil on canvas, 25⅝ x 21¼"
Museum Kröller-Müller, Otterlo

Agostina Segatori in Paris

IN THE SPRING OF 1887, Le Tambourin, 62 boulevard de Clichy, just around the corner from where the Van Gogh brothers lived in Paris, became a stage of great importance for Van Gogh. The café had a brief existence, from 1885 to 1887, but it started in a very ambitious key, according to the opening advertisement in the *Gazette du bagne*. It was to be no less than a theme café, with the tambourine as its emblem of Italian conviviality. Moreover, the café was to be a place for artists as well as an exhibition hall. Its prototype was the *brasserie à femmes*, a beer hall with waitresses instead of *garçons*, which had been emerging since the Exposition Universelle of 1867. (The function of *brasseries à femmes* was somewhat cloaked. In many of them, the waitresses provided sexual services as well as beverages. In fact, these brasseries were places of illegal prostitution for employers and girls who wanted to escape the official regulation of brothels.) Outside, there was a tambourinelike sign, and the tabletops and stools were likewise tambourine shaped. The waitresses wore Italian dresses. Le Tambourin opened on April 10, 1885, with an exhibition of paintings and painted tambourines by Jean-Léon Gérôme, Benjamin Constant, Paul Besnard, Henri de Toulouse-Lautrec,

and many others. The woman who ran the café was Agostina Segatori, forty-six years old and a former model to, among others, Manet and Corot. Though no longer in her prime, La Segatori must still have radiated sexuality. After having read an amusing story about a sensuous sow by Charles Morice, Van Gogh wrote to his brother: "Very good, it just makes one think of Segatori. No doubt you will read this article with pleasure." This association is confirmed by the author and painter Georges Auriol, who wrote about "her maturity that was not short of piquancy." The collector Ernest Hoschedé (whose wife left him for Monet) was one of the gourmet patrons of the place. In jest the painter Henri Pille, one of the regulars, called himself *"le maquereau de la boîte"* ("the house pimp").

At one point Van Gogh painted a woman sitting in the café, her arms folded, a cigarette between her fingers, her parasol folded on a stool, and a beer mug in front of her. The table and stools bear the signature form of the house. It seems that even the dishes that brought the macaroni were tambourine shaped. (In the dishes one would every now and then find some off-white hairs of the rabbits kept by Segatori.) In Van Gogh's portrait, the sitter wears a somewhat exotic dress and sports a fashionable red hat. The wall behind her is covered with paintings and Japanese prints. Is this

Woman at a Table in the Café du Tambourin, F370
Paris, 1887.
Oil on canvas, 22 x 18½"
Van Gogh Museum, Amsterdam

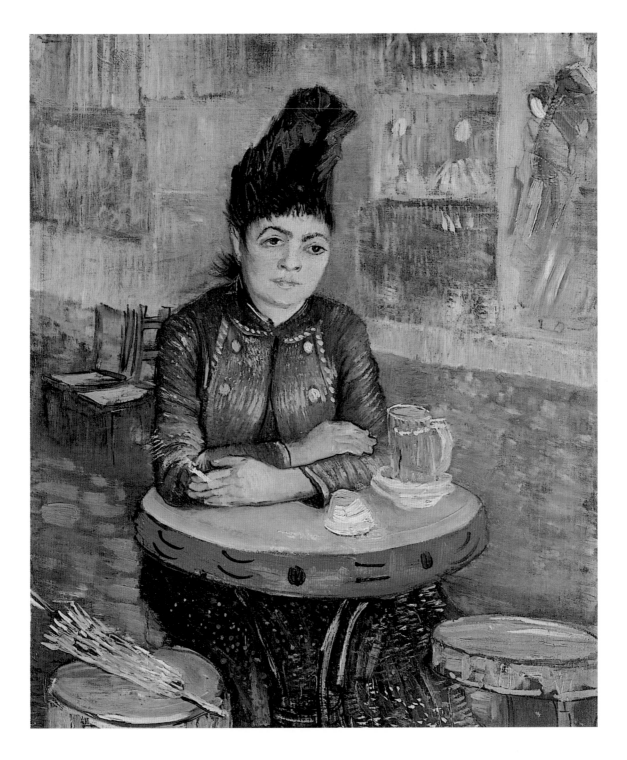

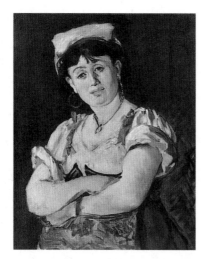

cigarette and sipping at a couple of beers. Who is she waiting for? Perhaps the beer belongs to a client, hence the empty stool. That the portrait would be the evocation of a social type rather than the portrait of an individual was far from atypical of Van Gogh. Rather than the group portrait of the De Groot family around the dinner table, *The Potato Eaters* portrays a group of "heads of people," a concept derived from the illustrated English magazines that Van Gogh was fond of. Once portrayed, the faces crossed the dividing lines between the social classes and lost their individuality in the process.

Early in 1887, Van Gogh started to take several meals a week at Le Tambourin. He used to pay with his work, mostly flower pieces, which soon covered the walls of the *établissement*. He even fell in love with La Segatori, who was twelve years his senior. Van Gogh took his atelier comrades Bernard and Anquetin with him, as well as Toulouse-Lautrec, who made a pastel portrait of Van Gogh (page 6) on the spot. Van Gogh was also granted permission to hang his collection of Japanese prints on the wall, which influenced Bernard and Anquetin. Around this time, the business started to fail. Apparently in debt, Agostina Segatori was no longer free to be the boss in her own house. There were rumors of people from the "milieu" taking over her

lady the notorious and enterprising La Segatori as tradition has it? It seems so, since there is a portrait by Manet, made in 1860, *L'Italienne*, for which Agostina Segatori seems to have posed. Even though some twenty-six years have passed, a certain resemblance remains. Yet why then does her glass stand on two small trays, indicating that she, who was the owner, had to pay for two drinks? And why did Van Gogh's portrait of her end up in the collection of the Van Goghs instead of hers?

Perhaps in fact the portrait wasn't of Segatori, but represented a *type* rather than a *person,* a fashionable demimondaine, quietly smoking her

Italienne
by Édouard Manet, 1860.
Oil on canvas, 29 x 23⅜"
Private collection

The Arlésienne with Books
(Madame Ginoux), F488
Arles, 1888.
Oil on canvas, 36 x 29"
The Metropolitan Museum of Art,
Bequest of Sam A. Lewisohn, 1951 (51.112.3)

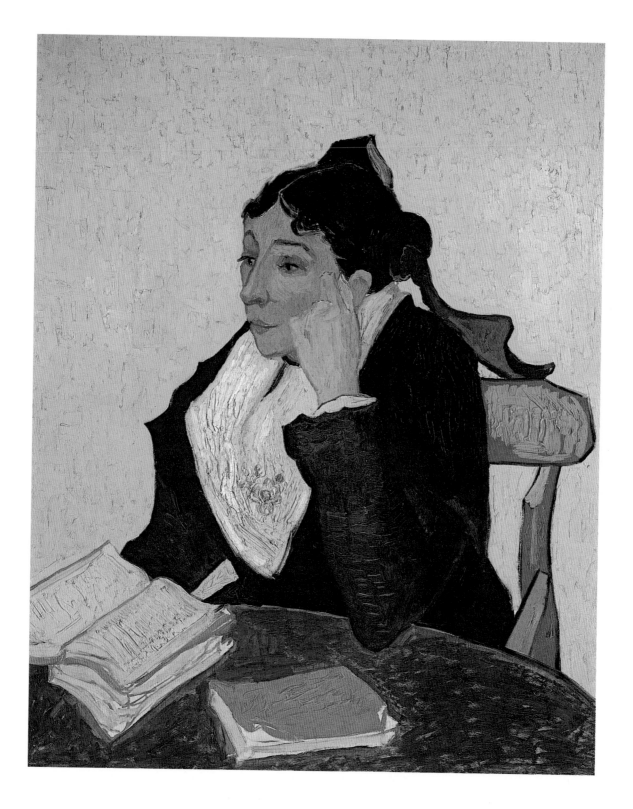

business, which confirms the suspicion that illegal prostitution may have been involved. Several police interventions occurred. Moreover, Mme. Segatori fell ill. Van Gogh feared that the works that hung on the walls of Le Tambourin would be confiscated by her debtors, so he went to see Mme. Segatori, who reassured him that "the paintings and the rest were at [his] disposition." Nevertheless, as Bernard recalled, many flower pieces by Van Gogh were sold in batches of ten, against a price of 50 centimes to 1 franc. It was a disquieting and disappointing end to Van Gogh's relationship with Mme. Segatori and Le Tambourin.

Arles: Marie and Joseph Ginoux

IN ARLES, JUST AS IN PARIS, Van Gogh became closely acquainted with the owners of the café where he was a regular. There, too, he was able to persuade them, as well as some of the visitors, to pose for him. With his limited budget, he could not afford professional models.

The notorious beauty of the *Arlésiennes* may have been one of the reasons Van Gogh chose to go to Arles. Soon after his arrival, he convinced an old lady, who may have been in need of some money,

to pose. In July he was able to snare a pretty girl in her early teens. The true *Arlésienne* continued to elude him until the owner of the Café de la Gare, Mme. Ginoux, consented to sit. Née Marie Julien, she had been born in Arles and, at seventeen, married Joseph-Michel Ginoux, already thirty years old. She had just turned forty. (Mme. Ginoux did more than sit for Van Gogh—she went far beyond

The Arlésienne
with Light Pink Background
(Madame Ginoux), F541
Saint-Rémy, 1890.
Oil on canvas, 25⅝ x 19¼"
Museum Kröller-Müller, Otterlo

Madame Ginoux in
the Night Café
by Paul Gauguin, 1888.
Oil on canvas, 28⅓ x 36¼"
Pushkin Museum, Moscow

the line of duty by attending to him while he was interned in the hospital in Saint-Rémy. "When you are friends, you are friends for a long time," she was wont to say. Moreover, she was his accomplice in illness, suffering from "nervous attacks" herself. She died in 1911.) "I have an Arlésienne at last," he wrote to Theo. He and Gauguin had staged the scene; first they offered the lady a coffee, and once she was sitting, Van Gogh had "slashed," as he put it, the portrait in one hour. Gauguin, who was making a drawing at the same time, kept on telling her, "Madame Ginoux, Madame Ginoux, your portrait will be hung in the Louvre, in Paris." And so it happened. (Today the first version hangs in the Musée d'Orsay, and the other is in the Metropolitan Museum of Art in New York.) Van Gogh described the Orsay painting to Theo: ". . . background pale citron, the face gray, the clothes black, black, black, with perfectly raw Prussian blue. She is leaning on a green table and seated in an armchair of orange wood." Before the paint was completely dry, he added a parasol and a pair of gloves, which together with her Arlesian outfit makes her quite ladylike. In the second version, painted in a more deliberate impasto, the feminine accessories are replaced by books. This pose, the "interrupted lecture," may well reflect Van Gogh's ideas about educated femininity.

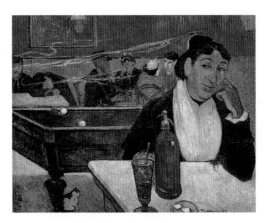

The drawing that Gauguin made at the same time served as a model for his painting *Night Café*. It was one of the works that Gauguin left behind after his hurried departure from Arles on December 25, 1888, and which Van Gogh took with him when he went to the asylum in Saint-Rémy, as so few models were available for posing. He was so fond of it that he used it as a base for no fewer than five paintings, one of which he marked for Gauguin. He wrote to him: "It is a synthesis of the Arlésiennes, if you like; as syntheses of Arlésiennes are rare, take this as a work belonging to you and me as a summary of our months of work together." In this portrait, the books are identifiable: Harriet Beecher Stowe's *Uncle Tom's*

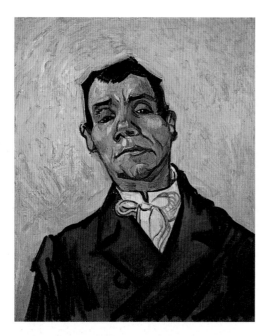

Cabin on top of Charles Dickens's *Christmas Carol*. Van Gogh had reread these books just before he went to Saint-Rémy, and to him they were models of morality and care. Had Harriet Beecher Stowe not written her book "while she was making soup for her children"?

Joseph-Michel Ginoux, the *limonadier,* or café proprietor, was fifty-two when Gauguin and Van Gogh asked him to sit for them. Van Gogh drew him from a low viewpoint. As his wife had, Ginoux seems to have dressed for the occasion. His dark blue coat, starched white collar, and tie frame a rather unkempt, irregular face. The Day-Glo yellow-green background seems to have gnawed at the concave contours, just as in Mme. Ginoux's dress. The remarkable face with its crooked nose and searching eyes verge on caricature; it has *"du vrai Daumier,"* as Van Gogh would say. And it is Joseph Ginoux, standing in the middle of his "rotten joint," whom Van Gogh painted in order to avenge himself of a financial dispute. "After all not a bad human being," the painter had judged him after he had calmed down a little. Ginoux proved to be an excellent landlord and, like his wife, a good and helpful friend. While Van Gogh was in Saint-Rémy, Ginoux stored the artist's furniture. During his stay, they kept in touch by letter. Whenever he went to Arles, Van Gogh visited the Ginoux, and when he decided to return to the north, the Ginoux helped him by sending the stored furniture to Paris. They had been very disappointed that the artist did not come by to greet them for the last time.

Paul-Eugène Milliet

IN THE ARLES CAFÉS, Van Gogh met some remarkable characters. In the sketchy painting of

Portrait of a Man, F533
Arles, 1888.
Oil on canvas, 25⅝ x 21⅝"
Museum Kröller-Müller, Otterlo

Tavern Scene (Le Bordel), F478
Arles, 1888.
Oil on canvas, 13 x 16⅛"
The Barnes Foundation Museum of Art,
Merion, Pa.

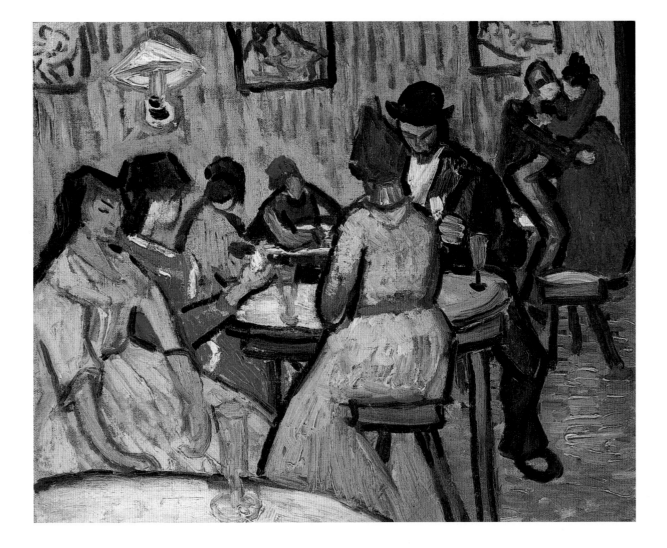

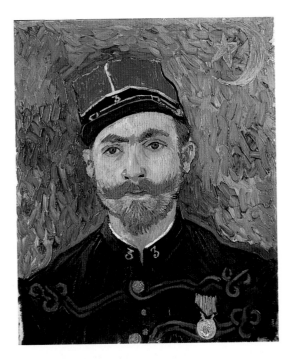

the brothel that Van Gogh made in 1888, a figure wearing a red kepi is sitting in the back, apparently engaged in lively conversation with one of the prostitutes. This tiny figure could very well be an evocation of Paul-Eugène Milliet, sous-lieutenant of the third regiment infantry of the Zouaves, then twenty-five years old. Milliet, who went on to distinguish himself in Tunisia, Algeria, Morocco, and the Great War, and had climbed to the rank of

lieutenant-colonel, well remembered his days in Arles in the company of the eccentric Dutch painter. Milliet's military career as well as his character gave him confidence to pass judgment on the art of painting. *Dessin* ("draftsmanship") was necessary and of foremost importance for the fine arts, he knew. As a draftsman himself, he could appreciate Van Gogh, but as far as painting was concerned, "I would never have accepted him as a *professeur* . . . I have even given him lessons. Drawing lessons, that is, because it happened to us, especially when we were drawing out in the open, that we made a drawing of the same landscape, and that we corrected each other's work, independently." Of Van Gogh's paintings he had a low opinion: "There is too little draftsmanship in them, his strokes are too broad, no attention to detail, no preliminary drawing. When he only set himself to it, he could really draw, I assure you. But he replaced drawing with color. And then, what color . . . exaggerated, abnormal, inadmissible. . . . A painting has to be coaxed [*pelotée*]; Van Gogh raped it."

The cocky opinions of the young Milliet were not lost on Van Gogh. Mockingly, Van Gogh wrote in a letter that two of his studies "have been approved of as having 'quite the modern touch' by the young rival of good old General Boulanger,

Lieutenant Milliet, F473
Arles, 1888.
Oil on canvas, 23⅜ x 19¼"
Museum Kröller-Müller, Otterlo

the very resplendent 2nd lieutenant of the Zouaves. This valiant warrior has given up the art of drawing, into the mysteries of which I endeavored to initiate him, but it was for a plausible reason, namely that he had unexpectedly to take an examination, for which I am afraid he was anything but prepared. Always supposing the aforesaid young Frenchman always speaks the truth, he has astonished his examiners by the confidence of his own answers, a confidence he had reinforced by spending the eve of the examination in a brothel." Milliet was a regular of the neighborhood behind the old city ramparts, where he could have "as many Arlésiennes as he wants." But, Van Gogh added, Milliet "can not paint them, and if he were a painter, he would not get them." In November, the soldier was to campaign in Algeria again, so he spent his last days among the prostitutes in Arles. For Van Gogh, this contributed to the problem of painting Milliet. "He poses badly," complained Van Gogh, "he has a nervous motion of the legs." In view of Milliet's behavior, it comes as no surprise that he thought he could very well serve as model for a painting of lovers. His attitude was unrestrained, and sitting still was not in Milliet's character. "I should have posed more, but I did not like it at all. As far as I can remember, it did not take a long time. After all, there was no preparatory design made, so he lost little time on it."

Milliet is painted in a black uniform with his Tonkin decoration on his chest, and three regiment insignia on his collar. He has a well-groomed pointed beard and mustache, and his red kepi is a little askew, in the manner of the colonials. The background is a dark green-blue, painted in heavy impasto, as are the crescent and a five-pointed star, the ensign of his regiment. About the likeness, the sitter was very much satisfied, but the uniform background did not please him. The painter himself was sufficiently pleased with the painting to hang it in his bedroom over his bed, the portrait of the soldier-lover next to his portrait of the poet.

Although he was generally highly critical of Van Gogh's painting, Milliet was a true friend. In order to save Van Gogh money, he took his recently completed paintings with him when he visited Paris and delivered them to Theo. He returned with some Japanese prints. Van Gogh thought this a just compensation for the free lessons he had given the soldier. Milliet sent a letter from Algeria, full of picturesque detail and enchantment for the North African landscape. But he complained bitterly about one thing, and his lamentation is remarkable for a second lieutenant in the infantry: "Not a single book to be read here, not even Balzac. What a wretched hole of a place! Moreover it is impossible to get one here. Have you succeeded in getting Bel-Ami?"

49

Joseph-Étienne Roulin

THE "POSTMAN" Joseph-Étienne Roulin, as Van Gogh called him, was in fact brigadier-chargeur at the Arles station, responsible for the loading and unloading of postal bags from the train. He and his wife and their two sons normally lived on the rue de la Cavalerie, between the two railroad tracks, but because his wife was expecting a third child in the early summer of 1888, she was staying in Lambesc with family. The postman was probably taking meals out like Van Gogh, and they may have met at the restaurant of Mme. Venissac, 28 place Lamartine, or while drinking together in the Café de la Gare. Or they could have become acquainted professionally because Van Gogh had sent cases of paintings and rolls of drawings by train to Paris. Roulin seems to have been a remarkable presence, physically and in manner and style. He was then forty-seven years old and almost two meters tall. Van Gogh was struck by his "big, bearded head, very Socratic." It was not only the man's size that fascinated him, but also Roulin's politics, "a republican through and through." They were indeed drinking companions, because he was "none the less Socratic for being somewhat addicted to liquor." Roulin's pride prevented him from accepting money for posing, but he ate and drank at the artist's expense and was given a book by Van Gogh. To Van Gogh, this expense seemed justified because he was a good model. Moreover, he would soon be able to paint the Roulins' newborn baby. (Here it should be noted that the painter received around 100 francs a month from his brother, while the income of the entreposeur des postes, as Roulin called himself, was 135 francs, on which he and his wife were living with two sons and a baby coming, a fact of which Van Gogh was well aware.)

When the baby came, Roulin refused to have it baptized, and chose instead to "baptise the child himself. Then he sang the *Marseillaise* in a frightful voice, after which he called the child Marcelle, after the daughter of 'le brav' général Boulanger," to the great indignation of this innocent babe's grandmother and some other members of the family." For Van Gogh, Roulin was a challenge: "I do not know if I can paint the postman *as I feel him.*"

But by mid-August, Van Gogh had made two portraits of this remarkable character. One depicts Roulin awkwardly sitting in a rattan chair (given his size and weight). The other shows only the head, "done at a *single setting.*" Van Gogh made another portrait of Roulin around the beginning of December, as part of a project to paint the whole Roulin family. The present portrait was done after Roulin had been transferred to Marseilles on

January 21, 1889, like two others that are variations on the theme. This painting differs from the earlier ones that were done from life by the high degree of stylization as seen, for example, in the arabesque curls of the beard. It is probable that he had copied the upper part of the first half-length portrait he had made and "kept for himself." Then he adapted the style and added a decorative background in the manner of the portraits that he had just made of Mme. Roulin as "Berceuse."

Van Gogh evidently admired Roulin's character and called him his friend in his letters, but realized that they were both "living much in cafés." To the artist he represented a man unbroken by the miserable situation to which his humble position in life had reduced him: "He is more or less a drunkard and has been one all his life. But he is so much the reverse of a sot, his exaltation is so natural, so intelligent, and he argues with such sweep, in the style of Garibaldi, that I gladly reduce the legend of Monticelli the drunkard on absinthe to exactly the same proportions as my postman." The warm feelings were reciprocal. When Van Gogh was consigned to the Arles hospital after a fight with Gauguin, it was Roulin who was the first to get him out, and who put the yellow house in good order again.

Auvers-sur-Oise: Adeline Ravoux

WITHIN A FORTNIGHT after his arrival in Auvers-sur-Oise, Van Gogh had started a portrait of Dr. Gachet and subsequently made its copy in a more summary style, using the more elaborate version as its basis, as he had with his portrait of Roulin. After another two weeks spent mainly painting still lifes and landscapes, he made a remarkable close-up study of a cornfield. But in a letter to Gauguin, he explained that after doing some studies of wheat he would "like to paint some portraits against a very vivid yet tranquil background." A week later he had found his subject: the daughter of the innkeeper, Adeline Ravoux. To his brother he wrote: "Last week I did a portrait of a girl of about sixteen, in blue against a blue background, the daughter of the people with whom I am staying. I have given her this portrait, but I made a variation of it for you, a size 15 canvas."

Sixty-six years later, Adeline Ravoux was asked what she remembered of Van Gogh's stay in Auvers. Before doing her portrait, the artist had only made the usual exchanges of politeness with then thirteen-year-old Adeline. "Then one day he asked: 'Would it please you if I were to do

your portrait?' He seemed to be very keen on it. I accepted, and he asked my parents' permission. I was then thirteen years old, but I seemed sixteen. He did my portrait one afternoon in one sitting. As I posed he did not speak to me; he smoked his pipe continually. He found me very well behaved and complimented me on not having moved. I did not become tired, but was amused watching him paint and very proud to pose for my portrait. Dressed in blue, I sat in a chair. A blue ribbon in my hair. And since I have blue eyes and he used blue for the background of the portrait, it became a *symphony in blue*. M. Vincent may have made a replica of it in a square format that he may have sent to his brother; he says he did in one of his letters. I did not see him execute this copy. There may also be a third portrait of me: I know nothing of this last one. What I can confirm is that I only posed for one portrait."

There is no reason to doubt Adeline's testimony in this respect. The original painting is the study done from life; the "variation . . . a size 15 canvas," today in a private collection (F769), seems to have been done in the same summary manner as was the second Gachet portrait. A third version is the square one, now in Cleveland (F786), that shows only Adeline's head against a background of roses. Here the painter has slightly shifted the point of view, but the style is compatible with the second version of the study. For the background, Van Gogh used parts of a still life of roses that he had made some days before (F595).

As he had done in one of his great Saint-Rémy self-portraits (F626), Van Gogh played on the combination of Prussian blue and cobalt purple. In Adeline Ravoux's dress, strokes in these shades give bulk and add shine to an underlayer of the same colors, toned down. In the background, both hues are freely mixed in horizontal stripes. The yellow-green face and hands work as a complementary color. In this clash of colors the sitter, especially her mouth, startles us. Small wonder that the proud sitter was "only moderately satisfied" with her portrait: "It was somewhat of a disappointment, for I did not find it true to life . . . My parents did not at all appreciate this painting either, nor did the other people who saw it then. At that time very few people understood Van Gogh's painting."

Adeline's testimony is especially important for us, since it gives the idea of Van Gogh's daily routine during his last weeks. It is remarkable that she stresses there was nothing eccentric about his behavior. Although "he neglected his dress" and he was "hardly of a communicative character," Adeline insisted that *"he never drank alcohol."*

Adeline Ravoux, F768
Auvers, 1890.
Oil on canvas, 26⅜ x 21⅝"
Private collection

This seems a clear break with the habit he had in Paris and Arles. He must have taken his plans to go and lead a healthier life in the north quite seriously. Moreover, he was a loner, who "never mingled with the clients of the café," but "took his meals with our other boarders, Tommy Hirschig (whom we called Tom) and Martinez de Valdivielse." Both were artists.

In her version of the dramatic events that took place in their café, Adeline Ravoux defends her father's honor. She has a tendency to slight the importance of Dr. Gachet and his son to Van Gogh: "I believe that a certain *legend* that chooses to give credence to Vincent's dining at the doctor's house every Sunday and Monday is probably wrong, or at least highly exaggerated, because I have no memory of M. Vincent *repeatedly* missing the meals that he regularly took at our place." These meals were quite simple: "The menu was typical for meals served at the time in restaurants: meat, vegetables, salad, dessert. I do not remember any culinary preferences of M. Vincent. He never sent a dish back. He was not a difficult boarder."

According to Adeline Ravoux, he spent his days "in a more or less uniform way; he ate breakfast; then around nine o'clock he left for the countryside with his easel and paint-box, with his pipe in his mouth (which he never put down); he went to paint. He returned punctually at noon for lunch. In the afternoon he often worked on a painting in progress in 'the artist's room.' Sometimes he just worked on until dinner; and sometimes he went out around four o'clock until the evening meal." That fatal last day "he had gone out immediately after lunch, which was unusual." At dusk, he had not returned, which surprised us a lot, because, being extremely proper in his relations with us, he always arrived on time for the meals . . . When we saw Vincent arrive, night had fallen . . ."

Dr. Gachet Sitting at a Table with Books and a Glass with Sprigs of Foxgloves, F753
Auvers, 1890.
Oil on canvas, 26 x 22½"
Private collection

Give Us Our Daily Bread

VAN GOGH WAS NOT A DIFFICULT BOARDER, but his relationship with food was complicated. Like his fellow Protestants, he equated virtue with abstinence from luxury. This held especially true for food, which he often reduced to its essence, "bread." For Van Gogh, bread was pure nourishment or fuel, much like potatoes were the essence of sustenance in his painting *The Potato Eaters*. Here, the potato eaters enacted a Biblical imperative that was dear to Van Gogh, and which he often quoted in his letters: "In the sweat of thy face thou shalt eat thy bread." As a painter he could honor the working class, whom he considered to be more honest than high society: "I have wanted to give the impression of a way of life quite different from that of us civilized people." To earn your bread meant to make a living, or rather to sustain yourself through your own efforts. To Van Gogh, who was supported largely by his family, in particular by his brother Theo, the mandate to pay his own way was a painful reminder of his shortcomings in that regard. His failure to earn his own bread—his own livelihood, in effect—was a constant source of worry, irritation, and guilt.

Van Gogh had a certain talent for suffering. Although he did his best to make money by selling his work, he felt compelled to defend himself against attacks from an art dealer: "I work as hard as I can and I do not spare myself, so I deserve my bread and they ought not to reproach me with not having been able to sell anything up to now." The only way

Plate with Onions, Annuaire de la Santé,
and Other Objects (detail), F604
Arles, 1889.
Oil on canvas, 19⅝ x 25¼"
Museum Kröller-Müller, Otterlo

bread; well, one will only be the healthier for it."

Nevertheless, even Van Gogh realized that virtue could lead to excess. While studying in Antwerp during the winter of 1885, he complained to Theo about his self-imposed frugality: "Do you know, for instance, that in the whole time I've had only three warm meals, and for the rest nothing but bread? In this way one becomes vegetarian more than is good for one." After several days of fasting, he again wrote: "Perhaps you will not understand, but it is true that when I receive the money my greatest appetite is not for food . . . but the appetite for painting is even stronger." He spent almost all his money on models: "All I have to live on is my breakfast served by the people I live with, and in the evening for supper a cup of coffee and some bread in the dairy, or else a loaf of rye bread that I have in my trunk." Even in Arles, Van Gogh saved on food when other priorities presented themselves. On October 8, 1888, he had just begun to make his yellow house habitable: "I had a meal this afternoon, but tonight I will have nothing to eat but a crust of bread. And all that money is spent on the house or on paintings." There is something ostentatious in Van Gogh's repeated demonstrations of simplicity. Apparently he felt the need not only to live this way, but also to report on it in detail, as if he wanted to make

out of this moral dilemma was to stint even more on food and other everyday necessities. For someone of Van Gogh's frugality, this was not a hard task. He even derived some pleasure from it. (When he was a preacher in Cuesmes in the Borinage, Belgium's mining district, he reported that he mainly lived on "dry bread and some potatoes or chestnuts." Only every now and then did he enjoy "a better meal in a restaurant whenever I can afford it.")

Often, he was able to distill virtue from necessity as he saw it. Shortly before, in Nuenen, he had been living in a barn that doubled as a studio. Buying painting supplies nearly depleted his finances, but he exulted in the simplicity of his lifestyle, exclaiming that he was "sick of the *boredom* of civilization. . . . One may sleep on straw, eat black

Still Life with Cabbages
and Clogs, F1
Etten, 1881.
Paper on panel, 13⅜ x 21⅝"
Van Gogh Museum, Amsterdam

Red Cabbages and Onions, F374
Paris, 1887.
Oil on canvas, 19⅝ x 25⅝"
Van Gogh Museum, Amsterdam

clear to Theo that he was doing his utmost in exchange for the money Theo sent him.

The Bible provided Van Gogh with another familiar admonishment: "Man can not live by bread alone." In his early years, Van Gogh put it in a purely Biblical context, but gradually this saying adopted a slightly different meaning. "Not by bread alone" could imply that one should strive for higher goals in life, such as art or literature.

With Van Gogh, what held for real life also held for painting. The still lifes of food that he made while living in Holland featured food from "the good earth," grown and harvested by common folk. For this artist, ethics and aesthetics were inseparable. For example, his painting of cabbages and clogs from 1881, or baskets of potatoes from 1885 celebrated an ethic also found in his drawings and paintings of men working in the fields. These paintings were never exercises in the rendering of texture, substance, or body movement. As Van Gogh once remarked: "His bald head, bent over the black earth, seemed to me full of a certain significance, reminiscent, for instance, of 'thou shalt eat thy bread in the sweat of thy brow.'"

In Paris in 1886–87, Van Gogh continued painting still lifes. For one thing, he hoped to produce something salable, and he also specifically chose subjects that challenged him. With flowers

he expanded and brightened his range of colors, whereas fish gave him the opportunity to match his loaded brush against the shimmering surfaces of his subjects. Toward the end of 1886, he began to show interest in avant-garde painting, which can be detected in his paintings over the next year. He also became keenly interested in the pictorial possibilities of Japanese prints, which he saw at Siegfried Bing's shop in Paris. From these prints, Van Gogh developed a feeling for pattern, which manifested itself in asymmetrical, risqué compositions, and interplay of subject and background. At the end of that year in 1887, Van Gogh's intense concern with avant-garde use of pure, unmixed color led to striking personal results. Here, one can perceive for the first time his great and original contribution to modern art. (A glance back to his first effort at cabbages, some six years earlier, is sufficient to realize that Van Gogh had reinvented his art.)

By the time Van Gogh left behind Parisian refinement for the countryside around Arles, he was glad to recover the simplicity of rural life: "What a mistake Parisians make in not having a palate for crude things . . . for common earthenware. . . . I am returning to the ideas I had in the country before I knew the Impressionists." In Arles, it became apparent that nature had

A Plate of Lemons
and a Carafe, F340
Paris, 1887.
Oil on canvas, 18⅛ x 15"
Van Gogh Museum, Amsterdam

supplanted the Bible as Van Gogh's inspiration, personified, in particular, in the sun and the endless blue sky: "When you are well, you must be able to live on a piece of bread while you are working all day, and have enough strength to smoke and to drink your glass in the evening, that's necessary under the circumstances. And all the same to feel the stars and the infinite high and clear above you. Then life is almost enchanted after all. Oh! Those who don't believe in this sun here are real infidels." In the late summer of 1888, color contrasts began to obtain an emotive power that spoke of Van Gogh's own perceptions of reality. By now, complementary colors even invested inanimate objects with personal meaning and feeling.

During his voluntary confinement in the Saint-Rémy asylum, Van Gogh again seemed to challenge his own past in new still lifes that displayed his recent stylistic conquests in compositions of geometrical simplicity. These icons of rural life probably coincided with his renewed interest in Millet, whom he revered as a painter of rural life par excellence. Around this time, he began to copy a series of prints after Millet.

During his stay in the south, sanity of mind and body became a concern of the artist's. The desire for good food became synonymous with care for his mental health. "Sanity," a recurring word in his letters, meant not only bodily or mental health, but also healthiness from an artistic or moral point of view. The first task was to have a healthy body.

In Arles, Van Gogh tried to restore his energy by improving his eating habits. Because he suffered from stomach problems, he tried to persuade restaurant owners to prepare special food for him, such as strong brew, but he met with little success: "It's the same everywhere in these little restaurants. But it is not so hard to boil potatoes. Impossible. Then rice or macaroni? None left, or else it is messed up in grease, or else they aren't cooking it today, and they'll explain that it's tomorrow's dish, there's no room on the stove, and so on. It's absurd, but that is the real reason why my health is so low." Once he found a new and better restaurant to have his meals, Van Gogh felt his health improve immensely: "My blood circulation is good and my stomach digesting."

In the Saint-Rémy asylum, Van Gogh felt that a good appetite and regular meals could help to improve his sanity in all respects. In the first days of September 1889, following a major attack, he started to eat his way back to sanity. Apparently Dr. Peyron, who treated him there, had prescribed that he eat as much as he could. Van Gogh admitted that it did him well: "Just like I swallow my food

A Private Life in Public Places Give Us Our Daily Bread

Bowl with Potatoes, F386
Arles, 1888.
Oil on canvas, 15⅜ x 18½"
Museum Kröller-Müller, Otterlo

with greed nowadays, I long to see my friends back and the northern countryside." But he soon got the impression he was overdoing it, since how much did a painter need anyway: "I don't see any advantage for myself in gathering enormous physical strength, because it would be more logical for me to get absorbed in the thought of doing good work and wishing to be an artist and nothing but that."

After a few months, he was able to see his friends back in Paris and to return to the healthy Auvers countryside. When Johanna, Theo's new wife, saw her brother-in-law for the first time, she was surprised by his looks. After reading Vincent's letters and hearing her husband's reports about the numerous attacks that Vincent had suffered, she had expected an emaciated figure, but there he was, "a sturdy, broad-shouldered man with a healthy color." And she thought, "He is completely healthy, he looks much stronger than Theo." (Indeed, Theo was suffering from syphilis, which eventually afflicted his mind.) Theo's health, plus that of the new baby, was worrisome, so it is no surprise that Van Gogh encouraged them to come and live in Auvers. Dr. Gachet not only gave the artist advice to improve his eating habits, but also recommended that a "father and mother must naturally feed themselves up." By this the doctor meant "2 liters of beer a day, etc."

In the meantime, Van Gogh had been painting at Dr. Gachet's house, which pleased him enormously. The artist was less happy, however, about the multicourse meals he was invited for once a week. Apparently Dr. Gachet, like his colleague from Saint-Rémy, believed that good food in large quantities was essential for maintaining good health. A game of politeness resulted in a situation that neither party desired or enjoyed. "For me it is pure vexation to eat there in the evening or afternoon, because the good man goes at great lengths in order to prepare meals of 4 or 5 courses. This is not only for me something dreadful, because he certainly has no strong stomach himself. What prevented me from commenting on it, is that it reminds him of the days of yore, when extensive meals were served in the family circle, something that is after all not unknown to us."

At Dr. Gachet's home, Van Gogh was a polite guest, just as he was a pleasant boarder at the Auberge Ravoux. One can imagine, though, that the simple food served in the auberge was something of a relief for the artist. As for Dr. Gachet, he could hardly believe that Van Gogh could be housed and fed for a mere three and a half francs a day.

Crab on Its Back, F605
Arles, 1889.
Oil on canvas, 15⅜ x 18½"
Van Gogh Museum, Amsterdam

A Remedy Against Suicide

In August 1877, as a young man studying in Amsterdam, Vincent Van Gogh wrote in jest to his brother, "I breakfasted on a piece of dry bread and a glass of beer—that is what Dickens advises for those who are on the point of committing suicide, as being a good way to keep them, at least for some time, from their purpose." Twenty-two years later, as he was packing for his departure to the asylum in Saint-Rémy-de-Provence, he remembered Dickens's advice and wrote to his sister Wil: "Every day I take the remedy which the incomparable Dickens prescribes against suicide. It consists of a glass of wine, a piece of bread with cheese and a pipe of tobacco. This is not complicated, you will tell me, and you will hardly be able to believe that this is the limit to which melancholy will take me; all the same, at some moments—oh dear me." Van Gogh appears to have adapted Dickens's remedy to fit his circumstances since, in fact, the "incomparable" wrote, under the heading "The genius of despair and suicide": "And my advice to all men is, that if ever they become hipped and melancholy . . . and if they still feel tempted to retire without leave, that they smoke a large pipe and drink a full bottle first."

A Table in Front of a Window with
a Glass of Absinthe (detail), F339
Paris, 1887.
Oil on canvas, 18½ x 13"
Van Gogh Museum, Amsterdam

There was another occasion when Van Gogh needed the comfort of a pipe and a bottle in order to reconcile with life. On January 7, 1889, he wrote to Theo: "I am going to set to work again tomorrow. I shall begin by doing one or two still lifes so as to get back into the habit of painting." It was two weeks after the drama with Gauguin. The still life is almost an inventory of all the objects that supported him, either in a literal sense or as symbols of survival. As in other paintings, the sprouting onions on the tray symbolize new life. One of the onions sits on top of a pink book, the popular health compendium *Annuaire de la santé* by Dr. F. V. Raspail, a book

that Van Gogh often consulted. In front of the tray, he put his ever-present pipe—the same pipe that comforts him in the famous *Portrait with Bandaged Ear*—and a paper bag with tobacco. In the corner, there is a letter addressed to him, presumably from Theo. A burning candle by daylight, precariously balanced on the edge of the table, likely stands for enlightenment, or artistic inspiration, as it had in the *Chair of Gauguin*. Next to it is lacquer to seal a letter, perhaps used by Van Gogh to seal his packages of paintings. Behind the table is a pitcher for water; in front, a bottle of absinthe, the favored alcoholic drug of artists.

Van Gogh had in fact become an immoderate absinthe drinker. The quarrel with Gauguin that had finally driven him to sacrifice a part of his own body was triggered by absinthe. If we believe Gauguin, they "went to the café; he took a light absinthe. Suddenly, he threw the glass and its contents at my head. I avoided the blow and, taking him bodily in my arms, left the café and crossed the Place Victor-Hugo; some minutes later, Vincent found himself in bed, where he fell asleep in a few seconds, not to awaken again until morning. When he awoke, he said to me very calmly: "My dear Gauguin, I have a vague memory of having offended you last evening.""

Plate with Onions, Annuaire de
la Santé, and Other Objects, F604
Arles, 1889.
Oil on canvas, 19⅜ x 25¼"
Museum Kröller-Müller, Otterlo

In Paris, his drinking companions from the atelier Cormon, like Bernard, Anquetin, and Toulouse-Lautrec, had introduced Van Gogh to the seedier side of café life, and to the absinthe bottle. Toulouse-Lautrec made a brilliantly characteristic pastel drawing of Van Gogh sitting behind a glass of absinthe, probably in the Café du Tambourin. The sitter seems to be staring intently at something that has caught his attention while he is making a small sketch. *La fée verte* that fills his flute is suggested by a simple rubbing of the blue and yellow chalk, which dominates the color scheme.

Van Gogh's intimate courtship of the absinthe bottle also becomes evident from a still life that was made around the same time. In an extremely elliptical fashion, Van Gogh has faithfully rendered what he saw while sitting in a café on a boulevard. A carafe of water, used to thin the absinthe and render it opaque green-white, is standing on a marble tabletop. The street and some passersby are sketched through the glass folding door of the café. With its willful asymmetry and arbitrarily cutoff shapes, the painting is undoubtedly indebted to the Japanese prints that fascinated Van Gogh at this time. The painting is the paler version of *Still Life with Lemons and Carafe* (*Nature morte au citrons et carafe*). Whereas the latter picture is a feast of bright complementary colors—reds,

greens, and yellows—the café scene exploits the sickly contrast of green and purple. Later, Van Gogh would confess that he left Paris "seriously sick at heart and in body, and nearly an alcoholic."

It was not only absinthe that had spoiled him, but the "bad wine of which I drank too much," which in his view contributed to the weakening of his stomach. Even a depressed mood, caused by "too little or spoiled blood," was apparently a consequence of "that damned dirty Paris wine and those filthy greasy steaks." When his health deteriorated in Arles, however, rather than moderate his drinking habit, he asked the people from the restaurant Carrel for better wine. He was only too happy to move to the restaurant of Mme. de Venissac on the place Lamartine, near the yellow house, where the wine was better. Van Gogh even started to develop ideas about a healthy life. Due to his syphilitic state, Theo was in very bad condition during the winter of 1887–88, so Van Gogh, completely the older, caring brother, told him to "get as much of the spring air as possible, go to bed *very early,* because you must have sleep, and as for food, plenty of fresh vegetables and no *bad* wine or *bad* alcohol." Apparently *good* wine and *good* alcohol were not considered health risks.

Before he came to live in the city that ruined him, coffee was his favorite drug, a habit he shared

with his Brabant countrymen. In Dutch, a cup of comfort is slang for a cup of coffee. The potato eaters are drinking coffee with their meal, and Van Gogh usually ate his bread with a cup of coffee. It was hardly considered a luxury, whether it was coffee made from beans or a surrogate. Van Gogh seems to have partaken of this relative innocuous drink in large quantities. Even in the south, coffee remained of great importance to him. As soon as he had rented the yellow house in May 1888, he bought some household utensils, among them a coffeepot "for making a little coffee and soup at home." He was so proud of his new possessions that he immediately set out to make a remarkable still life of them.

With the "superb" still life *Blue Coffeepot* by Émile Bernard in the back of his mind, he began to paint "a blue enamel coffeepot, a cup (on the left), royal blue and gold, a milk jug in squares of pale blue and white, a cup—on the right—of white with a blue and orange pattern, on an earthen tray of grayish yellow, a jug in earthenware or majolica, blue with a pattern in reds, greens and browns, and lastly 2 oranges and 3 lemons; the table is covered with a blue cloth, the background is greenish-yellow, so that there are six different blues and four or five yellows and oranges." He even devised an appropriately painted frame for this display of

controlled color and highly defined shapes that Van Gogh scholar Ronald Pickvance has so aptly described as "a celebration of possession." Indeed, it was a declaration of independence, since this crockery enabled him to live independent of restaurants and cafés.

His excessive use of the stimulant brought him even to mock himself in a letter to his sister Wil. In the case of "immersion in melancholy," he was "in the habit of taking large quantities of bad coffee . . . because my strong imaginative powers enable me to have a devout faith—worthy of an idolater or a Christian or a cannibal—in the exhilarating influence of said fluid." A few months later, he confessed to Theo that, for lack of money, he had been living from Thursday to Monday on "23 cups of coffee with bread" that he still had to pay for. Small wonder that the good doctor Félix Rey of the Arles hospital considered his eating habits reprehensible from a medical point of view. Van Gogh wrote, "Instead of eating enough and at regular times, I kept myself going on coffee and alcohol." During three months of recovery with several relapses, he had apparently continued his old drinking habits. But Van Gogh had an excellent excuse—at least in his own eyes—"to attain the high yellow note that I attained last summer, I really had to be pretty well keyed up." With

Still Life with Coffee Pot, F410
Arles, 1888.
Oil on canvas, 25⅝ x 31⅞"
Goulandris collection

exquisite empathy for Van Gogh's extraordinary personality, the doctor had finally encouraged him not to allow himself to be put off by the people in Arles who wanted him in an asylum: "An artist is a man with his work to do, and it is not for the first idler who comes along to crush him for good."

Van Gogh's only concern was whether his drinking would affect his painting. Soon after his arrival in Arles, he had already begun to find excuses for drinking a lot and eating a little. It was the Midi that was so different: "Here one doesn't need great quantities of food." But then there was the example of the Marseillais painter Adolphe Monticelli, whom he admired so much for his daring impasto and the freedom with which he applied his colors. (Theo had some of his paintings for sale and in his own collection.) Monticelli had died during Van Gogh's stay in Paris and was said to have destroyed himself by drinking too much, but Van Gogh could not accept that story: "I ever more start to doubt this legend about Monticelli as having swallowed enormous quantities of absinthe. If I look at his work, it seems to me impossible that it has been made by a man impaired by drinking too much." He attributes it to gossip. Indeed, Monticelli did not contradict the legends that were woven about his life, as long as it enhanced his reputation of an *artiste maudit*. Later, he found an

excuse for Monticelli that could well work for his own lifestyle: "I so often think of Monticelli, and when my mind dwells on the stories going around about his death, it seems to me you must not only exclude the idea of his dying a drunkard in the sense of being besotted by drink, but you must also realize that here as a matter of course one spends one's life in the open air and in cafés far more than in the north. My friend the postman, for instance, lives a great deal in cafés and is certainly more or less a drinker and has been so all his life. But he is so much the reverse of a sot" So in the Midi drinking was a way of life, and for the artist even a necessity, he thought. Painting was a rational affair for Van Gogh, and in order to relax, drinking and smoking were a worthy counterpoint to the mental effort of painting: "Very often I think of that excellent painter Monticelli . . . when I come back myself from the mental labor of balancing the six primary colors—red, blue, yellow, orange, lilac, green. Sheer work and calculation, with one's mind strained to the utmost, like an actor on the stage in a difficult part, with a hundred things to think of at once in a single half hour. The only thing to bring ease and distraction, in my case and other people's too, is to stun oneself with a lot of drinking or heavy smoking. Not very virtuous, no doubt, but it's to return to the subject of

Monticelli. I'd like to see a drunkard in front of a canvas or on the boards."

Nonetheless Van Gogh began to understand, or perhaps to accept, what he already knew: that alcohol "had surely been one of the main causes of my insanity." Immoderate pipe smoking could also have contributed to his opinion. But then he rebelled against the idea that to deny oneself these luxuries was virtuous in itself: ". . . the frightful superstition of some people on the subject of alcohol, so that they take pride in never smoking or drinking. We are already ordered not to lie or steal, etc., not to commit other crimes great or small, and it would become too complicated if it was absolutely indispensable to have nothing but virtues in the society in which we are undeniably planted, whether it be good or bad." Leading a simple life and denying himself even the most modest luxuries, Van Gogh needed a solace, something to caress his body and ease his mind. In this regard, he wavered between Dickens's humorous advice to indulge in smoking and drinking (and even saw them as a way to deal with life) and the well-intended warnings of his doctors, who viewed his overindulgence as responsible for his waves of insanity. When he was lying on his deathbed in the small attic room in the Auberge Ravoux, Van Gogh was smoking his pipe.

73

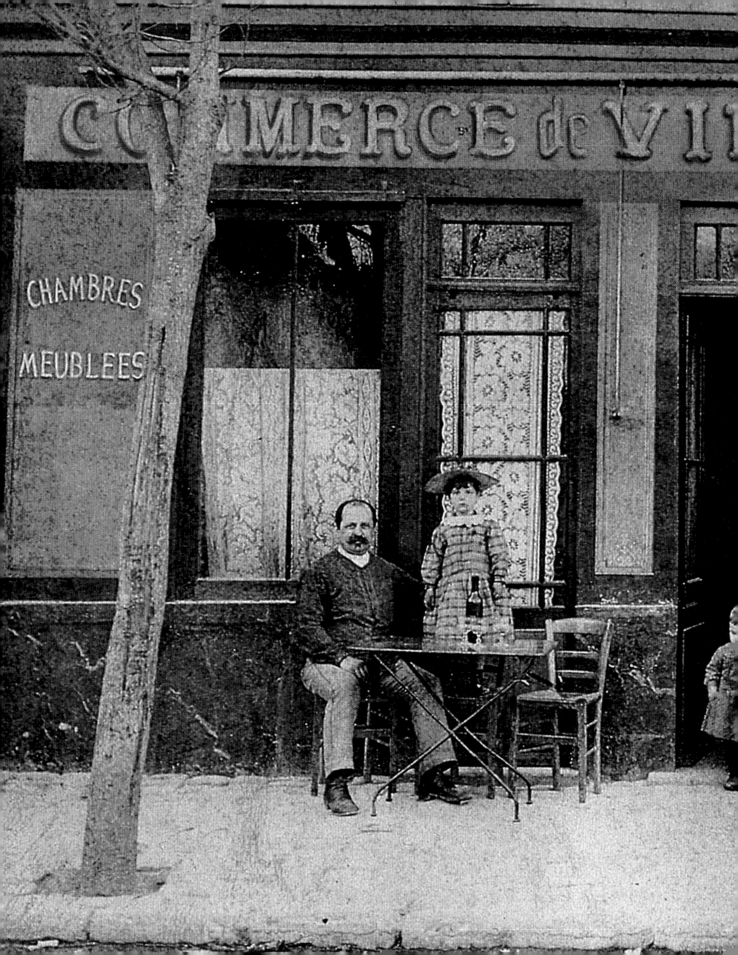

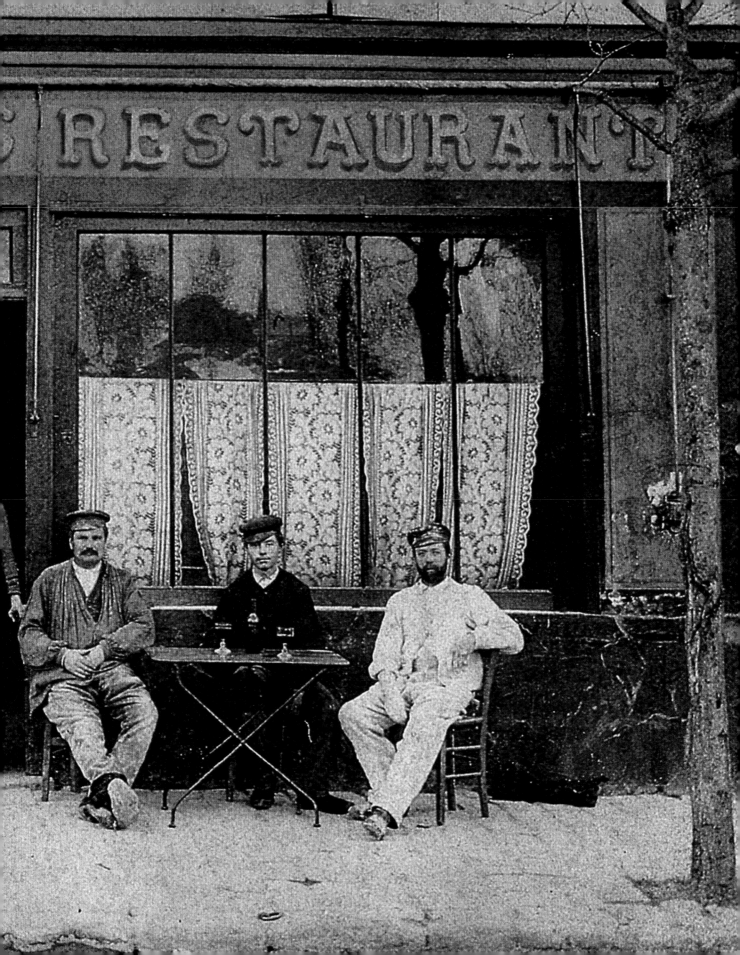

The Auberge Ravoux

In the middle of the 1800s, Auvers-sur-Oise, a village of less than two thousand people and an administrative seat of the Seine-et-Oise *département*, was a typical French village, stretching for seven miles along the river Oise. With its location so close to Paris by train, sophisticated Parisians as well as artists became habitués, adding to the life of the village by supporting numerous cafés and even a casino. At the top of the village stood the church, towering over the picturesque town. Beyond the church lay cultivated fields that seemed to go on and on forever. In the mid-nineteenth century, a master mason by the name of Auguste Crosnier built a house for his family on the site of an old barn on the main road leading from Auvers-sur-Oise to Pointoise. Like many builders, he used materials from earlier works to create his house, including an entire wall from an eighteenth-century farmhouse. This location turned out to be ideal. With the town hall serving as the local school and the post office nearby, the house (later the auberge) found itself in the very heart of Auvers-sur-Oise.

Crosnier's daughter, Valentine, and her husband, Alfred Levert, took advantage of the location by opening a retail wine business. Wine was the lifeblood of French culture and

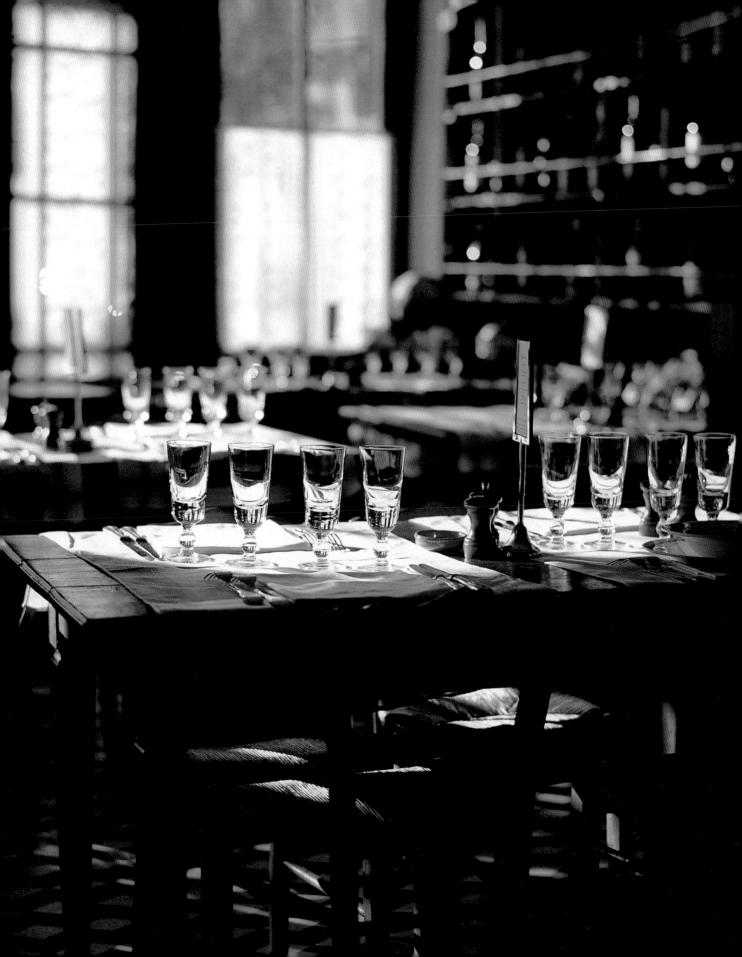

wine sellers did a brisk business. Wine was part of the staple diet, as important as bread, and drunk from the break of dawn to well after sundown. In 1884, the Leverts remodeled the front of the house and installed a shop front complete with windows and colorful hand-painted signs. The ideal location and genial ambience transformed the home into a lively café and auberge. Its main customers were the local craftsmen and farm workers as well as visitors who rented accommodations. It was typical of the times that cafés provided small and modest rooms for travelers.

Around this time it was common for unknown artists to walk in the footsteps of established artists. Most of these accomplished artists, such as Daubigny and Corot, had spent their summers as children in the countryside in the company of their nurses. As adults, they returned to villages like those on the banks of the Oise. It was these villages that later attracted the Impressionists who were seeking countryside locales to paint. With such a wealth of successful talent locally available, a steady stream of young painters arrived almost daily in Auvers and transformed the village into an artists' colony.

The Leverts managed a thriving business, but as they neared retirement, in 1889, they

looked to lease the auberge. The lease was taken over by Arthur Gustave Ravoux. Mr. Ravoux, born in 1848, had followed the typical pattern of the day, taking on a variety of jobs until he settled down as an innkeeper. A round-faced, beefy man with a bushy mustache, he was a keen conversationalist who delighted many customers, except with his overlong tales of the Prussian War. With his wife, Louise, thirteen-year-old daughter Adeline, and baby Germaine, he moved into the auberge.

The outside of the building featured two doors on the front façade: one for the restaurant and one leading to the wine merchant. Alongside the building was a passageway with iron rings attached to tie up horses. Through this passageway lodgers encountered a third door that allowed them access to the rooms. A narrow, dark staircase led upstairs to the four rooms on the second floor and the three rooms on the third floor, essentially the attic. In Van Gogh's, time the rooms were completely occupied by Dutch, American, and Cuban painters. Years later, Adeline Ravoux explained that the back of the inn "was completely given over to artists." Inside the café, ambience, not décor, was the compelling reason for visiting. Lively conversation and smoke filled the air. Clustered around small tables, patrons imbibed aniseed- or absinthe-based apéritifs, local wines from Argenteuil or the Coteaux de l'Oise wines, called *ginglet*. Games covered the tables. Oil lamps were lit and the iron stove flickered throughout the winter. In the summer, people moved outdoors with great and endless discussions continuing into all hours of the morning.

On May 20, 1890, Van Gogh arrived at this artists' colony. He had come seeking Dr. Gachet, a local physician who supported artists while dabbling in painting himself.

Gachet had been recommended to him by Pissarro, whose wife, because of their five children, found Van Gogh's recent stay in the asylum reason enough to deny him living accommodations with them. Undoubtedly Theo approved of this relationship with Dr. Gachet as he would have considered Gachet a kindred spirit to, and support for, his brother. During his seventy-day stay in Auvers-sur-Oise, this proved to be the case, with Dr. Gachet not only taking care of Van Gogh but even sitting for two portraits. Van Gogh, however, did not live out the entire summer, but died in his room on July 29.

At the auberge, life went on. In 1892, the Ravoux family welcomed a third daughter, Olga Rejanne. Eight months later, they moved to Meulan to run a brasserie. At this point Mr. Leleu took over the auberge. He oversaw the ushering in of the twentieth century in Auvers-sur-Oise. In 1895, gas lamps lit up the streets. By 1902, telephones arrived. Van Gogh's reputation began to grow in the period between the wars, and a steady trickle of art historians, sightseers, and photographers came to visit his room. The Blot family, who succeeded the Leleu family as leaseholders of the auberge, began to invite people to view the room. In 1926, the Auberge Ravoux was renamed Maison de Van Gogh. For the next seventy years, the auberge lived through many transitions. Throughout these changes, the various landlords of the inn always preserved the soul of the house.

As in all of Europe, Auvers-sur-Oise, including the auberge, suffered during World War II. Artists deserted the countryside and gathered instead in various arrondissements in Paris. In 1952, Roger and Micheline Tagliana bought the auberge and revitalized it through sheer determination and warmth. They reestablished Van Gogh's room with the help of

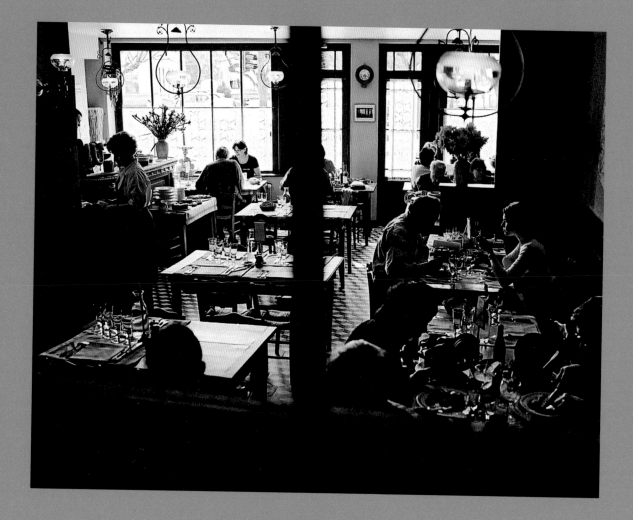

Adeline Ravoux, who visited in 1954. A few years later, in 1956, Vincent Minnelli filmed *Lust for Life*, starring Kirk Douglas as Van Gogh, in Auvers, introducing the world to the Auberge Ravoux as Van Gogh's last home, thus correcting the popular misconception that the artist had died in Provence. After the film's release, painters such as Serge Poliakoff and Pignon and patrons André Malraux and Iannis Xenakis again sought the intimacy of the inn.

Roger Tagliana continued to promote the auberge and imbue it with an artistic mantel. Using the Hollywood experience as a lure, he succeeded in influencing other movie producers to use the auberge as a film location. He also mounted exhibitions of local painters. In 1964, for example, he had an exhibition on Émile Bernard, Van Gogh's friend. Through all of these efforts, Tagliana, who died in 1984, endeavored to preserve the purpose of the auberge as a place for art. His widow, nearing retirement herself, began to seek a buyer for the auberge. It was at this time that fate stepped in.

Late Twentieth Century

DOMINIQUE-CHARLES JANSSENS, FROM BRUGES, Belgium, lived in Paris and worked for a multinational corporation. On July 21, 1985, while he was driving home with his family from a day in the country, a drunk driver hit their car from behind.

The police report on the accident mentioned that it had occurred in Auvers-sur-Oise, just a few yards from the Auberge Ravoux, which the police report called Maison Van Gogh. During Janssens's convalescence, he took the opportunity to read Van Gogh's letters.

Through them he discovered Van Gogh the humanist and his deepest dreams, and became passionate about the artist's work and life. Van Gogh's letters, although largely written in French, maintain a Dutch sensibility easily discernible to a fellow Dutch speaker, and that nuance spoke to Janssens.

While convalescing, Janssens learned that the auberge had been classified as an historical landmark and was currently for sale. He decided to buy the house with the objective of preserving it for others. After fifteen months of negotiations with the seller and various French landmark authorities, his offer was accepted by the Tagliana family. In spite of competition from other bidders, Mrs. Tagliana favored Janssens because she felt he would preserve the soul of the inn.

For the next eight years, Janssens spent his time, energy, and financial resources to rebuild the house. In this case, "rebuilding" was not only a physical challenge, but also involved cultural, financial, and aesthetic struggles.

Van Gogh's status in the international art world was soon to soar as well. Two years after negotiations for the purchase of the auberge began in 1986, three major Van Gogh paintings, *The Sunflowers*, *The Irises*, and *Dr. Gachet*, set new records at auction. Van Gogh's escalation in the art world actually paralleled an escalation of problems for Janssens, as politicians criticized for passing up the opportunity to own Van Gogh's last home renewed efforts to wrestle the auberge away from him.

The renovation of the auberge was done by Bernard Schoebel, an award-winning architect from Paris who had specialized in landmarked renovations throughout his career. Not just his technical expertise, but also his emotional involvement, was brought to bear on this renovation. Like him, craftsmen were sought who felt a certain emotional connection to the project.

All artisans were asked to send a letter describing their reasons for wanting to work on the restoration, a process that would ensure technical specialists who were also spiritual soul mates. Most of those selected were from the Compagnons du Tour de France, an organization that trains young people from the age of fifteen to restore landmarks.

To ready the auberge for the public, extensive strengthening, underpinning, and reinforcing of the entire structure from foundation to roof was required. In order to conform with safety regulations, eight tons of caulk were injected into the four supporting walls, as were fifteen tons of structure cement per level. Mold and mildew that would normally be of little consequence would be exacerbated by the visiting public and so had to be completely destroyed. The walls and the woodwork required nine months of chemical treatments to bring the house into compliance with regulations and to ensure its longevity.

The worthiness of all this effort shows. Upstairs visitors discover Van Gogh's room, preserved and embellished only by the patina of time. Nearby is the room of fellow Dutch painter Thomas Hirschig, furnished in the style of the day. Next to Hirschig's room is the barn, where a slide show has been set up to guide visitors through the auberge. Included are examples of Van Gogh's paintings, and his own words are used to convey some of his personal thoughts. Downstairs is the dining room where Van Gogh took his meals. The

historical research for this room, as well as for the whole complex, helped to restore it to its earlier glory. During the renovation, the workmen discovered a fresco under two layers of linen, five layers of wallpaper, and one layer of metal paper meant to retard humidity. In addition to the original auberge, the surrounding buildings were also converted.

The landmark commission was involved in some additions to the complex. One building, which had been destroyed in 1954, was replaced by the *guinguette*. This building provides all of the necessary technology to keep the complex running and, in the hot summer months, doubles as a dining room. True to the vision of the auberge, the *guinguette* was created to reflect a Van Gogh work, *La Sirène*. For the courtyard, several panels were commissioned to depict the story of Van Gogh's life through the thirty-eight places he lived. Once read, these panels prepare visitors to view the artist's last home. Complete with cobblestones, the courtyard runs along all of the houses and so unifies the whole complex. Behind the *guinguette,* visitors enter the auberge through the passageway door, as would all those in past centuries. Everything in the foyer is original. The foyer also leads to the stairs up to Van Gogh's room. At the opening celebration, to which the townspeople were invited, an eighty-year-old lady remarked as she climbed the stairs, "When are you going to start the renovation?" The auberge had triumphed. Furnishings foraged among flea markets and barns were selected for their historical accuracy. Often these searches yielded unexpected treasures. Although gas lamps were found, they were illegal to use. Happily, after four years of research, a Turkish artisan was discovered, an engineer by trade, who specialized in converting European gas lamps to electric lamps. These lamps, with their

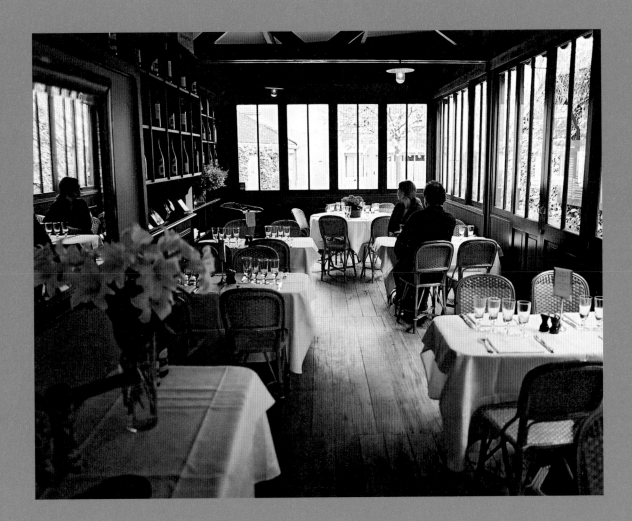

delicate dimmer switches, now grace the ceiling of the dining room. Inspired by Van Gogh's paintings, Janssens also sought artisans who could capture the past in the materials of the present. The floors, reproduced by Spanish artisans, required the same level of detail. Nineteenth-century tiles were a combination of cement and marble dust. Any "new" tiles, then, had to replicate the original tilework.

One of the unexpected delights of this search were the contributions of the local people. They would teach the renovators about the house, the colors, the materials, and anything else they could share. Some gave objects that could be used in the house. Others gave good company. The smells and the tastes were next, with food coming under investigation. Ultimately, a chef was found with supreme technical skills and a philosophical approach sympathetic to the revitalized auberge. Christophe Bony has been trained in one of the best restaurants in Paris. At the same time, he is a local man who shares the values of the village and the auberge. Now fragrances of his delectable cooking fill the room. The daily management of the dining room resides in Marc Schoenstein's capable hands.

Come now into the auberge and enjoy the sounds, sights, smells, tastes, and touch that make the dining experience at the Auberge Ravoux so special. For those who care about Van Gogh, there will always be a seat for you at his table.

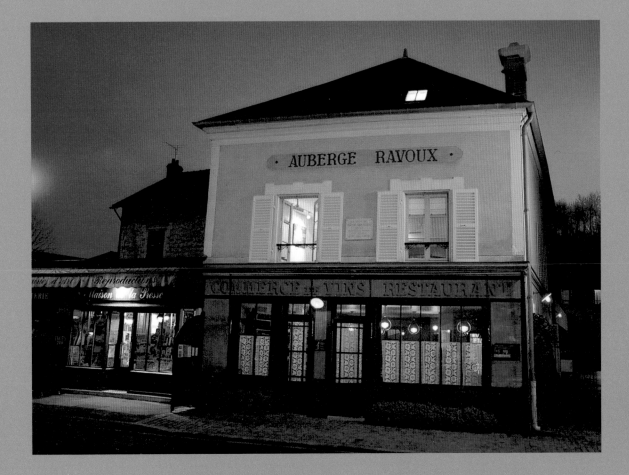

Recipes from Van Gogh's Table

WHETHER IT IS THE AGE-POLISHED, century-old oak tables around which they gather, or the custom-made absinthe glasses used to serve wine, seltzer water, or the house apéritifs, patrons at the Auberge Ravoux quickly realize that the meal they are about to enjoy will be far from ordinary. Dining in the very room where Van Gogh took his meals in 1890 in the charming village of Auvers-sur-Oise is a moving experience. The bubbly, dark pink *Cerdon*, accompanied by thinly sliced *saucisson sec* served on a small wooden cutting board, is the right start to this unique meal. Robust but refined, this typical French country sausage, paired with the slightly fruity, sparkling wine, offers a hint of what is to follow—a lunch or dinner that will satisfy the senses through its honesty, excellence of ingredients, and one-of-a-kind setting.

Ravoux's kitchen evokes the flavors and cooking style of Van Gogh's time by revisiting classic French dishes, such as *gigot de sept heures, blanquette de veau, boeuf Bourgignon, poule au pot, suprème de volaille, riz au lait, mousse au chocolat, clafouti,* and the Tatin sisters' eponymous inverted apple tart.

Much of the countryside surrounding the auberge has remained agricultural. Large stretches of the region known as Le Vexin are national park land, and virtually unchanged since the time of Van Gogh's sojourn there.

IN THE AGE OF THE INTERNATIONAL PANTRY," where a chef has a greater range of ingredients to choose from than at any other time in history, Chef Christophe Bony does not stray far from his local, native France. For him, the challenge has been about enhancing and updating the old. And the recipes gathered here reflect these values and sentiments. Though all are traditional French recipes from Van Gogh's time, they have been organized into three distinct categories to highlight their differences: *cuisine populaire,* or traditional home-style cooking; *cuisine du terroir,* or regional cooking; and *cuisine bourgeoise,* fancy home cooking. The recipes are at the end of each chapter, following an explanation of each cuisine type.

The featured dishes are not "fussy," nor do they demand hours in the kitchen. They do, however, require selecting only the best ingredients, the basis for all good food. Many of the recipes call for a handful of ingredients—all the more reason to use the freshest and most flavorful available. To best capture the flavors of Ravoux's inn in the home kitchen, shop for locally grown ingredients at farmers' markets for seasonal

produce at its freshest. Buy organic whenever possible; you will taste the difference. Use imported unsalted butter from France or the premium butter now domestically produced. Both have about 82 percent butterfat, whereas standard American butter has only 80 percent.

Free-range eggs and free-range chickens are recommended. Choose hearty, whole-grain or country-style breads to accompany meals. Baguettes were not served at the auberge during Van Gogh's time, nor are they today. When you are using wine in these recipes, dry table wine is fine. Because the *lard* (an uncured pork product) used in many French dishes is not available in the United States, substitute slab bacon (smoked or unsmoked), or pancetta; both are found in the deli sections of specialty food stores. Use organic heavy cream whenever possible. And for the chocolate desserts, use only premium dark chocolate that contains 50 to 70 percent cocoa butter.

Working closely with Chef Bony, dining room director Marc Schoenstein buys a wide range of wines for the restaurant, both from Taillevent's *cave* in Paris and from many small producers throughout France. The wine list features *vins du terroir* from Alsace, Burgundy, Provence, and the Loire Valley, along with *premier cru* reds and whites, and *grands crus classés,* such as Pomerol, Saint Emilion, and Saint-Estèphe.

HAVING A MEAL AT THE AUBERGE is also special because the dining room is just that, a dining room, even though it is a restaurant. Like a dining room in a home or hotel, all who come to eat there have something in common, in this case Van Gogh. The invisible

bond that exists between people enjoying a meal chez Ravoux adds an additional level of intimacy to the experience. The large 1884 mural on the wall, opposite a simple wood-framed mirror, adds a cheerful warmth to the room. The bucolic scene, painted in several shades of pastel green, brings the lushness of the Auvers countryside into the simply furnished café.

The focus of this part of the book is on the Auberge Ravoux and the village of Auvers as they were in 1890 and as they can be experienced by a visitor today, beginning with Van Gogh's return to the north of France.

A New Home in Auvers

AFTER A YEAR spent at the asylum in Saint-Rémy near Arles, where he continued to suffer attacks, Van Gogh wrote Theo to find him other living arrangements. Their correspondence from this period reflects both candor and compassion, as the two brothers discussed new surroundings in the north of France for the artist.

Van Gogh had entered the asylum of his own volition and would depart "uncured," despite Dr. Peyron's final report, which pronounced his patient "cured." Yet where could he go? Living with Theo, as he had done when his brother was a bachelor, was now out of the question. Circumstances had changed. Theo was a married man with a new baby. Besides, being in Paris with the noise, crowds, and distractions would be too much of a strain. Might it be possible to live with Camille Pissarro outside of the city, in Pontoise, where it would be more peaceful? There he would have the company of another artist. But Madame Pissarro flatly refused the idea. A madman living with the family?

"It is as I thought, I see more violet hues wherever they are. Auvers is decidedly very beautiful."

Letter from Vincent to Theo, June 1890

Perhaps Dr. Gachet, recommended by Pissarro, would be able to accommodate Van Gogh in the neighboring village of Auvers-sur-Oise. Between the doctor's many years of experience working with mental patients and his appreciation for the arts, not to mention the fact that he had a large, old house an hour from Paris by train, it seemed the perfect solution to the problem.

While Gachet was unwilling to permit Van Gogh to lodge with him, no doubt wary since he had an unmarried daughter, he did suggest a nearby inn where the painter might stay; this way the two men

Mon cher Theo et Jo, dans l'autre
lettre j'ai d'abord oublié de te
donner l'adresse d'ici qui est
provisoirement Place d.l. mairie
chez Ravoux.
puis lorsque je t'ai écrit je n'avais
encore rien fait. A présent j'ai
une étude de vieux toits de chaume
avec sur l'avant plan un champ de pois
en fleur et du blé fond de colline
une étude que je crois que tu aimeras
Et je m'aperçois déjà que cela m'a
fait du bien d'aller dans le midi
pour mieux voir le nord.
C'est comme je le supposais je vois
des violets d'avantage où ils sont
Auvers est décidément fort beau
Tellement que je crois que ce sera
plus avantageux de travailler
que de ne pas travailler malgré
toutes les mauvaises chances qui
sont à prévoir dans les tableaux.
C'est très coloré ici - mais comme
il y a de jolis maisons de campagne
bourgeoises bien plus jolie que
villa d'avenue se à mon goût.

could remain in close contact. If Van Gogh needed anything, particularly medical assistance, the doctor would be there to help.

Cheered by the prospect of returning to the north and seeing friends and loved ones, Van Gogh journeyed from Arles to Paris unescorted and seemingly calm, despite everyone's worries. There he was met at the Gare du Lyon by Theo. The two brothers, reunited again, later met up with Johanna, who was at home with their infant son, Vincent.

The stay in Paris was to be very brief, cut short by Van Gogh's impatience to settle into his new home. There had, however, been time to meet Jo and the new baby, time to critique paintings he had done almost two years earlier, and an opportunity to attend an important art exhibition, the first *Salon du Champ-de-Mars*.

Finally, onward to Auvers. After so much planning and anticipation, so many letters exchanged, and the long journey from Arles, Van Gogh arrived at his new home. The date was Tuesday, May 20, 1890. In Auvers he would live, work, and with the help of sixty-one-year-old Dr. Gachet, hopefully recover.

Leaving the station and meandering through the narrow streets of the village, past cafés, *épiceries* (small grocery stores), old stone houses, and well-tended flower gardens, he reached the winding rue des Vessenots and the home of the eccentric homeopathic doctor/arts enthusiast. Van Gogh quickly sized up his "protector" and later wrote to Theo, "I have seen Dr. Gachet, who gives me the impression of being rather eccentric, but his experience as a doctor must keep him balanced enough to combat the nervous trouble from which he certainly seems to me to be suffering at least as seriously as I."

After this long-planned encounter, Gachet accompanied Van Gogh to his new home at the Auberge Saint-Aubin. Located not far from the

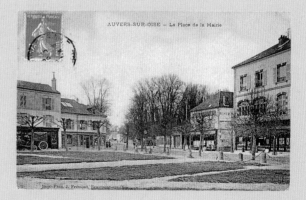

doctor's house, it was one of the more luxurious hotels in the village. Upon discovering that the daily rate for a full pension was 6 francs, considerably more than he had ever paid for lodgings, and certainly more than he could afford, he set off on his own to find a place to stay. Gachet could do nothing to stop him.

Because of its lovely, unspoiled countryside and its proximity to Paris, by the middle of the nineteenth century Auvers was a magnet for painters and a destination for those taking day trips and vacations. Consequently there were a good half-dozen hotels and inns from which to choose. Van Gogh settled on the Auberge Ravoux, situated down the road from the train station and opposite the town hall, which he would paint some two months hence. The daily rate was 3 francs 50 for a cramped, sparsely furnished room at the top of the stairs—a bargain compared to the doctor's choice.

When Van Gogh came inquiring about a room that first day in Auvers, Arthur and Louise Ravoux had been running their inn for about a year. Arthur, a forty-one-year-old former butcher/poulterer from Paris, had taken over the successful auberge from a couple by the name of Valentine and Alfred Levert. And so it was there, in Arthur's popular auberge frequented by local craftsmen, traveling salesmen, painters, and agricultural workers, that Van Gogh

ate, drank, slept and, on occasion, worked when bad weather prevented him from painting out-of-doors. In the relaxed and friendly environment of the café, the painter enjoyed the company of other artists, as well as that of Monsieur and Madame Ravoux and their two daughters, Adeline and Germaine, aged thirteen and one respectively, who became a surrogate family to Van Gogh.

SINCE THE ARRIVAL of painters such as Charles-François Daubigny and Honoré Daumier in the 1850s, Auvers had attracted artists from all over the world, some of whom would become famous. Besides their French comrades such as J. B. Corot, Auguste Renoir, Berthe Morisot, Paul Cézanne, and Camille Pissarro, there were the Americans Charles Sprague Pearce and Robert John Wickendon, Cuban-born Martinez de Valdivielse, Australian Walpole Brooke, and now Vincent van Gogh, whose presence soon attracted another Dutchman, Anton (Tom) Hirschig. Auvers has, in fact, often been likened to the Barbizon in terms of its importance as a magnet for painters during the latter half of the nineteenth century. All were drawn to the natural beauty of the village, the narrow and winding Oise, the fields of newly mounded haystacks, the soft green hillsides of flowering peas, and the clear skies that lit up the surrounding meadows.

While much of the countryside in the vicinity of Paris had become industrialized and overly developed, Auvers remained, in the spring of 1890, verdant and picturesque.

In his first letters from Auvers to Theo and Johanna, written in French rather than in the customary Dutch, Van Gogh seemed delighted by his new home: "Auvers is very beautiful, among other things a lot of old thatched roofs, which are getting rare. . . . One is far enough from Paris for it to be real country, but nevertheless how changed it is since Daubigny. But not changed in an unpleasant way, there are . . . various modern middle-class dwellings very radiant and sunny and covered with flowers . . . I find the modern villas . . . almost as pretty as the old thatched cottages, which are falling into ruin . . . I see, or think I see, in it a quiet like a Puvis de Chavannes, no factories, but lovely, well-kept greenery in abundance. . . . There is a great deal of color here. . . . And I already feel that it has done me good to go South, the better to see the North."

Each day in Auvers was a discovery for Van Gogh. The old stone farmhouses with their spacious inner courtyards, where chickens scratched the hot, dry earth, captured his eye and became subject matter for a number of paintings depicting these characteristic dwellings. The great old Gothic *Eglise d'Auvers* also inspired him, and he soon painted it, slightly distorted, against a cobalt blue sky. The town hall on Bastille Day, July 14, 1890, across the dirt road from Ravoux's inn, was also captured on canvas. Tricolored flags and banners decorate the village square surrounding the sturdy white building. One suspects that the work may have been done the morning after the celebration, as not a soul is seen in the painting. Is it the crack of dawn and everyone in the village, except Van Gogh, still lies sleeping after a night of merrymaking?

The Oise itself, which ran along the edge of town, was occasional subject matter for the artist. Like the Seine, the Oise attracted Parisians who came for such outdoor pleasures as rowing, swimming, sailing, or dining at a *guinguette* ("riverside café"). Trains ran frequently between Paris and Auvers, from both the Gare Saint-Lazare and the Gare du Nord, either direct or with a connection in the neighboring town of Pontoise. Though Auvers was farther from the capital than other pleasure spots, such as Asnières, Argenteuil, Bougival, Chatou, and Croissy, it was still close enough for a one-day excursion. The more than a dozen cabarets in the village, where one could dance, enjoy popular music, and sip wine, beer, and *orgeat* (an almond-flavored soft drink), proved to be a draw as well.

A variety of factors contributed to the town's popularity. The proliferation of guidebooks to Paris

AUVERS-sur-OISE. - La Gare

and *la région Parisienne* during the second half of the nineteenth century familiarized people with the village. A growing awareness, too, of the importance of outdoor exercise, combined with an increase in leisure time in late-nineteenth-century France, made Auvers an attractive place to visit. Here one could breathe clean air, eat freshly picked produce, engage in a variety of sports, or simply relax beneath great old shade trees with the sensation of being many kilometers from Paris—when in truth Auvers was a mere twenty-two miles northwest of the city. Van Gogh, for one, strongly believed in the curative powers of the countryside and dreamed of Theo's taking a pied-à-terre in Auvers where he, Johanna, and especially his young namesake, could enjoy the good air and tranquility of the country.

From his correspondence with Theo and Johanna and other members of his family, Van Gogh seemed pleased with his living situation at the auberge. Writing to Theo shortly after his departure for Arles, he had complained bitterly about the food at the Hotel-Restaurant Carrel where he was paying 4 francs per day for his room and board: "You know, if I could only get really strong soup, it would do me good immediately: it's preposterous, but I never can get what I ask for, even the simplest things, from these people here. And it's the same everywhere in these little restaurants. But is it not so hard to bake potatoes?

"Impossible.

"Then rice, or macaroni? None left, or else it's all messed up in grease, or else they aren't cooking it today, and they'll explain that it's tomorrow's dish, there's no room on the stove, and so on. It's absurd, but that is the real reason why my health is so low." Unlike his dissatisfaction with the food there, he had, as far as one knows, no complaints about Ravoux's kitchen. The fact, too, that boarders from the other hotels in the village took their meals there suggests that one ate well chez Ravoux.

Arthur Ravoux's elder daughter, Adeline, recalled in a 1954 *Paris Match* interview the fare at her parents' inn in 1890. "It was what was served in restaurants at

105

the time, meat, vegetables, salad, dessert." And, she added, that Van Gogh never sent back a meal. By all accounts, the painter got on well with the *aubergiste* and his family, painting Adeline's likeness on more than one occasion.

The auberge kitchen, from what we know, was a busy place during that summer of 1890. Louise Ravoux was probably occupied with overseeing the work of a hired cook, no doubt female, and a few young girls from the village, to help with tasks like peeling potatoes, shelling peas, scrubbing pots and pans, and fetching wood or coal to feed the large cast-iron stove. Produce would have been procured from any number of sources in Auvers, quite possibly from farmers at the biweekly market, which was set up in the square just opposite the inn.

Auvers, with a population of just over two thousand, boasted more than a half-dozen cafés, nine *épiceries,* three pastry shops, two butcher shops, six *charcuterie* shops, two bakeries, one brewery, six butter-and-egg merchants, and three mushroom producers—far more purveyors than are found in the village today. By the time of Van Gogh's stay, the people of Auvers had begun to enjoy a prosperity unknown to them a half century earlier. Farmers benefited from the sale of high-quality produce, and business owners profited from the tourism.

With such large numbers of yearly visitors to Auvers, Ravoux would certainly have served meals to many of them. Patrons of the auberge would have been graciously treated to a warm plate of some kind of fricassee or stew and, depending upon the season, potatoes, turnips, carrots, green peas, a salad of tender, freshly picked lettuce, a glass of wine, a chunk of Gruyère or Brie, and a dish of rice pudding or *compôte de fruit*; a coffee and Cognac or some other type of *digestif* might well have followed the meal.

Ravoux's café, like others in villages throughout France at the turn of the century, served a large cross-section of the population. Unlike cafés in cities, which tended to be frequented by people of similar socioeconomic backgrounds, this country café welcomed artists, farmers, civil servants, traveling

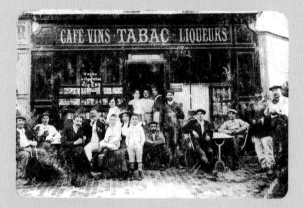

and local businessmen, and Parisians. From what we know, Van Gogh did not mingle much with Ravoux's customers. Instead, he took his meals in the company of other painters with whom he sat at the "artists'" table in the rear of the café.

In addition to the café/hotel run by Monsieur and Madame Ravoux, a *commerce de vins* (wine shop) occupied a front corner of the restaurant. At the time it was not uncommon to have such multiservice establishments in French villages. Cafés, where wine was available by the glass, frequently sold bottles of wine, beer, cider, or spirits to its customers. The firm distinction between a wine shop that only sold wine or other alcoholic beverages and a café where one would enjoy a beer or brandy *sur place* did not exist during Van Gogh's time. Even as these distinctions developed in Paris and in other large cities in France, shaped by changing times and new legislation, the countryside remained more traditional. And an establishment like Ravoux's, where one could quench one's thirst, fill one's belly, get out of the cold and into the light, or simply sip a coffee by a wood stove in winter, served an important social function.

Conveniently located on the town's main street, the auberge was the ideal place for day visitors and painters to pick up something to drink before heading out of the village into the open countryside for a picnic party or painting expedition. Ravoux had

vins ordinaires, a mouth-puckering Coteaux de l'Oise wine known as *ginglet,* along with other wines, possibly from the vineyards of nearby Argenteuil. Most likely Ravoux's wine shop was also licensed to sell beer and cider, some of which may have been locally produced. Possibly, too, other stronger alcoholic drinks, such as *eaux-de-vies* and brandies, were also sold at his *commerce de vins.*

Another alcoholic drink of the time, widely available at any café in Auvers, was absinthe. It had become popular among French soldiers returning home from Algeria in the 1830s, who had originally been prescribed the alcohol as an antiviral remedy to be mixed with their drinking water. Until it was banned on the eve of World War I, *la fée verte* ("the green fairy") as the drink was known, enjoyed immense popularity among French citizens—men and women, the working class and the bourgeoisie. Part of the appeal of absinthe had to do with the fact that, unlike Cognac, whisky, or eau-de-vie, there was a ritual surrounding its consumption.

The liquor was enjoyed in a tall glass that had an elongated cup made especially for drinking it. It was prepared in the following manner: A delicate, perforated spoon, usually tin, was set across the rim of the glass. A lump of sugar was then placed in the spoon and water was slowly poured over the sugar. The dissolving cube along with the water

would then trickle down into the glass, sweetening the drink. As the contents of the glass were stirred, the absinthe-and-water-mix turned a cloudy, pale yellow-green. For some, a single glass at five o'clock in the afternoon was sufficient. For others, who lacked self-control or were addicted, half a dozen glasses or more was the norm. It is no wonder that the Société de Tempérance Française was alarmed by the statistics on absinthe consumption. While many in the league would have liked to turn France into a nation of teetotalers, banning *all* alcoholic beverages, the French were not about to give up such an important part of their nation's patrimony.

Van Gogh enjoyed his absinthe, having at times consumed large quantities of the anise-flavored alcohol in the company of Toulouse-Lautrec, Émile Bernard, and Paul Gauguin. It seems, though, that while staying at the auberge, he kept his drinking in check, no doubt being more cautious about his health than he had been previously. Another breakdown would be a terrible setback, and he could not afford to lose any more time. Besides, the heavy drinking spells seemed to coincide with poor eating, and at the auberge he took his meals regularly, ate fresh, nourishing food, and drank better-quality wine than he had in the south.

The inn was a friendly, informal place where the *Auverois* (locals) played cards, dominoes, and other popular café games while sipping wine and exchanging stories. A billiard table, a common fixture in cafés, could be found in one corner of the room, and a chunky, wood-burning stove stood in the center. The auberge was a place of sociability, entertainment, and nourishment.

Cuisine Populaire

Inspired by the flavors of Louise Ravoux's
1890 kitchen and the homey quality of
nineteenth-century auberge cuisine,
Chef Christophe Bony has reinterpreted
several slow-cooked classic dishes from Van Gogh's era. This
section includes many of the restaurant's most popular dishes,
such as Seven-Hour Lamb Ravoux Style with Potatoes and
Smoked Slab Bacon, Chocolate Mousse Sabayon, and Tarte Tatin.

Marinated Herring and Salmon with Potatoes en Vinaigrette

HARENGS ET SAUMON MARINÉS À L'ANCIENNE, POMMES DE TERRE EN VINAIGRETTE

As a first course, or as an addition to your Sunday brunch table, the herring and salmon together are a wonderful accompaniment to the warm dressed potatoes.

SERVES 6

1/2 cup coarse sea salt

1/4 cup sugar

3 tablespoons crushed white peppercorns

3 tablespoons coriander seeds

1 pound salmon fillet (approximately 1 inch thick)

One 8-ounce package smoked herring (or smoked brook trout)

1 medium white onion, thinly sliced into rounds

1 large carrot, cut into 1/8-inch-thick slices

1/2 leek (white and light green part), rinsed well and julienned (matchstick cut)

Soy or canola oil for marinating

Potatoes en Vinaigrette (recipe follows)

Combine the salt, sugar, peppercorns, and two tablespoons of the coriander seeds in a small bowl. Mix well. Place the salmon in a pan skin side down, and spread the salt mixture on top, using your hands to cover the fillet evenly. Cover the pan with plastic wrap and refrigerate for 6 hours.

When the fish is cured, brush off as much of the salt mixture as possible, then rinse the salmon under cold running water. Pat it dry with paper-towels and place the fish in a colander set on a dish or deep plate. Cover and refrigerate for 6 hours. The fish will become firm and darken slightly as part of the curing process.

Remove the fish from the refrigerator and place on a work surface. Using a knife with a long, thin blade, remove the skin. Place your knife on a diagonal against the salmon and cut into 1/3-inch-thick slices.

Arrange the salmon slices in a shallow glass or ceramic dish that is at least 4 inches deep, overlapping them, if necessary. Top with the herring. If using trout, cut into 2-inch-long pieces. Spread the onion, carrot, and leek over the fish and sprinkle the remaining coriander seeds over the top. Pour on enough oil to completely cover the fish. Cover and refrigerate for 24 hours. Remove the fish from the refrigerator a few hours before serving. (It should not be eaten too cold.) Serve with the dressed potatoes (recipe follows).

POTATOES EN VINAIGRETTE

6 small waxy oval-shaped potatoes, such as White Rose

Fine sea salt

3 tablespoons soy, canola, or corn oil, or a combination

1 tablespoon red wine vinegar

Freshly ground pepper

Chopped fresh chives

Coarse sea salt

Place the potatoes in the basket of a vegetable steamer. Steam until a sharp paring knife easily enters the flesh, 20 to 25 minutes.

Meanwhile, to prepare the vinaigrette, dissolve a pinch of salt in the vinegar in a small bowl. Add the oil, whisking until emulsified. Season with pepper and add salt, if necessary. Set aside.

Drain the potatoes. When cool enough to handle, peel them.

Cut each potato into 1/3-inch-thick slices and place one potato in overlapping slices on each plate. Drizzle the vinaigrette over the potatoes and sprinkle with chives and coarse sea salt. Place a serving of salmon and herring beside each potato.

Monkfish and Mussel Stew

WATERZOOI DE POISSONS

This little-known Flemish fish stew is offered in celebration of the artist's heritage. The dish could be considered a northerner's bouillabaisse, made with cream and butter rather than olive oil and without such Provençal flavors as garlic, tomatoes, and saffron. The flavor of the dish is delicate, with aromatic notes coming through in the cream sauce. To accompany the stew, serve boiled or steamed potatoes, tossed with a little butter and seasoned with salt and pepper.

SERVES 4

FUMET AND CREAM SAUCE

4 tablespoons ($^1/_2$ stick) unsalted imported or organic butter

About $^1/_4$ pound trimmed monkfish ends or a 2-inch monkfish medallion

4 shallots, thinly sliced

I celery stalk, coarsely chopped

I carrot, quartered lengthwise and cut into $^1/_2$-inch pieces

Several leafy sprigs thyme

2 teaspoons coarse sea salt

I teaspoon mixed peppercorns

I quart cold water

$^3/_4$ cup dry white wine

I cup heavy cream (preferably organic)

2 tablespoons plus 2 teaspoons cornstarch dissolved in $^1/_4$ cup cold water

VEGETABLE GARNITURE

4 tablespoons ($^1/_2$ stick) unsalted imported or organic butter

$^1/_4$ celery root, peeled and julienned (about 2 cups)

2 leeks (white and light green parts), ends trimmed, washed, cut into thirds, and julienned

2 carrots, halved and julienned

FISH AND SHELLFISH

$2^1/_2$ pounds monkfish fillets, rinsed, patted dry, and cut into $1^1/_2$-inch medallions

20 mussels, scrubbed

To prepare the fish fumet, melt the butter in a large saucepan over medium heat. Add the monkfish ends, shallots, celery, carrot, thyme, salt, and peppercorns. Sauté for 10 minutes, stirring with a wooden spoon. Add the water and wine, and simmer for 30 minutes.

Meanwhile, to prepare the vegetable garniture, melt the butter in a saucepan over medium heat. Add the celery root, leeks, and carrots, stirring often until softened, about 5 minutes. Transfer to a plate and reserve until needed.

Remove the fumet from the heat and set aside to cool slightly. Pour through a sieve into a large saucepan. Discard the solids. Whisk in the heavy cream and the cornstarch mixture and bring to a simmer. Cook, whisking, until the sauce thickens. Gently add the monkfish and carrot-leek mixture. Arrange the mussels on top and cook, covered, for 10 minutes or until mussels open. Discard any that do not open. Serve immediately.

Stewed Chicken with Mustard-Cream Sauce
La Poule au Pot et Sa Crème à la Moutarde

If you've not yet experienced the joys of a strong seeded mustard from Meaux, then here's your chance. The delicate lean quality of the stewed chicken marries beautifully with the pleasant grainy richness of the mustard sauce. The sauce can also accompany hot or cold meat or fish dishes. The recipe is a fine example of *"cuisine économique"* (the watchword of the nineteenth-century French *ménagère* [housewife]), for after enjoying the chicken dish, you still have at least a quart of rich homemade stock. Use it to make the Cream of Carrot Soup (page 191), Pumpkin Soup (page 151), Rice Pilaf (page 123), or Fricassee of Rabbit (page 116).

SERVES 4

Stewed Chicken

1 free-range roasting chicken (3¹/₂ to 4 pounds), rinsed
2 medium onions, quartered
2 carrots, cut into thirds
1 leek (white and light green parts), trimmed, washed, and cut into thirds
2 celery stalks, cut into thirds
1 celery root, peeled and quartered
Several leafy sprigs fresh thyme
1 teaspoon whole black peppercorns
1 tablespoon coarse sea salt
¹/₃ pound slab bacon (optional)

Mustard-Cream Sauce

2 tablespoons unsalted imported or organic butter
2 tablespoons all-purpose flour
³/₄ cup hot chicken stock, strained
¹/₂ cup heavy cream (preferably organic)
1¹/₂ tablespoons moutarde de Meaux, or any grainy Dijon mustard
¹/₄ teaspoon fine sea salt
Freshly ground pepper

Rice pilaf (page 125), for serving (optional)

To prepare the chicken, put all of the ingredients in a large pot with enough water to cover the chicken. Bring to a boil, then reduce the heat and simmer until chicken is fully cooked, about 1 hour. Pour ³/₄ cup of the chicken stock through a sieve and keep warm until ready to use for the sauce.

To prepare the mustard sauce, melt the butter in a medium saucepan; whisk in the flour, mixing vigorously for 30 seconds. Pour in the reserved hot stock, a little at a time, and continue to whisk until the mixture thickens, about 45 seconds. Stir in the cream, the mustard, and season with salt and pepper. Stir to blend thoroughly, then transfer to a serving bowl.

Remove the chicken and vegetables from the cooking liquid. Cut the chicken into quarters or eighths. Transfer to a serving platter or onto individual plates along with the vegetables and spoon 2 to 3 tablespoons of the sauce over. Serve with rice pilaf, if desired.

OPTIONAL: Other vegetables, such as cabbage and turnips can be added to this dish. Just be sure to wash, trim, and quarter them; add to the chicken during the last 30 minutes of cooking.

Fricassee of Rabbit with White Wine, Herbs, Pearl Onions, and Sautéed Potatoes

Fricassée de Lapin au Thym, Oignons Nouveaux et Pommes Rissolées

Rabbit, similar in texture to a true free-range chicken, is a versatile food that is delicious when cooked with a generous amount of fresh herbs and white wine. The meat has a delicate flavor that goes well with the sweetness of the onions and the slight nuttiness of the sautéed potatoes.

SERVES 4

½ pound pearl onions, trimmed and peeled

Salt

1 pound small white potatoes, such as fingerling

2 tablespoons peanut oil

1 rabbit, cut into eight pieces (ask the butcher to cut it up)

Freshly ground pepper

1 large onion, cut into ½-inch pieces

2 carrots, cut into ½-inch pieces

1 celery stalk, cut into ½-inch pieces

2 cups dry white wine

2 garlic cloves, thinly sliced

4 leafy sprigs fresh thyme, plus an additional sprig for garnish (optional)

1½ quarts homemade chicken stock or reduced-sodium broth

2 to 3 tablespoons olive oil (see Note)

1 lightly seared cherry tomato

Put the onions in a small saucepan with enough water to cover. Add a pinch of salt. Bring to a boil and cook until tender but still firm, about 10 minutes. Using a slotted spoon, transfer the onion to a bowl and reserve until needed.

To prepare the potatoes, put them in a small pot with enough water to cover. Bring to a boil and cook until fork-tender, 15 to 20 minutes. Do not overcook. Transfer the potatoes to a bowl until needed.

Heat the peanut oil in a large sauté pan over medium-high heat. When the oil is hot, add the rabbit and season with salt and pepper. Brown the rabbit pieces evenly on both sides. (If your pan is not large enough, brown the rabbit in two batches.) Transfer the rabbit to a large pot and set aside until needed.

Add the onion, carrots, and celery to the sauté pan and cook, stirring, until they have some color. Stir in the wine, garlic and the thyme. Bring to a boil and reduce by half.

Add the stock and bring to a boil. Reduce the heat and simmer for 20 minutes. Pour the liquid into the pot with the rabbit. Simmer until rabbit is fully cooked, about 30 minutes, adding the onions to the pot about 20 minutes before the rabbit is done.

Meanwhile, heat the olive oil in a large skillet over medium-high heat. Add the potatoes, season with salt, and cook, tossing until evenly browned, about 10 minutes.

Serve the rabbit with the potatoes on the side. Garnish with the cherry tomato with a small sprig of fresh thyme stuck into it, if desired.

NOTE: If you happen to have some duck or chicken fat on hand, brown your potatoes in a few spoonfuls of it rather than in the olive oil.

Seven-Hour Lamb Ravoux Style, with Sautéed Potatoes and Smoked Slab Bacon

GIGOT D'AGNEAU RAVOUX DIT "DE SEPT HEURES," POMMES DE TERRE SAUTÉES AU LARD

This is a three-step recipe that includes making lamb stock a day ahead, marinating the leg of lamb for twenty-four hours, and then slow-cooking it in the oven. This old-fashioned, melt-in-your-mouth stew is a real treat when served with the oven-crisped potato and bacon dish. The nineteenth-century version of this dish, known as *gigot de sept heures*, was actually cooked at a gentle temperature for seven hours, or until the lamb was tender enough to be eaten with a spoon. At the Auberge Ravoux, the cooking time has been reduced to three hours.

SERVES 6

LAMB STOCK

3 pounds lamb bones and meat scraps
2 tablespoons peanut oil
1 large carrot, coarsely chopped
1 celery stalk, coarsely chopped
1 medium onion, coarsely chopped
2 bay leaves
Several leafy sprigs fresh thyme
Several leafy sprigs parsley

MARINATED LAMB

Half leg of lamb (about 3 pounds)
1 medium carrot, coarsely chopped
1 medium onion, coarsely chopped
1 celery stalk, coarsely chopped
1 head garlic, cut crosswise in half
3 leafy sprigs fresh thyme
3 bay leaves
1 tablespoon mixed peppercorns
3 bottles (750 ml each) dry white table wine, approximately
3 tablespoons peanut oil

Preheat the oven to 400° F.

To prepare the lamb stock, spread the lamb bones and meat scraps in a lightly oiled baking pan large enough to hold the bones in a single layer. Roast for 1½ hours, turning the bones and scraps 2 or 3 times for even browning.

Meanwhile, heat the oil in a large heavy-bottomed pot and brown the carrot, celery, and onion. Set aside until needed.

Transfer the browned bones and scraps to the vegetables in the pot. Increase the heat to high and pour in the water. Using a wooden spoon, scrape up any caramelized bits that are stuck to the bottom or sides of the pan. Pour the liquid into the pot and add enough water to cover the bones. Add the bay leaves, thyme, and parsley. Bring the stock to a boil, then reduce the heat and simmer, partially covered, for 3½ hours.

Strain the stock and set aside 1 quart for the lamb. Freeze the leftover broth in quart-size freezer containers for up to several months.

MAKES ABOUT 3½ QUARTS

Meanwhile, put the lamb in a large container or pot. Add the carrot, onion, celery, garlic, thyme, bay leaves, and peppercorns; pour in enough wine to cover completely. With your hands, stir to mix the ingredients, making sure the lamb is completely submerged in the wine. Cover with plastic wrap and refrigerate for 24 hours.

Preheat the oven to 300° F.

Remove the lamb from the container. Pour the vegetable mixture through a colander set in a bowl to catch the liquid. Reserve the wine and the vegetables in separate containers.

In a skillet large enough to hold the lamb, heat the peanut oil over medium-high heat. When it is quite hot, add the leg of lamb and brown evenly on all sides, turning the meat with tongs. Once the meat is well browned, transfer it to a large ovenproof pot.

Add the reserved onion, carrot, and celery to the same skillet (discard remaining ingredients). Cook, stir-ring, over medium heat, until the vegetables are lightly browned. Transfer them to the meat in the pot. Add the reserved wine (from the marinade) along with the reserved lamb stock. Bring the mixture to a boil; cover the pot and transfer to the oven. Bake for 3 hours, or until very tender, then remove from the oven and allow to cool to room temperature. Refrigerate until ready to serve.

Set the lamb on a carving board and slice into $^3/_4$- to 1-inch-thick pieces. Place the meat slices in a saucepan and transfer enough of the cooking juices to fully cover the lamb. Simmer over a low heat, 20 to 30 minutes. To serve, spoon some of the cooking juices over the lamb and accompany with the Sautéed Potatoes with Smoked Slab Bacon (below).

Sautéed Potatoes with Smoked Slab Bacon
Pommes de Terre Sautées au Lard

Potatoes and ham go together just like bacon and eggs, the salty, smoky pork contributing flavor to an otherwise bland food. These potatoes are first pan-fried, then finished in a hot oven, where they become golden brown and slightly crunchy.

SERVES 4 TO 6

2 pounds all-purpose potatoes, scrubbed (see Note)
2 tablespoons vegetable oil
1 to 1 $^1/_2$ ounces slab bacon or pancetta, cut into small dice
1 tablespoon finely chopped fresh chives
Coarse salt

Preheat the oven to 400° F.

Place the potatoes in the basket of a vegetable steamer. Steam until a sharp paring knife easily enters the flesh, 20 to 25 minutes. Transfer the potatoes to a bowl. When cool enough to handle, peel the potatoes and cut into $^1/_3$-inch-thick slices.

Heat the oil in a large skillet over medium-high heat. When it is hot, add the potatoes. Cook, tossing occasionally, until the potatoes are golden brown. Transfer to an oven-proof dish and bake for 20 to 30 minutes. This last step renders the potatoes crunchy on the outside and soft on the inside. A few minutes before the potatoes are ready, sauté the bacon (or pancetta) over medium-high heat until golden. When the potatoes are ready, add the bacon, sprinkle with the chives and coarse salt; transfer to a serving dish or onto individual plates.

NOTE: If using larger potatoes, such as Red Bliss or Yukon Gold, halve or quarter the slices.

Burgundy-Style Beef Stew

RAGOÛT DE BOEUF À LA BOURGUIGNONNE

Like coq au vin, its counterpart in the poultry department, boeuf bourguignon typifies the classic home-style French cooking of the nineteenth century. Meat and vegetables are marinated overnight in red wine, browned in hot oil, and then slow-simmered in their marinade for several hours. In our time-pressed age, such a dish requires that we step back for a moment and remember that some things in life are worth waiting for—especially stews.

SERVES 6

BEEF STEW

3 pounds stewing beef, cut into
 2-inch chunks
2 onions, halved, with one clove
 stuck into each half
2 medium carrots, coarsely chopped
1 celery stalk, coarsely chopped
Several leafy sprigs fresh thyme
2 teaspoons mixed peppercorns
3 bay leaves
2 to 3 bottles (750 ml each)
 dry red table wine
2 tablespoons peanut oil
2 tablespoons all-purpose flour
2 teaspoons coarse salt
1 Golden Delicious apple, cored
 and quartered
2 tablespoons cornstarch dissolved in
 1/4 cup cold water (optional)
Fine salt and freshly ground pepper

CARAMELIZED ONIONS

3/4 pound pearl onions
1 1/4 teaspoons sugar
3 tablespoons unsalted imported or
 organic butter, cut into pieces
Pinch of fine sea salt

To prepare the stew, put the beef, onions, carrots, celery, thyme, peppercorns, and bay leaves in a large bowl and add the wine. The meat should be fully submerged. Cover with plastic wrap and refrigerate overnight.

Strain the meat and vegetables through a colander set in a bowl. Let drain for 1 hour. Reserve the liquid; separate the meat and vegetables.

Heat the oil in a large pot over medium-high heat. Add the meat, in batches, and brown well on all sides. Transfer to a bowl and set aside until needed. Add the reserved vegetables to the pot and cook, stirring, until browned and softened, about 5 minutes.

Return the meat to the pot with the vegetables and sprinkle with the flour, stirring to blend well. Add the coarse salt and pour in the reserved wine from the marinade. Bring the mixture to a boil, then reduce the heat and simmer, skimming the foam from the surface, as necessary. Simmer, stirring occasionally, for 2 hours.

Meanwhile, prepare the caramelized onions. Bring a small pot of water to a boil and add the onions. Simmer for 1 minute then transfer to a colander to cool. Trim the root and stem ends and peel the onions. Place the onions in a pan large enough to hold them in one layer, add enough water to barely cover. Sprinkle with the sugar and add the butter.

Cut a round of parchment paper to fit in the pan so that it snugly covers the onions. Cut a whole in the center to allow steam to escape. Cook over medium heat until the

onions have caramelized, 25 to 30 minutes, adding a little water if the pan seems dry. Season with a pinch of fine salt.

When the meat is done, strain the contents through a colander set in a bowl. Discard the thyme and bay leaves. Pour the liquid back into the pot and add the apple. Bring to a boil and continue boiling for 15 minutes. The apple will absorb any bitterness in the wine. Using a slotted spoon, fish out the apple pieces and discard. Add the cornstarch mixture to the pot, if using, stirring with a wooden spoon until the liquid thickens, 2 to 3 minutes. Return the meat and vegetables to the pot and simmer for 5 minutes to reheat. Serve with the caramelized onions on the side and buttered broad egg noodles, if desired.

Rice Pilaf
Riz Pilaf

This rice dish tastes like a risotto, but is light and fluffy rather than creamy. Serve as an accompaniment to any number of main-course dishes, especially the Veal Stew with Mushrooms (page 125).

SERVES 6

3 tablespoons unsalted imported or organic butter
1/4 cup minced onion
2 cups long-grain white rice
3 1/2 cups homemade chicken stock or reduced-sodium broth, heated
1/4 teaspoon fine sea salt
1 leafy sprig fresh thyme

Melt the butter in a medium saucepan over medium heat. Add the onion and sauté until soft, about 5 minutes. Add the rice and stir to coat the grains evenly with the butter. Add the chicken stock, salt, and thyme sprig. Cover and simmer over low heat until all liquid is absorbed, about 20 minutes.

Allow the rice to sit for 15 minutes before discarding the thyme sprig; fluff with a fork and serve.

Veal Stew with Mushrooms

BLANQUETTE DE VEAU

Subtle in flavor and silken in texture, Blanquette de Veau, when properly made, can bring cries of joy from Frenchmen. It's a simple dish, but it does require some focused attention at the end to get the sauce just right—velvety and smooth, neither too thick nor too thin. The stew works nicely with Rice Pilaf (page 123) or with boiled and buttered potatoes. No matter when you serve the dish—a sit-down dinner party, a buffet luncheon, or plated in the kitchen and brought out to guests—it's fun to pass around a whole nutmeg and let your diners grate their own.

SERVES 6

3 pounds veal shoulder, cut into 3-inch chunks

2 carrots, cut into 2-inch pieces

2 onions, 1½ of the onions coarsely chopped and 2 cloves stuck into the remaining half

1 celery stalk, cut into thirds

1 leek, ends and green leaves trimmed and washed well

2 teaspoons coarse salt

1 teaspoon whole black peppercorns

Bouquet garni (4 parsley stems, 6 sprigs thyme, and 1 bay leaf tied together with kitchen string)

MUSHROOM GARNITURE
¾ pound white mushrooms, quartered

Juice of ½ lemon

ROUX
⅓ cup heavy cream (preferably organic)

1 large egg yolk

7 tablespoons unsalted imported or organic butter

⅓ cup all-purpose flour, sifted

1 quart veal stock or cooking broth

Salt and freshly ground pepper

1 whole nutmeg

Place the veal in a large pot and add enough cold water to cover. Bring to a boil over medium-high heat. Once the water boils, drain and add enough fresh cold water to cover. Add the carrots, onions, celery, leek, coarse salt, peppercorns, and bouquet garni. Simmer over medium-high heat until the meat is very tender, about 2 hours. Skim any foam that collects on the surface during cooking. Remove the meat from the cooking liquid; transfer the cooking broth to a bowl, if using. Wash out the pot; return the veal to the pot.

To prepare the mushroom garniture, place the mushrooms and lemon juice in a small non-reactive pan with enough water to cover. Simmer for 10 minutes. Drain and set aside.

To prepare the roux, whisk together the cream and egg yolk in a small bowl. Melt the butter in a large saucepan over medium-high heat. Add the flour, and whisk to blend; cook, whisking constantly, for 1 minute. Add the veal stock, a little at a time, continuing to whisk until the sauce begins to thicken, about 3 minutes. Slowly add the egg-cream mixture to the sauce, stirring constantly with a wooden spoon. When the sauce is smooth and fully combined, add the mushrooms to the veal in the pot; pour the sauce over. Cook over medium heat until heated through. Season with salt and pepper and a few scrapes of fresh nutmeg.

125

Red-Wine Poached Pears with Cinnamon and Vanilla

POIRES POCHÉES AU VIN ET AUX ÉPICES

This two-step poached pear recipe involves first marinating the pears overnight in a spiced wine mixture, then poaching them in the wine mixture. The pale, smooth pears turn deep maroon, and have vanilla and cinnamon accents. Choose pears with their stems intact for the most eye-catching presentation.

SERVES 6

6 medium to large Bartlett pears, peeled, the core removed by cutting through the blossom end

2 to 2½ bottles (750 ml each) red table wine

2 tablespoons crème de cassis (blackcurrant liqueur)

1 vanilla bean, split and scraped

2 cinnamon sticks

2 star anise, plus additional for garnish

2 cups sugar

Place all the ingredients except the sugar in a deep container so the pears are completely submerged in the wine. Cover and refrigerate overnight.

Using a slotted spoon, gently transfer the pears to a large pot; pour in the wine mixture. Add the sugar and stir gently. Bring to a slow boil and simmer until the pears are tender but still firm when pierced with a fork. The cooking time will vary from 15 minutes to 1 hour, depending upon the ripeness of the fruit. From time to time, spoon the wine mixture over the pears while they cook.

Carefully transfer the pears to a dish and allow to cool. Serve chilled or at room temperature with 1 to 2 tablespoons of the poaching liquid spooned over. Garnish each dessert plate with a star anise, if desired.

Rice Pudding Ravoux

RIZ AU LAIT RAVOUX

Infused with rich undertones of vanilla, this rice pudding is denser and chewier than the classic. To maintain its enticing texture, the pudding is not refrigerated. Instead, it is served at room temperature, a few hours after being prepared. Enjoy as is or serve it with Quince Compote (recipe follows) in the fall and winter, or Rhubarb Compote (page 162) in the spring.

SERVES 4 TO 6

1 cup Arborio rice
2 cups water
3 cups milk
1/2 vanilla bean, split
3 tablespoons sugar

Combine the rice and the water in a medium saucepan. Bring the mixture to a boil, stirring occasionally. Pour the mixture through a sieve. Hold the sieve under cold running water to cool the rice quickly; drain. (You can leave the rice in the strainer set over a bowl until you need it.)

Pour the milk into the same saucepan. Scrape the seeds of the vanilla bean into the milk and add the bean. Place the pan over medium heat and cook, stirring often, until the milk boils. Discard the vanilla bean. Add the rice and mix well.

Cook at a low boil, stirring occasionally with a wooden spoon, until all of the milk is absorbed and the pudding is quite thick, 20 to 30 minutes. Allow to cool slightly before transferring the rice pudding to a serving bowl. Add the sugar and mix well.

Cover with plastic wrap and set in a cool, but not cold, place until ready to serve. For an unusual presentation, use two large spoons to shape the pudding into quenelle-like ovals, two per serving. Place in individual serving dishes with a serving of the quince compote alongside, if desired.

Quince Compote

COMPOTE DE COINGS

Delicate vanilla notes make this fruit compote the perfect accompaniment to Ravoux's rice pudding. Quinces tend to be available only during fall and winter months in specialty food shops, so should you be fortunate enough to find them in your local farmers' market, snatch them up, because their growing season is short and production tends to be small.

SERVES 4 TO 6

5 firm unblemished quinces, peeled
 and cored
Juice of two lemons
1 1/4 cups cold water
1/2 vanilla bean, split and scraped
1/4 cup sugar

Cut the quinces into 1-inch cubes and put in a medium, heavy-bottomed pot. Add the lemon juice and mix well to coat evenly. Add the water and cook over low heat until the fruit begins to soften, about 20 minutes.

Add the vanilla bean and seeds and sprinkle in the sugar, a little at a time, stirring well. Mix and continue cooking until the fruit is soft and has the consistency of chunky applesauce.

Remove from the heat and discard the vanilla bean. Using a large fork or a masher, mash the quinces until almost smooth, leaving a few chunks.

Serve warm or chilled.

129

Chocolate Mousse Sabayon

MOUSSE CHOCOLAT AU SABAYON

Because this recipe calls for egg whites instead of heavy cream (thus, a sabayon), it's much lighter than traditional chocolate mousse. Tempting as it might be to eat this dessert soon after making it, you do need to refrigerate it for a full twelve hours. Chill the mousse in an earthenware bowl as is done at the auberge, and when you're ready to serve it, pass the mousse around the table, letting family or friends help themselves.

SERVES 10 TO 12

7 ounces premium dark chocolate, chopped (50 to 70 percent cocoa butter is suggested) (see Note)

1/2 pound (2 sticks) cold unsalted imported or organic butter

10 large eggs, separated

1 1/4 cups confectioners' sugar, sifted

Unsweetened cocoa powder or chocolate curls (optional)

In a double boiler or small saucepan set over simmering water, combine the chocolate and butter. Heat, stirring often, just until melted and smooth. Remove from the heat.

Combine the egg yolks with half of the sugar in large bowl of an electric mixer. Beat for several minutes, until the yolks are thick and pale yellow.

In another large bowl (with clean beaters), beat the whites with the remaining sugar until soft peaks form.

Pour chocolate mixture into the bowl containing the egg yolks and stir with a rubber spatula to blend. Fold the egg whites into chocolate mixture gently, but thoroughly. Transfer the mousse to a serving bowl; refrigerate, covered, for 12 hours. When ready to serve the mousse, dust with cocoa powder or top with chocolate curls, if desired.

NOTE: 100-gram (3.5 ounce) bars are standard weight for imported chocolate.

Warm Tarte Tatin with Crème Fraîche
"Tarte Tatin" Chaude et sa Crème Fraîche

Ideally, this tart should be made in the fall when apples are at their peak in flavor and firmness. In this recipe, the apples are not actually caramelized before the pastry is laid on. Rather, a caramel sauce is poured into the bottom of a baking pan and the apple quarters are then nestled and anchored on top of it. When the tart is inverted, it strongly resembles a true Tatin, its glistening caramel syrup enrobing the fragrant fruit. At the auberge, it is served warm. Reheat the tart in a 300° F. oven for 15 minutes before inverting onto a plate.

SERVES 6 TO 8

6 tablespoons unsalted imported or
 organic butter
1 cup sugar
5 large baking apples such as Winesaps,
 Mutsus, Golden Delicious, or
 Jonagolds, peeled, cored,
 and quartered
Approximately $1/2$ pound puff pastry
 (page 166), thawed if frozen
Crème fraîche or vanilla ice cream

Preheat the oven to 425° F.

Melt the butter in a small heavy-bottomed saucepan over medium heat. Add the sugar and stir constantly with a wooden spoon until the mixture is deep caramel in color. Remove from the heat.

Pour the caramel into a 10-inch cast-iron skillet or heavy metal pan that is $2^{1}/_{2}$ to 3 inches deep, tilting the pan to evenly coat the bottom.

Working from the outside in, wedge the apple quarters into the syrup, standing up, to form a snug ring. Cut the last few pieces to fit into the center.

On a lightly floured surface, roll out the pastry to a thickness of about $1/_3$ inch and place on top of the apples. Trim away the excess pastry, leaving a slight overhang to tuck into the pan. Poke small steam holes using a sharp paring knife.

Bake for about 50 minutes, or until pastry is golden brown and apples are tender. Transfer to a wire rack to cool for several hours before serving. Invert the tart onto a serving plate just before serving to prevent pastry from becoming soggy.

Serve with crème fraîche or vanilla ice cream.

133

Fields of Wheat and Flowering Peas

WHEN VAN GOGH ARRIVED in Auvers late in the spring of 1890, pea plants in blossom covered the gently sloping hillsides outside the village; the harvest, if it had not already begun, would soon commence, rallying men, women, and children of all ages. Protected from the sun by broad-brimmed straw hats and clad in long cotton aprons, the *Auverois* along with migrant workers, mainly from the north of France and Belgium, would pick the firm, smooth pods by the handful, depositing them in stout handwoven baskets. Part of the crop would be sold at market, and some of it would be kept for personal consumption by the farmers and their families.

Just as Van Gogh had been drawn to the olive groves and vineyards of Provence, the agrarian face of Auvers with its wheat fields, pea fields, and craggy old vineyards captured his imagination. Though his palette had brightened and he had matured as an artist, the *Potato Eaters* series from 1885, along with studies made after works by "father" Millet, clearly evinced from the start Van Gogh's partiality for the *paysans* (country folk) and

"I often think of you, Jo, and the little one, and I notice that the children here in the healthy open air look well."

Letter from Vincent to Theo, June 1890

their earthbound world. Whether depicting landscapes of undulating grain fields or images of peasant women clad in brightly colored cottons, Van Gogh's paintings strongly conveyed the rural beauty that was Auvers.

Inspired by the verdant splendor of his new surroundings, Van Gogh's first Auvers painting (*Thatched Cottages,* May 1890) showed a sloping field of blossoming peas with stalks of wheat beside them. He wrote Theo: "I have one study of old thatched roofs with a field of peas in flower in the foreground and some wheat, the background of hills, a study which I think you will like."

Mon cher Theo, déjà depuis plusieurs jours j'aurais désiré t'écrire à tête reposée mais ai été absorbé par le travail. Ce matin arrive ta lettre de laquelle je te remercie et du billet de 50 fr. qu'elle contenait. Oui je crois que pour bien des chôses il serait bien que nous fussions encore ensemble tous ici pour une huitaine de tes vacances si plus longtemps n'est pas possible. Je pense souvent à toi à Jo et au petit, et je vois que les enfants ici au grand air sain ont l'air de bien se porter. Et pourtant c'est déjà ici aussi difficile assez de les élever à plus forte raison est ce plus ou moins terrible à de certains moments de les garder sains saufs à Paris dans un quatrième étage. Mais enfin il faut prendre les chôses comme elles sont. M. Gachet dit qu'il faut que père et mère se nourrissent bien naturellement et parle de prendre 2 litres de bière par jour &c. Dans ces mesures là. Mais tu feras certes avec plaisir plus ample connaissance avec lui et il y compte déjà en parle toutes les fois que je le vois que vous tous viendrez. Il me parait certes aussi malade et ahuri que toi ou moi et il est plus âgé et a perdu il y a quelques années sa femme mais il est très médecin et son métier et sa foi le tiennent pourtant. Nous sommes déjà très amis et par hasard il a connu encore Brias de Montpellier et a les mêmes idées sur lui que j'ai que c'est quelqu'un d'important dans l'histoire de l'art moderne. Je travaille a son portrait

 la tête avec une casquette blanche très blonde très claire les mains aussi à carnation claire un frac bleu et un fond bleu cobalt appuyé sur une table rouge sur laquelle un livre jaune et une plante de digitale à fleurs pourpres. Cela ~~faible avec~~ est dans le même sentiment que le portrait de moi que j'ai pris lorsque je suis parti pour ici. ~~Mr Gachet a~~ M. Gachet est absolument fanatique pour ce portrait et veut que j'en fasse un de lui si je peux absolument comme cela ce que je désire faire aussi. Il est maintenant aussi arrivé a comprendre le dernier portrait d'arlésienne ~~et~~ dont tu en as un en rose. Il revient lorsqu'il vient voir les études tout le temps sur ces deux portraits et il les admet en plein mais en plein tels qu'ils sont.

At the time of the artist's brief sojourn, Auvers was still overwhelmingly a farming community. Its principal crops—green peas, beans, asparagus, artichokes, and cabbage—were mainly planted in the fertile, well-drained fields that bordered the meandering Oise river; grains, among them wheat, rye, barley, oats, corn, buckwheat, and rice, were grown in the open fields above the village, beyond where the church of Auvers stood. The climate was generally mild due to its proximity to the river and the surrounding hills that protected the land from strong north winds. Because of these favorable growing conditions, it was sometimes possible to coax three harvests a year from the land, although two was the norm.

As Cazier describes in his unique "Monographie Communale d'Auvers-sur-Oise" (1899), a fascinating account of daily life in Auvers written shortly after Van Gogh's time there, a farmer would fertilize his fields with manure in the fall and plant peas in February in order to harvest them in May. The fields would then be ploughed under, lightly fertilized, and sown with beans, which would be ripe for picking in September. In late June or early July, cabbage was planted for a December harvest.

While Cazier is not specific about varieties when he lists the vegetables under cultivation, we might hypothesize that both red and green cabbages were grown. Emile Zola, in his preparatory notebooks

for *The Belly of Paris,* describes the mountains of cabbages of all types—white, purple, and frisé—that could be found in the vegetable pavilion at Les Halles, the setting for his 1874 novel of republican politics and family betrayal.

Of Auvers's asparagus culture, it is most certainly the white *Asperge d'Argenteuil* to which Cazier is referring when he makes mention of this delightful vegetable. Prior to the first quarter of the nineteenth century, the asparagus that were popularly grown in France were green. After this time, however, the white Argenteuil asparagus becomes the preferred variety, served *tiède* (at room temperature) with a Hollandaise on the side, in a ragout delicately flavored with veal stock and dry sherry, or in an omelette where only the tenderest tips were used.

As for the artichokes noted by Cazier, it is more than likely the *Artichaut de Paris* to which he is referring, for not only is this variety still cultivated in Auvers today (in a field just beyond the stone wall of the cemetery where the twin graves of Vincent and Theo can be found), but it was the most common artichoke grown in northern France. Traditional in the Val d'Oise region, this fleshy variety with its large *fond* (bottom) was the artichoke par excellence of the nineteenth century—the first choice of chefs and home cooks alike for such dishes as stuffed artichoke bottoms with duxelles and Madeira sauce; artichoke bottoms with spinach, anchovy paste, Mornay sauce, and Gruyère cheese; and artichoke bottoms with asparagus tips, stewed in butter and cream.

This bright green variety is notable for its shape, for unlike the more common globe artichoke with its tightly compacted leaves, the outer leaves of these artichokes open up like flowers, as wide as one's palm. When taken to market, they were often sold directly from the tall, oversize baskets used to transport them. A *vendeuse* (female vendor), working either from a sidewalk outside the main pavilions of Les Halles or inside the *pavillon de légumes*, would arrange the artichokes along the rim of her basket, showing them off to shoppers and passersby. Their long, firm stems intact, these

Artichauts de Paris seemed more like exotic flowers than vegetables. With the industrialization of agriculture, however, particularly in the years following World War II, production of this lovely artichoke plummeted to virtually nothing, its wonderful and novel shape adapting poorly to shipping. Fortunately for food lovers, farmers in the Val d'Oise today understand the need to preserve their culinary patrimony and have begun replanting this delicious, classic artichoke.

As for the vineyards in Auvers, change had not been kind. By 1890, the once flourishing viticulture in the region had practically ceased except on a very modest scale. Indeed, there were still small producers pressing their own grapes for personal consumption, a fact that Van Gogh captured in his *Old Vineyard with Peasant Woman* (F1624). The work depicts a farm outside the village with a good-size grape arbor; an *Auveroise* with a basket on her arm, is wearing a full-length skirt, probably made from a sturdy combination of cotton and linen. On her head is a *marmotte*, the traditional kerchief worn by peasant women of the time. As many *Auverois* did not have their own presses, a *pressoir ambulant* (portable press), which would go from farm to farm, was used, and for a nominal fee the press could be used for this preliminary step in wine-making.

Another work depicting viticulture in the village is *Vineyards with a Group of Houses* (F762). In a letter to his sister Wil, Van Gogh described the painting as "a landscape with vines and meadows in the foreground, and behind them the roofs of the village." Theo, too, was apprised of the work in a letter written on the 14th of June. "I have a vineyard study, that M. Gachet liked very much the last time he came to see me." The work features the most extensive view of vineyards Van Gogh produced in Auvers. The painting's predominantly green and yellow tones are accented by red tile roofs and red-orange poppies with patches of white scattered across the canvas. Unlike *Old Vineyard with Peasant Woman*, which presents an up-close perspective of the craggy, twisting vines and includes the figure of a woman, *Vineyards with a View of Auvers*, with its sweeping perspective of planted fields, stone houses, and low wooden fences, seems more to be about the interplay of man and nature as evidenced by agriculture, or in this case viticulture.

Writing about viticulture, Cazier notes, "Vines are no longer cultivated much in Auvers. There had been a lot, proportionally to our region, before the invasion of new diseases. The old plants were torn out and replaced by others which were more profitable." The reasons for the decline in grape-growing in the area have to do both with the phylloxera epidemic that devastated large portions of French vineyards beginning in the late 1870s and with economics.

A new tax that had been levied on the *Auverois* who produced their own wine proved a disincentive to replant. After pulling up the old, diseased plants, instead of replanting the vines, other more lucrative crops were planted.

The Ile-de-France, and particularly Argenteuil, with its climate very similar to that of Champagne, had historically furnished its best wines to royal tables in and around Paris, including Saint-Germain, Versailles, and Picardie to the North. The Argenteuil soil composition, chalky and fast-draining, was ideal for grape-growing. And the fact that that the region included three riverbank exposures (the Seine, Oise, and Marne) and hilly, protected terrain made the area well suited to wine-making.

Before the advent of shipping by rail during the nineteenth century, wine from Bordeaux and the Languedoc as well as many parts of Burgundy could not reach tables in the *région Parisienne* in any kind of mass quantity. Thus, the vineyards of Argenteuil, a mere sixteen miles by water and seven miles by rail from Paris, were the logical sources of wine for the region. It was these vineyards that supplied the many *guinguettes* (riverside cafes) and cabarets that sprang up along the Seine, Marne, and Oise rivers.

Rustic red and white *ginglets* were the perfect accompaniment to a *friture de Seine* or *friture de l'Oise*, small freshly caught river fish, dipped in batter and deep-fried, perhaps with a side of *pommes frites*. Wine sold (by the producers themselves) outside the city limits was not subject to taxation, so it was less expensive and consequently more available.

By the end of the century, however, there was much less need to produce one's own wine thanks to improved methods of transport and the industrialization of alcohol production. The price of wine, beer, cider, and distilled drinks dramatically fell and was affordable to almost everyone. Therefore, there is a bittersweetness to the vineyard scenes Van Gogh depicted in Auvers. Like his studies of thatched houses in the village, the vines represent a vanishing way of life.

In Auvers today, only one man still makes his own wine; octogenarian Maurice Giordano. A fourth-generation *Auverois*, this semiretired cabinetmaker and his family have been making wine for generations. His production of red *ginglet* made from baco grapes, an American variety developed in the late nineteenth century, is quite small these days. From a yield of five hundred liters ten years ago, his production has dwindled to a mere fifty liters today; still, it suffices for family and friends. On November 15 each year, his wine, along with others from neighboring villages, is judged and sampled at the *Fête de Saint-Martin* in nearby Pontoise. At the three-day fair, which dates back to the mid-twelfth century, it is a tradition to drink locally made wine as an accompaniment to *harengs grillés* (grilled herring), seasoned with a squirt of fresh lemon juice. The *ginglet* drunk at the fair recalls the centuries-old wine-producing heritage of Pontoise and the surrounding region. The grilled fish evokes the significance of fish during the *jours maigres* (fast days) in medieval France and the triangular-shaped, sixteenth-century *harengerie*, a large stone building devoted exclusively to the sale of saltwater fish and considered *une très belle poissonnerie* (a very nice fish store). Freshwater fish, much of it coming from the Oise, was sold by street vendors.

The grapevines that line the unpaved pathway leading to Giordano's picturesque, sprawling stone home are as much a part of his garden as his lemon and fig trees, cabbage, leek, and lettuce patches. For years, he also produced his own cider, which an old wooden press in a shed suggests. Giordano and his wife, a friend and neighbor of Dr. Gachet's now-deceased son and daughter, Paul and Marguerite (Clementine), are in many ways a living link to the Auvers of Van Gogh's time. In fact, a number of trinkets and minor paintings in their small dining room were once owned by Dr. Gachet.

In addition to wine, cider was a staple during Van Gogh's life. Cazier lists two thousand apples trees growing in and around Auvers. This fruit would have been shipped to neighboring markets and to Les Halles or pressed into cider and eau-de-vie. Some of the production was strictly for the use of the farmers, many of whom had their own cider presses and did not rely on *pressoirs ambulants*. Cider was also commercially produced in the area, supplemented with apples from Normandy. In general, there were two categories of cider, one known as *petit cidre,* with an alcohol content of only 3 to 4 percent, and the other *gros cidre,* with twice the alcohol level.

Beer was also a popular beverage, considered health-giving by many. It was high in calories yet lower in alcohol than wine, not to mention easy on the pocket. Cazier lists one *brasseur* (brewer) in Auvers and several warehouses where beer was stored and distributed. Considering the large number of agricultural workers in the area, especially migrant workers from Belgium, this is not surprising. For some Frenchmen, beer drinking was seen as a patriotic act, a gesture of solidarity for those living in Alsace-Lorraine, a region lost to the Germans during the Franco-Prussian War of 1870–71.

What is perhaps the most curious aspect of Auvers's agriculture at the turn of the nineteenth century was its mushroom caves; Cazier lists three mushroom producers in his inventory. As Paris's building trade flourished during the Second Empire—the population doubled between 1850 and 1880—stone was quarried from the hillsides closest to the capital and shipped, first by boat and later by rail, to Paris. Gypsum and other organic substances, used in the making of what came to be known as plaster of Paris, were also extracted.

The caves that resulted from these mining activities were well suited to mushroom-growing. Although some kind of mushroom cultivation had existed in Europe since classical times, it was only in the nineteenth century that the production of *champignons de couche* (cultivated mushrooms) was undertaken on any kind of large-scale basis. Auvers, which was quarried both for building stone and

freestone, had a number of mushroom caves in operation, the last of which was shut down only a decade ago. These small, white mushrooms were so popular at the *marchés* (markets) in Paris that they came to be known as *Champignons de Paris.* Postcards from Auvers, circa 1900, popularly featured views of mushroom caves, often with agricultural workers proudly displaying baskets of their freshly gathered *champignons.* Some mushroom growers transformed abandoned caves into living quarters, considered even then to be *habitations rustiques.* A small drawing featuring these curious dwelling places was sketched by Van Gogh.

The *Auverois* also raised two types of beets: one that was used as animal feed and the other for sugar production. The *betterave à sucre* (sugar beet) was a relative newcomer to France's agriculture. Despite the early experiments in 1590 of French botanist Olivier de Serres, who managed to extract a sugary syrup from beet roots, it was not until the Napoleonic Wars that the vegetable's potential as a source of sugar was fully realized.

Besides the crops that were commercially raised by farmers in Auvers, most *Auverois* had their own gardens, where a variety of vegetables and herbs were grown. In addition, there were fruit and nut trees, such as fig, cherry, apple, pear, and hazelnut, as well as a flock of chickens and most likely a rabbit hutch.

Cazier also lists geese, ducks, turkeys, guinea hens, pigeons, and pheasants. Farms also had workhorses, donkeys, cows, sheep, goats, and several pigs; the latter outnumbered the sheep five to one. This is not surprising considering the historic importance of pork in the diet of the French *paysan*, for what was more ubiquitous than a mixed vegetable soup with a chunk of salted or smoked pork thrown in for flavor?

The rhythm of Van Gogh's life in Auvers mirrored that of the men and women who toiled in the fields: up at daybreak and to bed by nightfall. Produce that was not sold to nearby restaurants, commercial canners, or various local *marchés* was taken by wagon to the vast central markets in Paris.

From the environs of Paris, men and women drivers would set out in the middle of the night to arrive at Les Halles by dawn for the opening activities. If they were lucky, they could quickly unload their mountains of green and purple cabbages, fiery red-orange carrots, blue-green kale, or freshly dug potatoes. Other times, amid a flurry of market activities—seafood auctions, wagons of turnips being discharged, a surprise visit from a market inspector, the assembling of fruit and flower displays, coffee served at one of the stalls—they had to work at finding the right customer. While food was shipped there via rail and boat from various regions throughout France, as well as

14 — Auvers-sur-Oise - Rue d'Hérouville

Barat à Auvers-sur-Oise

from other European countries, it was mainly the produce from the Ile-de-France localities closest to the capital, arriving by horse-drawn wagon, that furnished Les Halles with fresh fruits and vegetables.

It was in the weathered, sun-darkened faces of the women of Auvers who labored in the fields he loved that Van Gogh saw natural beauty. As was the case in Arles, Auvers provided the painter with subjects for his portraits—peasants in full-length cotton dresses, ambling down well-worn pathways or standing obligingly amid stalks of ripening wheat, their simple straw hats set off by colored ribbons. Whether captured in motion or seated, their gazes averted, Van Gogh depicted these hardworking women gracefully and with an immediacy and humanity that was all his own.

Cuisine du Terroir

The historic bounty of the Ile-de-France region serves as inspiration for the recipes that follow. The term *cuisine du terroir* translates literally as "the cuisine of the soil," suggesting that soil is an important determinant of taste. Implied, too, is the notion that soil components in one location differ from the soil composition of another region and these differences affect flavor. The local produce found in the auberge kitchen is grown less than thirty miles from Auvers-sur-Oise.

Scrambled Eggs with Asparagus

Oeufs Brouillés aux Asperges

This is a twist on the classic nineteenth-century spring dish, scrambled eggs with asparagus tips. Here the entire spear is used, making the presentation more visually engaging. It's an ideal dish for a brunch when asparagus are at their best in flavor and appearance.

SERVES 4

3/4 pound thin asparagus, rinsed, woody ends removed

3 tablespoons unsalted imported or organic butter

12 large eggs, lightly beaten

1/4 to 1/2 cup heavy cream (preferably organic)

3 tablespoons finely chopped chives

Salt and freshly ground pepper

Place the asparagus in the basket of a vegetable steamer and steam until tender, about 10 minutes. Immediately plunge into a bowl of ice water and drain. Pat dry. Cut each spear in half on a diagonal and cut the bottom of the spears into small dice.

Melt half of the butter in a medium skillet over medium heat. Add all the asparagus and cook, gently stirring, to heat thoroughly.

Meanwhile, melt the remaining butter in a large skillet. Add the eggs and whisk in a figure eight, making sure that the edges of the eggs don't stick. When the eggs are almost set, slowly pour in the cream, a little at a time, continuing to whisk briskly.

Sprinkle in the chives and whisk until the eggs are completely set. Divide the eggs and asparagus evenly among four plates, placing the spears and diced asparagus around the eggs or stack the spears so they lean against the eggs. Season with salt and pepper.

Pea Soup with Smoked Slab Bacon

Soupe de Pois Cassés au Lard

Two elements are the inspiration for this robust autumnal soup: One is a poetic rendition of the Auvers countryside featuring a field of peas in blossom, painted soon after Van Gogh's arrival. The other is that peas were a staple crop of the village during the artist's time. Pea soup lovers will enjoy the smoky flavor imparted by the slab bacon. For optimum flavor, make this soup early in the day so that the flavors meld by the time you enjoy it in the evening.

SERVES 6 TO 8

2 tablespoons vegetable oil
4 ounces diced smoked slab bacon (preferably nitrate-free) or pancetta
1 medium onion, diced
1 large carrot, cut into $1/2$-inch-thick slices
1 pound split peas, picked over and rinsed
9 cups water
3 leafy sprigs fresh thyme
2 bay leaves
Salt and freshly ground pepper

Heat the oil in a large pot over medium heat. Add the bacon, onion, and carrot and cook, stirring often, for 10 minutes. Add the peas, water, thyme, and bay leaves, stirring well to be sure that the peas don't stick to the bottom of the pan. Bring to a boil, skimming the foam from the surface. Reduce the heat and simmer, stirring occasionally, until the peas have completely dissolved, about $1^{1}/2$ hours. Remove the bay leaves and thyme sprigs.

Allow the soup to rest for a few hours before serving.

Reheat, adding a little water, chicken broth, or milk if the soup is too thick. Season to taste with salt and pepper.

147

Pumpkin Soup

SOUPE DE POTIRON

In fall and winter, the farmers' markets in Auvers and L'Isle Adam offer large orange crescents of pumpkin, ready to be taken home and baked or turned into pumpkin soup. Because the pumpkins can be quite large as vegetables go, selling the squash "by the slice" is a practical solution. Farmers' markets in this country sell tan-colored cooking pumpkins, cheese pumpkins (the favorite of most chefs), and the round, dark orange "sugar" or "pie" varieties, which are the most common. This velvety soup has a delicate flavor, with celery lending asparagus notes.

SERVES 4

8 tablespoons (1 stick) unsalted imported or organic butter
1 medium onion, cut into small dice
1 celery stalk, finely chopped
3 pounds pumpkin, peeled, seeds and strings scraped out, and flesh cut into 1-inch chunks
3 cups homemade chicken stock or low-sodium broth
2 leafy sprigs fresh thyme
1 cup half-and-half
¼ teaspoon fine sea salt
Freshly grated nutmeg

Melt the butter in a large pot over medium heat. Add the onion and celery and cook, stirring, until the vegetables soften, about 10 minutes.

Add the pumpkin, chicken stock, and thyme, and bring to a boil. Reduce the heat and simmer until the pumpkin is very soft, about 45 minutes. Discard the thyme.

Puree the mixture in batches in a blender or food processor. Return the soup to the pot and whisk in the half-and-half and salt. Heat for an additional 5 minutes. Ladle the soup into individual bowls and grate a little nutmeg over the top.

Mâche, Pine Nut, and Raw Foie Gras Salad
Salade de Mâche et Pignons de Pin au Copeaux de Foie Gras Cru

In this light but highly satisfying salad, three distinct textures are combined with delightful results. The slightly crunchy mâche contrasts with the dense buttery smoothness of the raw foie gras, which in turn contrasts with the almost smoky undertones of the pine nuts. Some specialty food stores carry raw foie gras in small individual packages weighing less than half a pound.

SERVES 4

House Vinaigrette
2 tablespoons sherry vinegar
2 teaspoons Dijon mustard
1/2 teaspoon salt
1/4 teaspoon freshly ground pepper
1/4 cup peanut oil
2 tablespoons walnut oil
2 tablespoons extra virgin olive oil

Salad
1/3 pound mâche or mesclun
1/4 cup pine nuts
6 ounces cold raw foie gras
Coarse salt
Toasted whole-grain bread (optional)

To prepare the vinaigrette, put the vinegar, mustard, salt, and pepper in a small bowl and whisk until smooth. Gradually add the oils, whisking until emulsified.

To prepare the salad, place the mâche in a bowl and toss with about 3 tablespoons of the vinaigrette. (The greens should only be lightly seasoned, not coated with the vinaigrette.) Divide evenly among four plates and sprinkle 1 tablespoon of pine nuts over the top.

Dip a long, sharp, thin-bladed knife in hot water and cut the foie gras into paper-thin slices. Place about 6 slices foie gras on top of each salad. Sprinkle with a few grains of coarse salt and serve with toasted whole-grain bread, if desired.

Rosemary Roast Chicken with Garlic Confit and Potatoes

POULET RÔTI AU ROMARIN, AIL CONFIT ET POMMES DE TERRES

Although largely ornamental, the rosemary bushes that grow on the grounds outside the auberge kitchen do on occasion come in handy, as was the case when this chicken recipe was made late one Sunday afternoon. Moist and tender, this simple roast chicken and potato dish will delight garlic lovers with its sweet pan-roasted garlic cloves and garlic-infused oil.

SERVES 4 TO 6

1 cup unpeeled garlic cloves
1 1/2 cups peanut oil

CHICKEN
1 free-range roasting chicken (about
 4 pounds), rinsed and patted dry
6 leafy sprigs fresh rosemary
2 to 3 leafy sprigs fresh thyme
2 to 3 tablespoons unsalted imported
 or organic butter, cut into pieces
1/2 carrot, cut into thirds
1/2 onion, coarsely chopped

PAN-FRIED POTATOES WITH
GARLIC CLOVES
1 1/2 pounds bintje, fingerling, or
 other small potatoes, scrubbed
2 tablespoons peanut oil
Reserved garlic cloves from the garlic oil
1 tablespoon chopped fresh
 rosemary leaves

Preheat the oven to 375° F.

To prepare the garlic oil, place the garlic cloves and peanut oil in a small saucepan and cook over low heat for about 45 minutes. Remove from the heat. When cool, strain out the garlic cloves and reserve. Transfer the oil to a container and store in a cool place or in the refrigerator for up to several weeks.

To prepare the chicken, place the chicken and 4 of the rosemary sprigs in a roasting pan. Place the remaining rosemary sprigs inside the cavity and scatter the thyme sprigs in the bottom of the pan. Pour 1/2 cup of the garlic oil over the chicken and sprinkle the butter on top of the chicken. Roast for 30 minutes, then baste with the oil and butter; add the carrot and onion to the pan. Baste every 20 minutes or so until the chicken is fully cooked, about 1 1/2 hours.

Meanwhile, to prepare the potatoes, place them in the basket of a vegetable steamer and steam until a sharp paring knife easily pierces the flesh, 25 to 30 minutes. Allow to cool slightly.

Heat the peanut oil in a large skillet over medium-high heat. Add the potatoes and brown evenly. Add the reserved garlic cloves and heat through. Sprinkle with the chopped rosemary. Place the chicken on a serving platter and surround with the potatoes and garlic.

Medley of Exotic Mushrooms with Hazelnuts

CASSOLETTE DE CHAMPIGNONS AUX NOISETTES

This fall/winter dish evokes Auvers's past as an important mushroom producer. The combination of rich, earthy mushrooms with hazelnuts and hazelnut oil is out of the ordinary. Try it as an appetizer or with a variety of egg dishes—scrambled eggs, omelettes, or quiche.

SERVES 4 TO 6

1 1/2 pounds mixed mushrooms, such as white, cremini, chanterelle, trumpet-of-death, and hen-of-the-woods
3 tablespoons unsalted imported or organic butter
1 tablespoon finely minced chives
Hazelnut oil
2 tablespoons finely chopped hazelnuts
Salt and freshly ground pepper

Briefly rinse the mushrooms in a large bowl of cold water and transfer to a colander to drain. Cut the mushrooms into bite-size pieces.

Melt the butter in a large skillet over medium-high heat. Sauté the mushrooms until soft. Sprinkle in the chives and cook for a few minutes longer. Remove from the heat.

Divide the mushrooms equally among the plates. Drizzle about 1/4 teaspoon hazelnut oil over each serving and sprinkle a generous teaspoon of chopped hazelnuts on top. Season with salt and pepper.

(pictured on page 135)

157

Chicken Breasts with Savoy Cabbage and Smoked Bacon

SUPRÊMES DE VOLAILLE AU CHOUX ET LARD

Inspired by two very common ingredients in the kitchen of the *Auverois* during Van Gogh's time—cabbage and *lard* (a pork product very like pancetta)—this homey chicken dish is a welcome winter night's dinner. The delicately flavored sauce, with bits of pan-crisped pancetta and a touch of white wine, works well with the lightly steamed cabbage and the moist baked chicken. Substitute a thigh and drumstick for the breast, if desired.

SERVES 4

2 to 3 tablespoons peanut oil

4 split chicken breasts, rinsed and
 patted dry

1/4 teaspoon fine sea salt

Freshly ground pepper

1 1/2 ounces diced pancetta

1 medium carrot, chopped

1/2 cup homemade chicken stock or
 reduced-sodium broth

1/4 cup white wine

1 cup heavy cream
 (preferably organic)

1 large egg yolk

Small savoy cabbage, cored and sliced
 into 1/2-inch-wide strips

Preheat the oven to 375° F.

Heat 2 tablespoons of the oil in a large ovenproof skillet, over medium heat. Place the chicken in the skillet, skin side down, and cook until brown, about 5 minutes per side. Season with salt and pepper.

Transfer the skillet to the oven and bake for 20 minutes, or until the chicken is cooked through. Remove from the oven, cover loosely with aluminum foil, and set aside until needed.

Meanwhile, heat the remaining peanut oil in a medium skillet over low-medium heat; cook the pancetta until golden, about 10 minutes. Add the carrots, chicken stock, and wine. Stir in 3/4 cup of the heavy cream. Simmer for 5 minutes;

transfer the sauce to a blender or food processor. Puree until smooth, then return the sauce to the pan and heat through.

Mix together the egg yolk and remaining cream in a cup. When the sauce is hot, add the egg-cream mixture and stir until the mixture thickens, about 5 minutes. Do not allow to boil. Remove from the heat and keep warm.

Place the cabbage in the basket of a vegetable steamer. Set over boiling water, cover, and steam until just tender, about 5 minutes. Put a serving of cabbage on each plate and place a chicken breast on top or alongside. Spoon about 1/4 cup sauce over the cabbage and chicken breast.

Lamb Stew with White Wine and Provençal Olives
Navarin d'Agneau aux Olives

This succulent, fork-tender lamb stew honors Van Gogh's love of olives and olive orchards. If Provençal Nyons olives are not available, substitute small black olives, preferably with the pit in. Just let your guests know so there are no surprises. Serve with the Rice Pilaf (page 123) or broad egg noodles tossed with butter or olive oil, and buttered steamed carrots or turnips. And though not traditional at the Auberge Ravoux, the dish also goes very well with couscous (semolina).

SERVES 6

3 tablespoons extra virgin olive oil

2 1/2 pounds stewing lamb, cut into 1-inch chunks (ask your butcher for a few pounds of bones)

Salt and freshly ground pepper

1 1/2 cups unpitted green or black olives

1 cup dry white wine

1 quart Lamb Stock (page 118), heated

3 leafy sprigs fresh thyme

1 1/2 pounds plum tomatoes, quartered lengthwise and seeded

Heat 2 tablespoons of the olive oil in a large skillet or sauté pan over medium-high heat. Season the lamb with salt and pepper. Brown the meat in batches, adding more oil as needed. Transfer the lamb to a heavy-bottomed casserole and set aside until needed.

Add the wine to the pan and deglaze, gently scraping up the browned bits that are stuck to the pan. Add the wine to the meat and add the hot Lamb Stock. Add enough hot water to cover the meat completely. Add the thyme sprigs and simmer over low heat for 1 hour. Add the tomatoes and simmer until the lamb is very tender, about 1 1/2 hours longer. During the last hour of simmering, add the olives.

NOTE: As is the case with all stews, the flavor improves if allowed to sit for several hours before reheating and serving. Making this dish a day ahead makes a world of difference.

159

Tuiles with Lemon Cream and Fruit

Craquelins au Crème Citron, Fruits Rouges

In this elegant two-step recipe, a pale yellow lemon cream is sandwiched between delicate, crackly tuiles, which resemble lace cookies. Any type of berries—raspberries, strawberries, blueberries, red or white currants, or blackberries—can be used for the filling. The coulis is optional. Make it if you wish to give the dessert a very finished appearance. You will have leftover tuiles and lemon curd, both of which hold well for another occasion.

SERVES 6

TUILE BATTER

$1^{1}/_2$ cups confectioners' sugar

$^{1}/_3$ cup all-purpose flour

7 tablespoons unsalted imported or organic butter, melted

$^{1}/_3$ cup fresh orange juice, strained

Finely chopped zest of 1 orange (preferably organic)

$^{1}/_4$ cup finely chopped almonds

LEMON CREAM

$2^{1}/_4$ cups heavy cream (preferably organic)

$^{1}/_2$ cup fresh lemon juice

$^{1}/_2$ cup granulated sugar

5 large egg yolks

$1^{1}/_2$ tablespoons cornstarch

30 raspberries or 6 strawberries, hulled and quartered

To prepare the tuile batter, combine the sugar and flour in a small bowl. Add the melted butter and mix until smooth. Add the orange juice and stir to blend. Mix in the orange zest and almonds. Cover the bowl with plastic wrap and refrigerate for 2 hours, or until needed. (You can make the batter up to 1 day ahead.)

While the batter rests, prepare the lemon cream. Pour $1^{1}/_2$ cups of the heavy cream into a metal bowl and refrigerate. Place the remaining heavy cream and the lemon juice in a medium saucepan. Bring to a gentle boil over medium heat, stirring occasionally. Put the sugar and egg yolks in a bowl and whisk until pale and smooth. Sprinkle in the cornstarch and whisk again. Slowly add the hot cream, whisking constantly until well mixed.

Stir the mixture back into the pan and cook over medium heat, whisking in large figure eights until the consistency of pudding, about 2 minutes. Transfer the lemon cream to a large bowl, and cover the surface of the lemon cream with plastic wrap or wax paper. Refrigerate until needed.

Once the lemon cream mixture has completely cooled, whip the heavy cream until soft peaks form. Fold the whipped cream into the lemon cream until blended. Cover and refrigerate up to 3 days. Makes about 3 cups.

To bake the tuiles, preheat oven to 375° F. Line a sturdy cookie sheet with a Silpat baking mat (see Note).

Drop about $1^{1}/_2$ teaspoons of batter onto the prepared baking sheet for each tuile, spacing them a minimum of 8 inches apart; they will spread during baking. You may only have room on your cookie sheet to make 4 tuiles at a time.

Bake for about 8 minutes, or until the edges are lightly browned and the tuiles are fully cooked and golden. Remove from the oven and allow to sit for a minute or two before "peeling back" the baking mat to remove the tuiles. Gently transfer the cookies to a cool, clean surface to harden. (The tuiles can be stored in an airtight container for up to 5 days.)

MAKES ABOUT 3 DOZEN

(continued on page 162)

To assemble the craquelins, place 1 teaspoon of the lemon cream in the center of a serving plate. It will anchor the tuile in place. Center a tuile on top of the cream. Place a tablespoon of the cream in the center of the tuile. Place 4 raspberries or strawberry quarters at 12, 3, 6, and 9 o'clock in the cream. Place another tuile on top. In the center of the tuile, put a small dollop of lemon cream and place a raspberry in the center.

NOTE: A Silpat, or nonstick silicone mat, is recommended for baking the tuiles because they can be tricky to work with. Many kitchenware stores carry them. These thin liner mats, a pastry chef's best friend, are ubiquitous in restaurant kitchens today.

COULIS

3 ounces strawberries, hulled
 and quartered
1/2 cup raspberries
1/3 cup granulated sugar
1/2 cup cold water

Combine the strawberries, raspberries, sugar, and water in a small saucepan and bring to a boil. Simmer for 5 minutes; remove from the heat and cool slightly. Transfer to a blender and puree. Strain through a very fine sieve, pressing the fruit with the back of a wooden spoon to extract the juice. Discard the seeds. Allow the coulis to cool completely before refrigerating. It can be made a day ahead.

To use the coulis, spoon enough into the well of each serving plate to cover in a thin layer. Then proceed to assemble the craquelins.

Rhubarb Compote
COMPOTE DE RHUBARBE

Rhubarb is incredibly simple to prepare, and its presence is a sure sign that summer is on its way. Serve the compote alone, with the Rice Pudding Ravoux (page 128) or Honey Madeleines (page 203).

SERVES 4 TO 6

1 1/2 pounds rhubarb
1 cup sugar

Rinse the rhubarb and remove any stringy outer "skin" using a sharp paring knife. Cut the rhubarb into 1-inch pieces and put in a bowl. Sprinkle 1/2 cup of the sugar over the top and refrigerate, covered, for at least 8 hours.

Using a slotted spoon, transfer the rhubarb to a saucepan and discard the liquid in the bowl. Add the remaining sugar to the rhubarb and mix well with a wooden spoon.

Cook over very low heat until very soft, about 30 minutes, stirring from time to time to prevent the rhubarb from sticking to the bottom of the pan. Remove from the heat and allow to cool fully before serving.

Grandmother's Apple Cake

Gâteau de Pommes Grand-Mère

Sautéing the apples in butter (along with a splash of Calvados) before adding them to the batter lends an extra dimension of richness to this very simple apple cake. Enjoy a wedge with a cup of coffee in the morning or as a welcome afternoon snack with tea.

SERVES 6

2 tablespoons unsalted imported or organic butter

2 large Golden Delicious, Jonagold, or other baking apple, peeled, cored, and coarsely chopped

1 1/2 tablespoons Calvados (apple brandy)

1 1/4 cups sugar

2 teaspoons ground cinnamon

2/3 cup plain yogurt

2 cups all-purpose flour

1 teaspoon baking soda

1/2 cup vegetable oil

3 large eggs

Preheat the oven to 350° F.

Generously grease an 8-inch round cake pan (no need to grease if pan is nonstick).

Melt the butter in a medium skillet over medium-high heat. Sauté the apples, tossing occasionally, until golden brown, 5 to 7 minutes. Stir in the Calvados, 1 tablespoon of the sugar, and the cinnamon. Set aside until needed.

Whisk together the yogurt and the remaining sugar in a large bowl, until very smooth, about 2 minutes. Combine the flour and baking soda, then add the oil and eggs, whisking well after each addition. Stir the apple pieces into the batter.

Pour the batter into the prepared pan, spreading it evenly. Set on a sturdy baking sheet and bake for 45 to 55 minutes, or until a toothpick inserted in the center comes out clean. Allow to cool on a wire rack.

NOTE: The cake is best made several hours before serving, or better yet, the night before.

Apple Tartlets with Caramel Sauce
Tartelettes aux Pommes, Sauce Caramel

Perhaps the inspiration for caramel apples was a warm, fragrant apple tart drizzled with caramel sauce, something like the one featured here. Served plain, for the purists, or accompanied by the pale amber dessert sauce, these individual apple tarts are delightfully crisp on the bottom and moist and tender on top.

SERVES 6

PUFF PASTRY

Although puff pastry seems like a time-consuming, labor-intensive pursuit, it's actually far easier to make than it appears. The dough needs to be rolled out and refrigerated several times, but the work can be spaced out over a day. And because the dough freezes well, once the work is done, you can enjoy the fruits of your labor whenever you like. If puff pastry is really not your thing, good-quality puff pastry is usually found in the frozen section of specialty food stores.

4 cups all-purpose flour, plus additional
 for sprinkling
2 teaspoons fine sea salt
1 1/4 cups ice water
3/4 pound (3 sticks) unsalted imported
 or organic butter

Put 3½ cups of the flour in a large bowl. Refrigerate the remaining ½ cup. Place the salt in a cup and add 2 tablespoons hot water. Mix well to dissolve the salt. Add the ice water to the flour a little at a time, slowly stirring it in. Stop adding water as soon as the dough begins to hang together in a ragged, spongy mass. Using your hands, shape the dough into a loose ball and turn out onto the work surface. Shape a bit more, if necessary, and wrap in plastic wrap or wax paper; refrigerate for at least 1 hour.

Remove the butter from the refrigerator and unwrap it. Using a rolling pin, beat the butter a few times to soften it. Sprinkle the butter with the ½ cup chilled flour and using your hands or a rolling pin, knead until the flour is well incorporated. (If your hands get warm, dip them in cold water for 30 seconds, dry well, and continue kneading.) During this process the butter will soften, but it should not melt.

Form the butter into a rectangle about 5 x 10 inches. Set aside until needed.

Remove the dough from the refrigerator. Lightly dust the work surface with flour and roll out the dough into a square roughly measuring 12 x 12 inches. Fold the dough in half, to make a rectangle that is 6 x 12 inches. Place the butter rectangle on top of the dough and fold a long side over, enclosing the butter rectangle. Pinch the dough edges to seal.

Lightly sprinkle the dough with flour and gently roll into a rectangle, about 20 x 24 inches. Fold a long side up to the middle, then fold the other long side on top of it, as though folding a letter, forming a narrow rectangle.

Give the dough a quarter turn and roll it out again to form a rectangle that is about 20 x 24 inches. Repeat the process of folding the dough.

Press two fingers into the dough to leave small depressions: a reminder that you have made 2 out of 6 turns. Rewrap the dough and refrigerate for at least one hour.

Remove the dough from the refrigerator and unwrap. Allow it to sit for 10 to 15 minutes if dough is very cold.

Lightly flour the work surface and roll out the dough as before. Fold (as you would a letter) and give the dough a quarter turn. Repeat and mark the dough with 4 depressions. Wrap the dough and refrigerate for another hour.

Remove the dough from the refrigerator and repeat as above. After the 6th turn, the dough is ready. You can divide the dough in half at this point and freeze part of it.

Since the yield is about 2 pounds of puff pastry, there is enough for all of the desserts in this book—the Tarte Tatin, the Iced Matchsticks, and the Apple Tartlets with Caramel Sauce.

APPLE TARTLETS

5 large Golden Delicious apples, peeled and cored
Juice of $1/2$ lemon
$1/2$ pound puff pastry
1 large egg yolk, beaten
3 tablespoons unsalted imported or organic butter, cut into very small pieces
2 tablespoons sugar

CARAMEL SAUCE

1 cup sugar
$1/4$ cup water
$1/3$ cup heavy cream (preferably organic)

Quarter the apples and cut into 1/3-inch-thick slices. Put in a bowl, and toss with the lemon juice to prevent browning.

Preheat the oven to 425° F.

Roll out the puff pastry to a thickness of $1/4$ inch. Using a small saucer or 4-inch ring as a guide, cut out 6 rounds of pastry. Transfer the pastry rounds to a nonstick baking sheet or one lined with parchment paper or a Silpat baking mat. Using a pastry brush, lightly brush the pastry with the egg yolk. Arrange the apple slices in concentric circles over the pastry starting at the edge.

Place 4 to 5 pieces of the butter on top of each tartlet and sprinkle each with 1 teaspoon sugar. Bake for 25 to 30 minutes, or until the apples are lightly golden and the pastry has risen and is fully cooked through.

Allow to cool before serving. (If you wish to serve the tartlets warm, reheat them in a 300° F. oven for 10 to 15 minutes.)

Meanwhile, to prepare the caramel sauce, combine the sugar and the water in a small heavy saucepan. Cook over medium-high heat, stirring with a wooden spoon to dissolve the sugar. Continue stirring, until the sugar caramelizes, about 20 minutes. Slowly pour in the cream (it will bubble up). Continue stirring until smooth and blended, about 3 minutes. Remove from the heat. Transfer the sauce to a bowl and set aside until needed.

When ready to serve, reheat the sauce over low heat, if desired.

167

Mixed Berries with Vanilla, Linden Flower, and Mint Syrup

La Nage de Fruits Rouges

There are fruit salads, and then there is this unique infused three-berry fruit dessert. What makes this special is that the raspberries, strawberries, and blueberries retain their individual flavors even after absorbing the vanilla-scented herbal syrup. A delightful way to end a summer meal.

SERVES 6

Syrup

1/3 cup plus 1 tablespoon sugar

1 3/4 cups water

2 tea bags of linden flower infusion or chamomile

2 leafy sprigs mint, plus additional sprigs for garnish (optional)

1/2 vanilla bean, split and scraped

Fruit

1 pint strawberries

1 pint raspberries

1 pint blueberries

To prepare the syrup, combine the sugar and water in a small saucepan. Add the tea bags, mint, and vanilla bean and seeds. Bring the mixture to a boil. Reduce the heat slightly and cook at a low boil for 5 minutes, stirring occasionally with a wooden spoon.

Remove from the heat and allow to steep for 30 minutes. Discard the tea bags, vanilla bean, and mint. Transfer the syrup to a jar and refrigerate until ready to serve.

About 30 minutes before serving, briefly rinse the strawberries, then hull and quarter. Briefly rinse the raspberries and blueberries. Divide the berries among individual dishes. (Shallow soup bowls works best.) Pour 1/4 cup of the herbal syrup over each serving. Garnish each with a sprig of fresh mint, if desired.

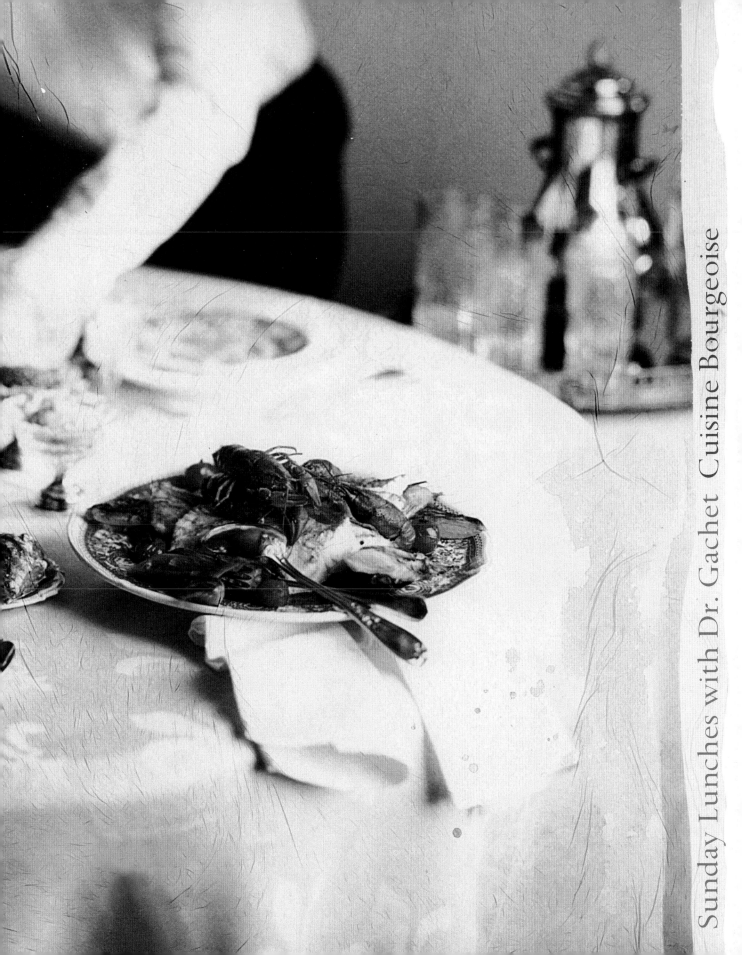

Sunday Lunches with Dr. Gachet

ON THE 4TH OF JUNE, two weeks after settling into his new home at the auberge, Van Gogh wrote a letter to Theo, describing Dr. Gachet's portrait on which he was already at work, ". . . the head with a white cap, very fair, very light, the hands also a light flesh tint, a blue frock coat and a cobalt blue background, leaning on a red table, on which are a yellow book and a foxglove plant with purple flowers. It has the same sentiment as the self-portrait I did when I left for this place."

In the same letter, Van Gogh mentions his plans to do a portrait of Gachet's nineteen-year-old daughter, Marguerite, whom he believes his sister-in-law, several years her senior, will like very much. Expressing his hope that Theo, Johanna, and baby Vincent will be able to spend time with him in Auvers during their summer holidays, Van Gogh suggests they take a room at the inn where he is staying.

Elsewhere in the letter, Van Gogh describes the nature of his regular visits to the Gachet home: "I feel that I can do not too bad a picture every time I go to his house, and he will continue to ask me to

". . . it is rather a burden for me to dine and lunch there, for the good soul [Dr. Gachet] takes the trouble to have four-or five-course dinners. . . .
The thing that has somewhat prevented me from protesting against it is that it recalls the old times to him when there were those family dinners which we ourselves know so well."

Letter from Vincent to Theo, June 1890

car cela n'a certes pas d'anormal fort d'y trouver à redire

pour lui comme pour moi. Ce qui m'a un peu retenu
c'est que je vois que lui cela lui rappelle les jours d'autre-
foi où l'on faisait des diners de famille qu'enfin nous
connaissons bien aussi

Mais l'idée moderne de manger un, tout au plus
deux plats est pourtant certes un progrès et un
bien retour à l'antiquité vraie.

Enfin le père Gachet est beaucoup mais beaucoup
comme toi et moi. J'ai lu avec plaisir dans ta lettre
que M. Peyron a demandé de mes nouvelles en t'écrivant
je vais lui écrire que cela va bien ce soir même car
il était très bon pour moi et je ne l'oublierai certes
pas. Desmoulins celui qui a des tableaux japonais
au champ de mars est revenu ici et j'espère bien le rencontrer
Qu'est ce qu'a dit Gauguin du dernier portrait d'arlésienne
qui est fait sur son dessin. Tu finiras par voir je crois
que cela est une des meilleures choses les moins mauvaises que
j'ai faites. Gachet a un Guillaumin femme nue
que je trouve fort belle il a aussi un très ancien portrait de guillaumin
par lui très différent du nôtre, noir mais intéressant

Mais sa maison tu verras c'est plein plein comme un
marchand d'antiquités de choses pas toujours intéressantes
c'est même terrible. — Mais dans tout cela il y a ceci de bon
que pour arranger des fleurs ou des natures mortes il y aurait
toujours de quoi. J'ai fait ces études pour lui pour lui
montrer que si ce n'est pas un cas où on lui
payerait en argent nous le dédommagerons pourtant
toujours de ce qu'il ferait pour nous.

Connais tu une eauforte de Bracquemond le portrait de comte
c'est un chef d'oeuvre.

Il me faudrait aussitôt que possible 12 tubes
blanc de zinc de Tasset et 2 tubes moyen laque
 geranium.

dinner every Sunday or Monday. But though it is pleasant to do a picture there, it is rather a burden for me to dine and lunch there, for the good soul takes the trouble to have four- or five-course dinners, which is as dreadful for him as for me—for he certainly hasn't a strong digestion. The thing that has prevented me from protesting against it is that it recalls the old times to him when there were those family dinners which we ourselves know so well." If these meals *en famille* were stressful for the artist, who cared little about the food he ate as long as it was plain, healthful, and of reasonably good quality, they were most enjoyable for the doctor, who liked nothing better than to gather around a well-laid table to eat, drink, and exchange ideas about art, politics, free love, and homeopathy.

From Van Gogh's letters, we learn that the painter dined at the doctor's home once or twice a week, in the garden weather permitting. One can assume that if Van Gogh painted at Gachet's in the morning or mid-afternoon, he was served refreshments of one kind or another. Thus, on a certain level, feeding the painter was part of the doctor's therapy. A good meal that stimulated conversation nourished both body and spirit. And having Van Gogh at his table ensured that the painter was in the company of others for at least a part of the day.

In his letters to Theo, Van Gogh relates Gachet's comments about the importance of good nutrition, so it is obviously something the two men discussed. Gachet well understood how poor diet and excessive drink often characterized a painter's lifestyle. Over the years, he had come to know many struggling artists, who often joined him at his table in Auvers. On several occasions, the doctor treated members of the Pissarro family, as well as Cézanne and others, in exchange for a drawing or canvas. This, too, was the understanding with Van Gogh. If he needed the doctor's help in a moment of crisis, he could pay him with a painting.

This arrangement must have been reassuring to the painter, for he wrote to his mother explaining the situation. Though Van Gogh was pleased with his

decision to return to the north, and he seemed to be doing reasonably well in the beginning (no one at the auberge suspected he was ill), he was still clearly concerned about the prospect of being carried off by the police in the event of a breakdown, only to be forcibly committed somewhere. If the copious lunches served at the Gachets were too rich for him, his presence at their table was a small price to pay for living and working freely in Auvers.

Gachet's residence, roughly a twenty-minute walk from the auberge, was a plain-looking, solidly built home, which was constructed in 1854 from locally quarried stone. At the time of purchase the doctor was living in Paris, where his medical practice was based, with his wife and young daughter. Pissarro, whom Gachet knew from artists' cafés in Montmartre, as well as through a friend living in Auvers, suggested the Val d'Oise region when the doctor decided to relocate his family outside the city. Like many Parisians at the time, Gachet acquired a second home within commuting distance of the capital. The doctor hoped that in Auvers, Madame Gachet might be cured of tuberculosis, and his children raised in the fresh air and sunshine. In spite of the salubrious environment, however, Madame Gachet died three years later.

Madame Chevalier had been hired a year before Madame's death to look after the children and raise

them as if her own. With Gachet working in Paris three days a week, it was she who ran the household, supervising the housekeeping duties and overseeing the work in the kitchen.

For the everyday needs of the family, dairy products, bread, meat, poultry, *charcuterie* products, pantry staples, and fresh fruits and vegetables were procured from merchants right in Auvers. A chicken coop, which stood in a corner of the garden, ensured a steady supply of the freshest eggs, and a *jardin potager* furnished the kitchen with herbs such as thyme, chives, bay leaves, rosemary, and parsley.

Cooking was done on a stout, black cast-iron range, whose well-polished copper handles shone in an otherwise plainly furnished kitchen. A sideboard contained a variety of cooking utensils, and kitchen duties were carried out on a sturdy wooden worktable: peeling and chopping vegetables for a *potage printanier,* slicing and stoning fruit for a *compôte d'abricot,* boning lamb for a Sunday roast, stirring cake batter for a *gâteau au chocolat,* and rolling out pastry for a *tarte à l'oignon.*

Off the kitchen was a small, squarish dining room, which must have been striking in appearance, its walls completely covered with paintings of varying styles and dimensions. In the center of the room stood a round dining table of well-polished walnut, around which were arranged four Louis Philippe chairs. It is

not known whether Van Gogh actually dined in this room amid the Cézannes, Pissarros, Guillaumins, and the huge copy of a work after Rubens. As the dining room was generally reserved for family meals, larger gatherings took place in the *salon,* an oversize rectangular living room.

In that same letter of the 4th of June, Van Gogh describes the doctor's cluttered home as resembling an antique dealer's: full of furniture and small objects he doesn't find especially interesting (apart from the paintings). In the letter, he picks up where he left off in an initial dispatch from Auvers, describing Gachet's house as "full of black antiques, black, black, black. . . ." This was a reference to the heavy, dark, enormously popular Neo-Renaissance–style carved wooden chairs, tables, and secretary, as well as the many bibelots and knickknacks that filled the house. In truth, the overstuffed home that had shocked Van Gogh was actually very much in the style of the time.

On Sunday the 8th of June, Theo, Jo, and baby Vincent journeyed by train from Paris to Auvers, arriving at eleven twenty-six at Chaponval, Auvers's other train station. Van Gogh was there to greet his family with a horse-drawn carriage arranged by the doctor, and carried with him a tiny bird's nest as an offering to his namesake. Though Gachet's home was

not far from the station, the streets leading up to his house were steep and winding, and the party would have to climb the twenty-two stone steps that led from the street to the garden above.

The rectangular red wooden table was set for company. There were seven for lunch that Sunday—the three Gachets, Madame Chevalier, and the Van Goghs, not counting baby Vincent. One can only conjecture who sat next to, or across from, whom. No doubt much of the conversation centered on art—Van Gogh's latest works, life at the Boussod et Valadon gallery where Theo was an art dealer, and, not unexpectedly, the paintings in the doctor's collection. Did Paul Gachet listen in silence out of deference to his father as the three men talked among themselves? Whatever the case, the doctor's son would make mental notes of the meeting and, years later, play a major role in safeguarding the work and memory of the special luncheon guest.

An atmosphere of joy generated by fine food, excellent wine, and freely flowing conversation reigned that day, as later recounted by Johanna, Paul Gachet, and Van Gogh. At meal's end, the two families went for a walk, making a stop in all likelihood at the Auberge Ravoux. There Van Gogh could show Theo paintings he had described in his

CHAPONVAL. — *Boucherie Henri-François*

letters. Two days after their meeting, he wrote to his brother and sister-in-law, "Sunday has left me [with] a very pleasant memory, and I hope that we shall see each other again. . . . as for taking this house or else another, this is how it is. Here I pay one franc a day for sleeping, so if I had my furniture the difference between 365 francs and 400 would be no great matter, and then I should very much like you two to have a pied-à-terre in the country along with me. . . ."

For Van Gogh, there would be few other meals shared with the Gachets that summer. Exactly two weeks after Theo and Johanna's visit, a very special double birthday party was organized for the doctor's son and daughter. On June 21, the summer solstice, Marguerite turned twenty-one and her brother

seventeen; the birthday celebration was held the following day in the garden. In his account of Van Gogh's seventy days in Auvers, Paul Gachet recalls Van Gogh's interest in the little place cards that embellished the table that Sunday. To the left of where the doctor has written "Monsieur Vangogh 22 Juin 1890" on the inviting little card, a woman in a formal, floral kimono stands before a tall, narrow screen behind which a willowy branch of flower blossoms is visible; beside her is a small lacquered cabinet. It is little wonder that the small paper place cards caught the painter's eye. He had long admired Japanese art and had even experimented with its aesthetics and principles in his landscapes and portraiture.

Although Van Gogh's initial encounter with Dr. Gachet on his first day in Auvers had been less than successful, through his letters and his portraits of the doctor and his daughter it appears that their relations, at least for a time, were quite good. During the latter half of the twentieth century, the enigmatic person of Dr. Gachet has won his share of admirers and detractors. What counts ultimately is that thanks to Dr. Paul-Ferdinand Gachet, a struggling and desperate Vincent Van Gogh went to Auvers, where he could once again live freely and render the portraits of those who entered his life. "What impassions me most—much, much more

177

than anything in my *métier*—is the portrait, the modern portrait," he wrote to his sister Wil soon after his arrival in Auvers.

Van Gogh went to Auvers seeking the tranquility he sorely needed. For a time, that is what he found. Today the same peacefulness can still be experienced by the visitor. The hillsides immortalized by Van Gogh remain, as do the old stone homes, the church, and the railroad station. More importantly, so does the Auberge Ravoux, at the end of Auvers's main street, opposite the old town hall. The simple, unpretentious artists' café still welcomes travelers daily for lunch and dinner, as it has since the time of Vincent Van Gogh.

Cuisine Bourgeoise

Plainly put, *cuisine bourgeoise* was a grand, elaborate kind of cooking commonly found in the homes of the well-to-do in nineteenth-century France. While *cuisine populaire* necessarily embraced economy, *cuisine bourgeoise* celebrated luxury. Frequently more labor-intensive than *cuisine populaire,* it was adapted to the lifestyle of the bourgeoisie who most likely had a cook and very possibly other household domestics in their employ, especially by the turn of the century. Fine napery, abundant glassware, and a wide array of flatware, dishware, and serving dishes—in porcelain and silver—graced their elegant, carefully laid tables and filled their dining room buffets.

Ingredients were more costly than those used in *cuisine populaire* either because they had to be shipped long distances, in the case of saltwater fish and shellfish, or because the cuts and kinds of meat and poultry—saddle of lamb, filet mignon, duckling, quail—were prime.

A Day in the Country
for Theo, Johanna, and Baby Vincent Willem

Evoking the *plein-air* luncheon the Van Goghs attended at
the home of Dr. Gachet, this menu is composed of the sort
of dishes that might have been served at such an informal,
though nonetheless proper, Sunday lunch.

Asparagus with Hollandaise Sauce
ASPERGES TIÈDES ET SA SAUCE HOLLANDAISE

~

Fillet of Striped Bass with Panfried Leeks and Beurre Blanc
LE DOS DE BAR AUX POIREAUX RÔTIS BEURRE BLANC

Roast Duck with Chanterelle Fricassee
CANETTE RÔTIE ET SA FRICASSÉE DE GIROLLES

~

Cherry Clafouti
CLAFOUTI AUX CERISES

Asparagus with Hollandaise Sauce

ASPERGES TIÈDES ET SA SAUCE HOLLANDAISE

Hollandaise, a quintessentially nineteenth-century sauce, recalls another era, suggesting a lifestyle that belongs largely to the past. When the sauce is properly made and paired with a green vegetable or steamed, poached, grilled, or baked fish, however, it is still a treat. Since getting the sauce to emulsify can sometimes be tricky, this version calls for softened, rather than melted, butter.

SERVES 4 TO 6

1 pound asparagus, preferably thin, washed, woody ends trimmed

HOLLANDAISE

3 large egg yolks
1 tablespoon cold water
8 tablespoons (1 stick) unsalted imported or organic butter, cut into pieces and softened
1 to 2 tablespoons fresh lemon juice
Pinch fine sea salt and freshly ground white pepper
Lemon slices

Put the asparagus spears into the basket of a vegetable steamer and steam until tender but firm, about 10 minutes. (Cooking time will depend upon the thickness of the spears.) Transfer to a plate and cover to keep warm. Set aside until needed.

Meanwhile, to prepare the hollandaise, place the egg yolks and water in the top of a double boiler or in a bowl set over a pot of simmering water. Be sure the bowl does not touch the water. Whisk until the yolks thicken and become very creamy. Add the butter, a few pieces at a time, and whisk until the butter has fully melted and sauce has emulsified. Whisk in the lemon juice and remove from the heat. Add the salt and season with pepper. Transfer to a small serving bowl or sauceboat. Serve with warm or chilled asparagus.

183

Fillet of Striped Bass with Panfried Leeks and Beurre Blanc

LE DOS DE BAR AUX POIREAUX RÔTIS BEURRE BLANC

In this recipe, striped bass is used instead of the more typical *bar,* a firm-fleshed freshwater fish that was once plentiful in French rivers. Striped bass also happens to be bar's salt-water "cousin." The bass fillet becomes crispy on one side and moist and tender on the other, and its sweetness balances perfectly with the slight tartness of the beurre blanc. The golden leek "logs" placed in an "x" beside the fish add texture and color to this simple yet regal dish.

SERVES 6

1 1/2 pounds leeks, ends trimmed

3 tablespoons peanut oil

BEURRE BLANC

1/3 cup coarsely chopped shallots

3/4 cup dry white wine

1 leafy sprig fresh thyme

3 tablespoons heavy cream

4 tablespoons (1/2 stick) imported or organic butter, cut into pieces

Freshly ground pepper

1/2 to 3/4 teaspoon sugar (optional)

FISH

2 1/2 tablespoons extra virgin olive oil

3 pounds of striped bass or red snapper fillets (with skin)

Freshly ground pepper

To prepare the leeks, wash them well under cold running water to remove any sand or dirt that is trapped between the layers. Cut into 3-inch logs, discarding the dark green parts.

Fill a medium saucepan with about 2 inches of water and fit with a steaming basket. Add the leeks and cook, covered, until tender but firm, about 10 minutes. Do not overcook. Transfer to a plate and reserve until needed. (The leeks can be steamed up to several hours ahead.)

To prepare the beurre blanc, put the shallots, white wine, and thyme sprig in a small saucepan. Cook over high heat until the wine is reduced by two-thirds. Reduce the heat to medium and stir in the cream. Add the butter and stir until it melts. Once the butter is fully melted, add 3 to 4 grinds of pepper. Do not allow the sauce to boil.

Strain the sauce through a fine sieve placed over a small bowl. Discard the shallots and thyme. (The sauce can be made up to 30 minutes before serving, but it cannot be reheated without risk of separating.)

Place the oven rack so it is 4 inches from the broiler. Set the oven on broil.

Rub the olive oil generously over both sides of the fillets and place, skin side up, on the rack of the broiler pan. Broil for about 10 minutes, or until the skin is very crisp and the fish is opaque throughout.

Meanwhile, to finish preparing the leeks, heat the peanut oil in a skillet over medium-high heat and cook the leeks, turning them gently with tongs, until lightly browned, about 10 minutes.

Divide the fish into serving portions and transfer to serving plates. Criss-cross 2 leeks to form an "x" next to each piece of fish. Spoon 1 to 1 1/2 tablespoons of beurre blanc sauce over the fish or allow guests to serve themselves.

NOTE: Due to the fragility of the leeks and the fish fillets, it's best to plate each dish separately rather than serving from a platter.

Roast Duck with Chanterelle Mushrooms Fricassee
Canette Rôtie et sa Fricassée de Girolles

In France, no self-respecting cook would enter a poulterer's shop and simply ask for a duck: One always specifies a female *(canette)* or male *(caneton)*. In the United States, being so particular, however, might be greeted with a sidelong glance. A Long Island duckling or a *canard de Barbarie* (Muscovy duck) will do nicely. To serve, set on a platter surrounded by the herb-flecked goldish-brown chanterelles.

SERVES 4

1 Long Island duckling
 (3 1/2 to 4 pounds)
2 tablespoons peanut oil
Salt and freshly ground pepper
3 tablespoons unsalted imported or
 organic butter, cut in pieces
1/2 onion, coarsely chopped
1 small carrot, coarsely chopped

CHANTERELLES
1 pound chanterelles
3 tablespoons peanut oil
1 large shallot, finely diced
1 1/2 tablespoons minced chives
1 teaspoon fine sea salt

Preheat the oven to 400° F.

Rinse the duck and pat dry with paper towels. Using about 2 feet of kitchen string, truss the bird, turning it over to be sure the wings are tied as well.

Spread 1 tablespoon of the oil in the middle of a roasting pan and set the bird in the pan. Drizzle the remaining oil over the top of the duck. Season generously with salt and pepper and dot the duck with the butter. Roast for 1 hour, basting every 15 minutes with the pan juices. Add the onion and carrot to the roasting pan.

When the duck is fully cooked, after about another 30 minutes, tip the duck forward so that its juices run into the pan. Transfer the duck to a plate and cover with aluminum foil to keep warm

Meanwhile, to prepare the chanterelles, place the mushrooms in a large bowl of water. Using your hands, push them under the water, then allow to sit in the water for 2 to 3 minutes. Gently lift the mushrooms out of the water and transfer to a bowl lined with paper towels. Trim the dry, rough ends and, if the mushrooms are very large, cut them in half lengthwise.

Heat the peanut oil in a large skillet over medium-high heat. When hot, add the mushrooms and sauté, tossing often, for 15 minutes. Add the shallot and cook for another few minutes, then add the chives and salt. Mix well. Remove from the heat and keep warm.

Carve the duck and arrange on a platter with the mushrooms.

185

Cherry Clafouti

CLAFOUTIS AUX CERISES

There are many different preparations for clafouti. Some are very custardlike, as is this version, while others almost resemble a thick pancake. All are made with very ripe fresh fruit. Using this basic recipe, the auberge kitchen turns out clafoutis with cherries, mirabelle plums, apricots, and fresh figs. And because a clafouti is a rustic country dessert, the cherries and mirabelle plums (a yellow plum variety no larger than a cherry) are not even pitted. If you are using unstoned fruit, let your guests know.

SERVES 6

3/4 pound cherries, washed but not pitted
3 large eggs
1 large egg yolk
2/3 cup sugar
1/3 cup all-purpose flour, sifted
2 cups milk
2 to 3 tablespoons unsalted imported or organic butter, melted

Preheat the oven to 350° F.

Dry the cherries with a paper towel and set aside until needed.

Combine the eggs, egg yolks, and sugar in a large bowl; whisk until smooth. Add the flour, a couple of tablespoons at a time, mixing after each addition. Be sure there are no lumps. Add the milk, about 1/2 cup at a time, whisking after each addition. When the batter is smooth, stir in the melted butter and mix to incorporate.

Scatter the cherries in a well-greased pie plate, about 10 inches across and 1 1/2 inches deep. Pour the batter over the fruit and bake for about 1 hour, or until the clafouti is puffy and slightly golden in color. Transfer to a wire rack. Serve warm, room temperature, or chilled.

NOTE: Depending on the size of the fruit you're using, you may want to halve or quarter it. If using fresh figs or apricots, place them in the baking dish, cut side facing up.

A Double Birthday Celebration
for Marguerite and Paul Gachet

Inspired by another very special Sunday lunch spent around the table
in the Gachets' garden, this four-course menu befits a double birthday.
Modeled after a classic bourgeois meal, the first course features
a soup, followed by a fish course, after which comes a meat dish,
in this case lamb. Dessert frequently included cheese and fruit,
which preceded a sweet of some kind. Coming from the verb
desservir, dessert was the course served after the table was cleared.

Cream of Carrot Soup
CRÈME CRÉCY

Scallops with Baby Artichokes, Mushroom Cream, and Truffles
NOIX DE COQUILLES ST. JACQUES AUX ARTICHAUTS,
CRÈME DE CHAMPIGNONS ET TRUFFES

~

Roast Saddle of Lamb Stuffed with Vegetables and Rosemary
SELLE D'AGNEAU RÔTIE FARCIE AUX LÉGUMES ET ROMARIN

Green Peas in the French Style
PETITS POIS À LA FRANÇAISE

~

Dark Chocolate Soufflé Cake with Crème Anglaise
LE FONDANT AU CHOCOLAT ET SA CRÈME ANGLAISE

Cream of Carrot Soup

CRÈME CRÉCY

Carrots are often relegated to a supporting role in soup making, but they quickly rise to the occasion when given the chance to play a leading role. This recipe takes its name from the town of Crécy, in the Ile-de-France, which was known during Van Gogh's time for its high-quality carrots. Also known as purée Crécy, the soup is velvety in texture and orange-yellow in color. Use the best carrots you can find, preferably organic and freshly dug. The soup can be made in the morning to serve in the evening; its flavor deepens when made a few hours ahead of time.

SERVES 6

8 tablespoons (1 stick) unsalted
 imported or organic butter
1 pound small carrots, halved
 lengthwise, and cut into 1-inch pieces
3 leafy sprigs fresh thyme
3 cups homemade chicken stock or
 low-sodium broth
3 cups water
Fine sea salt
2 cups half-and-half
1 tablespoon chopped fresh tarragon

Melt the butter in a medium saucepan over medium heat. Add the carrots and cook, stirring often, until softened slightly, about 5 minutes. Add the thyme, chicken stock, water, and $\frac{1}{4}$ teaspoon salt; simmer until carrots are very soft, about 30 minutes.

Remove the thyme sprigs and discard. Stir in the half-and-half and bring to a simmer. Remove the pan from the heat. Puree the soup, in batches, in a food processor or blender, until smooth. Adjust the seasoning, if necessary. Serve hot, sprinkled with tarragon.

NOTE: Refrigerate if not serving within an hour. Reheat, adding a few tablespoons of water or chicken stock if the soup is too thick.

Scallops with Baby Artichokes, Mushroom Cream, and Truffles
Noix de Coquilles St. Jacques aux Artichauts, Crème de Champignons et Truffes

Before the global economy became a fact of life, it was a great luxury to eat foods that were not locally available. This dish uses produce from Auvers—artichokes and mushrooms—and luxurious ingredients from other parts of France—scallops and truffles—and is clearly meant to impress. The truffles not only add visual appeal to the dish but make the mushroom cream "sing."

SERVES 6

6 baby artichokes, stems cut off
2 tablespoons extra virgin olive oil
1 1/2 pounds sea scallops, rinsed in cold water and patted dry
Salt and freshly ground pepper

Mushroom Cream
1 1/2 cups white mushrooms, cleaned and sliced
3 tablespoons unsalted imported or organic butter
5 tablespoons heavy cream
2 teaspoons sliced black truffles in oil, chopped
Salt and freshly ground pepper

Set artichokes in the basket of a vegetable steamer and steam until tender, about 20 minutes. Transfer to a bowl and set aside to cool. Using a very sharp knife, slice each artichoke lengthwise into quarters. Remove a few of the outer leaves and discard. Set the artichokes aside until needed.

Place rinsed scallops in a bowl or container lined with paper towels.

To prepare the mushroom cream, combine the mushrooms and enough water to cover in a small saucepan. Add the butter and bring to a boil over medium heat; maintain a low boil until the mushrooms are tender, about 10 minutes. Transfer the mushrooms and their liquid to a blender or food processor and puree until smooth. Add a tablespoon of water if too thick to blend.

Return the mushroom cream to the saucepan and whisk in the cream. Bring to a simmer, then remove from the heat and stir in the truffles. Season with salt and pepper. Set aside until needed.

Heat a large skillet (preferably nonstick) over medium-high heat for 3 to 4 minutes. Add the oil and, 30 seconds later, add the scallops, a few at a time, turning them as they brown, about 1 1/2 to 2 minutes per side. Season them with salt and pepper as they cook. Transfer to a plate and keep warm. Add artichoke quarters to the skillet to reheat, about 5 minutes.

To assemble the plates, divide the scallops evenly among six plates. Arrange 4 artichoke quarters on each plate, then pour about 2 tablespoons of the mushroom cream over all.

Roast Saddle of Lamb Stuffed with Vegetables and Rosemary

SELLE D'AGNEAU RÔTIE FARCIE AUX LÉGUMES ET ROMARIN

The saddle is the filet mignon of the ovine world and its most costly cut. It is made from the whole loin, which is located between the ribs (rack) and the thigh. It is also the most delectable part of the lamb. Here the saddle is stuffed, then rolled and tied like a roast, revealing a spiral of orange and green, tempting the eye as well as the palate. It is served with a traditional spring dish of Gachet's time, Green Peas in the French Style (recipe follows).

SERVES 4 TO 6

1 whole saddle of lamb, about 6 pounds bone-in (ask the butcher to bone and trim it for you)

5 tablespoons unsalted imported or organic butter

$1/2$ carrot, finely diced

$1/3$ celery stalk, finely diced

$1/4$ onion, finely minced

1 tablespoon fresh rosemary leaves, finely chopped

1 teaspoon fresh thyme leaves, finely chopped

1 large egg yolk

$1^{1}/2$ tablespoons vegetable oil

Salt and freshly ground pepper

3 sprigs rosemary

Preheat the oven to 375° F.

To prepare the stuffing, melt 3 tablespoons of the butter in a medium skillet over medium heat. Add the carrot, celery, and onion and cook, stirring, until they have softened, about 10 minutes. Stir in the rosemary and thyme; and remove from heat. Once the mixture has cooled, add the egg yolk and blend until you have a thick paste.

Place the lamb on a clean work surface and open it flat. Spread the stuffing lengthwise along the center and cover with the flaps. Fold down the large outer flaps to form a roast. Tie the roast at 1-inch intervals with kitchen string, to maintain the log shape and ensure even cooking. Set on a plate and refrigerate for 1 hour.

Spread the vegetable oil in a roasting pan and set the roast in the pan. Season with salt and pepper. Cut the remaining butter into pieces and place on top of the roast. Place the rosemary sprigs around the roast. Roast for about 40 minutes (until rare), or an instant-read thermometer reaches 125° F.

Let the roast rest for about 15 minutes before carving into 1-inch slices. Arrange on a serving platter along with the peas.

NOTE: Turnips and Brussels sprouts steamed and then quickly pan-fried in butter with salt and freshly ground pepper also work well as an accompaniment to the lamb.

Green Peas in the French Style

Petits Pois à la Française

We propose this simple nineteenth-century dish, which was inspired by the fields of flowering peas that were such a part of the Auvers landscape, as the accompaniment to the lamb. The dish works well with a variety of roasted meats, and it takes only minutes to make once the peas are shelled.

SERVES 6

3 1/2 cups fresh peas or frozen organic

3 tablespoons unsalted imported or organic butter

1/2 medium onion, finely chopped

1/2 head Boston lettuce (if small, use the entire head), julienned

1/2 teaspoon sugar

Fine sea salt (optional)

Bring a large pot of lightly salted water to a boil; add the peas, and cook for five minutes. Drain the peas and plunge into a bowl filled with ice water. When the peas are cool, drain and reserve until needed.

Meanwhile, melt the butter in a medium sauté pan over medium heat. Add the onion and cook, stirring, until translucent, about 5 minutes. Add the lettuce and stir until wilted, 1 to 2 minutes; add the peas. Cook over low heat for a few minutes, then sprinkle in the sugar, stirring to combine. Season with salt, if desired. Transfer to a serving bowl.

195

Dark Chocolate Soufflé Cake with Crème Anglaise
Le Fondant au Chocolat et sa Crème Anglaise

What rises like a soufflé, has an interior as creamy as a mousse, yet is chewy on the outside like a brownie? This unique dark chocolate cake. It's delicious either on its own or served with Crème Anglaise (recipe follows). Chilling it properly is an important step: If it is unmolded and sliced too soon, the cake will collapse. Patience with chocolate is a virtue.

SERVES 8 TO 10

7 ounces premium dark chocolate, chopped (50 to 70 percent cocoa butter is suggested)

7 ounces (1 stick plus 6 tablespoons) unsalted imported or organic butter

6 large eggs

1²/3 cups granulated sugar

³/4 cup all-purpose flour, sifted

1 to 2 tablespoons confectioners' sugar (optional)

Preheat the oven to 400° F. Place a rack in the middle of the oven. Grease the bottom and sides of an 8-cup soufflé dish. Cut a round of parchment paper about ³/4 inch larger than the diameter of the dish. Line the dish with the parchment, pressing it against the side of the dish. Grease the parchment.

Melt the chocolate and the butter in a pan set over boiling water. Stir with a wooden spoon once the chocolate and butter begin melting. Just before the butter is fully melted, remove the bowl from the heat and stir until smooth. Set aside to cool slightly.

In the bowl of a standing mixer, or in a large bowl with a hand-held mixer, lightly beat the eggs. Add the sugar and beat at medium speed for about 2 minutes. Add egg-sugar mixture to the chocolate mixture, blending slowly and carefully with a wooden spoon. When it is completely mixed, add the flour a little at a time, stirring until smooth.

Pour the batter into the prepared soufflé dish and place on a baking sheet. Bake for 35 minutes, or until the soufflé cake has risen and is firm yet springy to the touch; it should have slight cracks on top.

Carefully remove from the oven and allow to cool on a wire rack. Once completely cooled (after about 2 hours), place the soufflé cake in the refrigerator for at least 8 hours. About 1 hour before serving, remove from the refrigerator. Run a long thin-bladed knife around the inside of the dish and invert the cake onto a large flat plate. Peel away the parchment paper and sift the confectioners' sugar over the cake, if desired.

When ready to serve, place a slice of the cake in the center of each plate and pour about ¹/4 cup of crème anglaise around the cake.

Crème Anglaise

SAUCE CRÈME ANGLAISE

Crème anglaise is a versatile dessert sauce that can accompany cakes, pies, berries, or rice pudding. It is almost like a custard in liquid form. In fact, the ingredients are the same for each; it's the manner of preparation that differs. While the sauce is not difficult to make, you do have to be very attentive while it cooks because overcooking will curdle the eggs. A *crème anglaise au café* (see Note) is also delicious and pairs wells with this chocolate mousse cake.

MAKES 2¹/₂ CUPS

2 cups milk
1 vanilla bean, split and scraped
5 large egg yolks
¹/₄ cup sugar

Combine the milk and vanilla bean and seeds in a small heavy-bottomed saucepan. Bring to a boil over medium heat, stirring often. Remove from the heat and remove the vanilla bean.

Combine the egg yolks and sugar in a medium bowl and whisk until fully blended. Temper the egg mixture by gradually stirring in ¹/₂ cup of the heated milk. Pour the egg mixture into the milk in the saucepan and place over medium heat. Maintain a low boil, stirring constantly in large figure eights with a wooden spoon to prevent sticking once it begins to thicken after about 5 minutes.

To check for doneness, run your finger down the back of the spoon. If the stripe holds, the cream is ready. Immediately transfer to a bowl and set into another bowl filled with ice. Once cold, place in the refrigerator until needed. The cream can be stored for up to 2 days.

NOTE: To prepare a coffee crème anglaise, add 1 teaspoon ground espresso to the milk as it is heating. Proceed with recipe, straining the cream just before the chilling step.

197

Afternoon Tea in the Garden

The many afternoons Van Gogh spent in the home and garden of the Gachets while at work on several portraits of Marguerite and her father is the concept behind this tea menu. Featured are popular beverages of the period along with several kinds of petits fours. France's anglophilia made tea drinking not only fashionable but commonplace among the bourgeoisie. It was served an hour later than English tea, often without milk, and was sometimes referred to as *"le five o'clock."*

Chinese Black Tea
THÉ NOIR DE CHINE

Orange "Soda"
ORANGEADE

Hot Chocolate
CHOCOLAT CHAUD

~

Honey Madeleines
MADELEINES AU MIEL

Iced Matchsticks
ALLUMETTES GLACÉES

Rum Truffles
TRUFFES AU RHUM

Rich Almondine Petit Four Cakes
FINANCIERS

Chinese Black Tea

Thé Noir de Chine

Choose your favorite tea for this, including herbal infusions such as verbena, linden flowers, chamomile, or mint.

1 teaspoon tea per 6-ounce serving

Fill a tea kettle with fresh cold water and bring to a brisk boil. Pour about ½ cup of the boiling water into the teapot to warm it. Add the tea leaves and pour in the desired amount of water. Allow to steep for not less than 3 minutes and not more than 5. Serve promptly, straining the tea if necessary.

Orange "Soda"

Orangeade

Before the advent of soft drinks, the choice of nonalcoholic beverages was rather limited. In the summer, fruit drinks—invariably fruit syrup mixed with flat or fizzy water—were popular. In the spirit of Van Gogh's time, we propose this refreshing orange drink as part of a tea menu that might have been served in the Gachets' garden. Orangeade, a classic warm-weather drink, was generally served iced from an attractive glass carafe.

SERVES 8 TO 10

10 large juice oranges, scrubbed if not organic, and juiced
3 medium lemons, scrubbed if not organic, and juiced
6½ cups cold water
1½ cups sugar
½ vanilla bean, split and scraped

Using a vegetable peeler, remove the zest from 2 of the oranges and 1 of the lemons. Halve all of the oranges and lemons and squeeze the juice into a bowl. Set aside.

Combine the water, sugar, and vanilla bean and seeds in a large pot. Add the citrus zest and bring to a boil; remove from the heat.

Allow to cool completely, then add the orange and lemon juice.

Refrigerate overnight before straining through a very fine sieve. Serve over ice cubes or add an ounce or two of cold seltzer water to each glass.

Hot Chocolate

Chocolat Chaud

Hot chocolate is one of the great pleasures of winter, yet for some reason it tends to be enjoyed most often outside the home despite how simple it is to make. During Gachet's time, it was frequently enjoyed by adults and children as part of *le petit déjeuner* (breakfast), or as an alternative to tea or coffee in the mid-afternoon. Hot chocolate was often served in a *chocolatière*, a pot made expressly for preparing or serving it.

SERVES 6

2 cups milk

1/2 vanilla bean, split and scraped

7 ounces premium dark chocolate, broken into pieces (50 to 70 percent cocoa butter is suggested)

2 to 3 tablespoons sugar

1 teaspoon ground cinnamon (optional)

2 cups heavy cream

Place the milk and vanilla bean and seeds in a saucepan and set over medium-high heat. When the milk comes to a boil, remove vanilla bean and add the chocolate. When it begins to melt, sprinkle in the sugar, a little at a time, whisking until the chocolate has fully melted. Whisk in the cinnamon, if using. Add the heavy cream and heat thoroughly. Do not allow to boil.

Honey Madeleines

MADELEINES AU MIEL

These plump little tea cakes differ slightly from classic madeleines because of the addition of milk and honey. Only slightly sweetened, they are a marvelous accompaniment to the Chocolate Mousse Sabayon (page 130), the Mixed Berries with Vanilla, Linden Flower, and Mint Syrup (page 168), or any fruit compote.

MAKES ABOUT 20 LARGE MADELEINES

7 ounces (1 stick plus 6 tablespoons) unsalted imported or organic butter

3 large eggs

3/4 cup sugar

1 teaspoon vanilla extract

1/3 cup milk

2 heaping teaspoons wildflower honey

1 3/4 cups all-purpose flour

2 1/2 teaspoons baking powder

Preheat the oven to 425° F.

To prepare a beurre noisette, heat the butter in a small heavy-bottomed saucepan over medium heat until it is a deep golden brown, 10 to 15 minutes.

Allow to cool slightly before dipping a pastry brush into the melted butter and lightly greasing the madeleine molds. Set the greased molds and the remaining beurre noisette aside until needed.

Mix together the eggs, sugar, and vanilla in a large bowl until smooth. Mix together the milk and honey in a small bowl and when honey is partly dissolved, whisk into the egg-sugar mixture. Sift together the flour and baking powder in another bowl. Add the flour, a little at a time, to the egg-sugar mixture, blending until smooth. Add the beurre noisette and whisk vigorously to fully incorporate. Refrigerate for 30 minutes.

Fill the prepared madeleine molds almost to the top with batter. Return the unused batter to the refrigerator until ready to bake the second batch of madeleines. Set the molds on a heavy baking sheet. Bake for 12 to 14 minutes, or until the madeleines are golden brown and have risen with the characteristic crack or hump in the center.

Unmold immediately onto a wire rack to prevent sticking and allow to cool. Repeat with the remaining batter.

203

Iced Matchsticks

Allumettes Glacées

When Chef Bony pulled these light and flaky pastries out of the oven late one night, I knew I wanted to include them in the book. During baking, they rise up and tilt somewhat, with a flat "roof" of icing. For texture and sheer looks, they're a delightful addition to a cookie tray. Serve them with a cup of tea, coffee, or a sweet, light liqueur, such as Cointreau or Grand Marnier.

MAKES ABOUT 4 DOZEN COOKIES

1 cup confectioners' sugar

1 large egg white

2 teaspoons fresh lemon juice

1/2 pound Puff Pastry (page 166), thawed if frozen

To prepare the icing, whisk together the confectioners' sugar and egg white in a bowl. Whisk in the lemon juice. Continue mixing until you have a smooth, thin paste. Set aside until needed.

Roll out the puff pastry on a lightly floured work surface into a rectangle, about 6 x 12 inches. The thickness of the dough should be 1/4 inch. Trim the edges, if necessary. Using a pastry brush, spread a thin layer of icing over the dough.

Using a sharp knife, cut the dough lengthwise in half, and then crosswise into matchsticks about 1 inch wide and 3 inches long. Using a spatula, carefully transfer them to a sturdy cookie sheet.

Bake for about 15 minutes, or until the matchsticks have puffed up and the icing is golden. Slide the cookies onto a wire rack to cool completely before serving.

NOTE: Vary the recipe by adding 1/2 teaspoon of vanilla or almond extract, or 1 teaspoon unsweetened cocoa powder to the icing, if desired.

Rum Truffles

Truffes au Rhum

For chocolate lovers, there is nothing quite like a fresh, homemade truffle. In this recipe, the chilled truffles are dipped in melted chocolate. This additional step creates a slightly crunchy chocolate layer between the dense, soft interior and the bittersweet cocoa-covered exterior. If you've never attempted truffle-making at home, you'll be delighted to discover that it's incredibly simple and requires less time than most other desserts.

MAKES ABOUT 3½ DOZEN TRUFFLES

TRUFFLE BASE
1½ cups heavy cream
 (preferably organic)
10 ½ ounces premium dark chocolate,
 broken into pieces (50 to 70 percent
 cocoa butter is suggested)
1 tablespoon strong coffee
1½ tablespoons dark rum

DIPPING CHOCOLATE
6 tablespoons unsalted imported or
 organic butter
3½ ounces premium dark chocolate,
 broken in pieces (50 to 70 percent
 cocoa butter is suggested)
Unsweetened cocoa powder

To prepare the truffles, put the cream in a large metal bowl and refrigerate until needed. Put the chocolate in a bowl and set over a pan of simmering water (the bottom of the bowl should not touch the water.) Stir occasionally until the chocolate melts. Remove from the heat and stir in the coffee just until combined. Do not overmix. The mixture will thicken to the consistency of peanut butter.

Add the rum to the cream and beat until firm peaks form. Add the chocolate and, using a rubber spatula, fold in just until fully incorporated. Line a baking sheet with parchment paper. Using a large spoon or spatula, spoon the chocolate mixture into a pastry bag fitted with a plain or star tip. Pipe walnut-size mounds of the chocolate mixture onto the lined baking sheet in long, straight rows, spacing the truffles so they do not touch. Refrigerate for 30 minutes.

To prepare the dipping chocolate, combine the butter and chocolate in the top of a double boiler or in a bowl set over simmering water, and stir often, until melted. Remove from the heat and pour into a small bowl. Line a baking sheet with clean parchment paper. Spread the cocoa powder on a plate. Remove the truffles from the refrigerator and, using small tongs, drop the truffles, a few at a time, into the melted chocolate. Lift out, one at a time, letting the excess chocolate drip off. Roll the truffles in the cocoa powder until well coated. Place on the lined baking sheet. Chill for several hours before serving.

Rich Almondine Petit Four Cakes
FINANCIERS

According to the *Petit Traité d'Ethno-Patisserie*, *financiers* were invented in the nineteenth century by a *patissier* named Lasne, who owned a pastry shop near Paris's *bourse*, or stock exchange. The *boursiers* (stockbrokers) found the moist, lightly sweetened *financiers* to be perfectly suited to their needs, as they could be daintily eaten with the fingers without risk of dirtying one's hands or clothes. Here ground almonds lend a toothsome quality to the cakes and the butter a marvelous richness. Bake your *financiers* early in the day to enjoy for afternoon tea. Their flavor develops if the cakes are allowed to sit for a few hours.

MAKES ABOUT 18 LITTLE CAKES

1¼ cups sliced almonds (about 5 ounces), or almond flour

1½ teaspoons granulated sugar (omit if using almond flour)

1 cup confectioners' sugar, sifted

½ cup all-purpose flour

6 ounces (1½ sticks) unsalted imported or organic butter

5 large egg whites

Generously grease financier, petit four pans, or 3-inch tartlet pans (preferably nonstick).

Grind the almonds with the sugar in a mini chopper or food processor. When ground to the consistency of medium-fine sand, transfer to a bowl and add confectioners' sugar; whisk until blended. Add the flour, a little at a time, then the egg whites and whisk until the batter is thick and smooth. Do not overmix.

Brown the butter in a skillet over medium heat, to make *beurre noisette*. Skim off the foam from the top before adding the melted butter to the batter. Let any dark brown sediment from the melted butter remain in the pan. Whisk well to incorporate the ingredients. Allow the batter to rest for 20 minutes.

Meanwhile, preheat the oven to 425° F. Fill the prepared pans a little more than halfway with the batter.

Bake for 15 minutes, or until golden brown. Allow the cakes to cool on wire racks for 10 minutes before tapping them out of the pans. Run a knife around the edge of the cakes if sticking. Serve at room temperature.

209

Notes

A PRIVATE LIFE
IN PUBLIC PLACES

8 "From his coffin . . . world." Susan
 Stein, ed., *Van Gogh: A Retrospective*
 (New York: Hugh Lauter Levin
 Associates/Macmillan, 1986),
 pp: 210–222; Brief Hirschig aan
 Plasschaert, September 8, 1911
 (B3023V/1983).

A PLACE TO LIVE,
A PLACE TO WORK

11 "Well, boy, if . . . bars?" Letter 212.

12 "a real gypsy soul." Letter 272.

12 "that particular torture . . . etc."
 Letter 343.

12 "pretty large room . . . drawbridge."
 Letter 332.

12 ". . . one must expect . . . advance."
 Letter to Theo, Hoogeveen C.
 September 27, 1883.

14 "Downstairs there is . . . a while."
 Letter 332.

15 "I am always . . . it." Letter R57.

15 "I have tried . . . food." Letter 404.

16 "a way of life . . . world." Ibid.

18 The structure . . . the regulars. Gustave
 Coquiot, *Vincent van Gogh* (Paris:
 Ollendorff, 1923), pp. 118–119.

20 The whole structure . . . the painter.
 Coquiot, *Van Gogh*, p. 140. See *Self-
 Portrait* F526, summer 1887.

20 The identification . . . a few months
 later. Ibid., notes section.

22 There was another . . . upstairs. Ronald
 Pickvance, *Van Gogh* (Martigny:
 Fondation Pierre Gianadda, 2000),
 p. 131; Coquiot, *Van Gogh*, pp. 145–146.

22 "patron de restaurant" Inventory list
 made by Andries Bonger and Theo
 van Gogh, nr.

22, 24 "kind of hall . . . 'invertebrate.'"
 Letter from A. H. Koning to
 A. Plasschaert, Voorthuizen, May 8,
 1912 (Archive VGM nr. b3024 V/1983).

24 In November of . . . friends." The most
 extensive source for this exhibition is
 the manuscript for an article written
 by Bernard in the summer of 1889
 for the short-lived magazine *Le
 Moderniste*. It was never published
 since *Le Moderniste* ceased to appear
 after September of that year.

24 "Two years ago . . . Bernard." Thanks
 to Dr. Roland Dorn.

24 "a view . . . shop." Letter 464.

24 On the front . . . 61. Ronald
 Pickvance, *Van Gogh et Arles*
 (Fabricant, Arles, 1989).

26 "It was frequented . . . bells." Coquiot,
 Van Gogh, p. 161.

26 After an argument . . . improve it.
 Letters 487 and 521; Roland Dorn,
 Décoration (Arles, Zurich/New York:
 1990), p. 372.

27 "Today I am . . . admitted." Letter 503.

27 "[I] told him . . . day." Letter 533.

27 "the picture is . . . Eaters." Letter 534.

27 "symbolic language . . . alone."
 Letter 503

27 "I have tried . . . made. Letter 533.

28 "I have tried . . . pub." Letter 534.

28 Zola's L'Assommoir . . . knew.
 Kodera, p. 46.

28 "The painter . . . I do." Letter 482.

28 "this little article . . . meaning."
 Letter 535.

28 "I have written . . . wheedling."
 Letter B19.

30 "I got busy . . . not to paint." Ibid.

30 "done a rough . . . picture." Letter 561.

30 "not sufficiently . . . money. Letter B19.

30 "The actual paintings . . . studio.
 Letter 558.

30 "figures seen in the brothels."
 Letter B19a.

31 "garish local . . . il faut." Letter
 Merthès 1984, nr. 177, p. 275.

31–32 "An enormous yellow . . . tints."
 Letter W7.

32 "On one of them . . . benches and
 chairs." F1508v.

33 The rear of a cart . . . through the
 window. On the back of another
 copy from Bargue (F1609v), made on
 paper torn from the same leaf as this
 one, Van Gogh sketched a coach that
 has a similar rear end as the one in
 the window (F1609r).

34 "Those frescoes . . . quality." Letter 136.

34 "One sees no . . . them." Letter 439.

34 "The exhibition . . . was!" Letter 510.

36 *"by far the . . . Paris."* Émile Bernard, "Notes sur l'école dite de Pont-Aven," *Mercure de France* 48 (1903): 678.

36 *Van Gogh even . . . wide.* "Tonio" [Antonio Cristobal], "Notes et Souvenirs: Vincent van Gogh," *La Butte,* 21 (May 1891): C'était un immense local "comme une chapelle méthodiste" disait-il en parlant à Camille Pissaro, qu'il voulait débaucher jusqu'à exposer là. Et le fait est que le restaurant valait un édifice: des murailles hautes de 10 mètres, large de 30 . . . etc.

36 *"Two years ago . . . was.* The most extensive source for this exhibition is the unpublished manuscript for an article written by Bernard in the summer of 1889 for the short-lived magazine *Le Moderniste.*

36 *"fifty or a hundred paintings,"* Émile Bernard, "Les peintres originaux. Vincent van Gogh," *L'Arte* 11, 13, nr. 12, 9 (February 1901): 1–3: ". . . lui, Vincent, met cinquante ou cent toiles, paysages, fleurs, portraits." This text was written in 1894 for *Le Coeur.*

36 *"violent still . . . faces."* Anne Rivière, ed., *Propos sur l'Art/Émile Bernard,* 2 vols. (Paris: Séguier, 1994), pp. 241–247.

36 *"The other artists . . . Van Gogh."* Letter 553.

36 *Van Gogh loaded . . . them.* Bernard, "Notes," p. 678, and "Tonio," "Notes."

37 *"Bernard sold . . . it."* Letter 510.

37 *"maybe there will . . . later."* Letter 512.

37 *"You cause a . . . Clíchy."* Letter 595.

37 *"81 worthy . . . mayor."* Ibid.

37 *"I think . . . café."* Letter 640.

TRUE FRIENDS

39 *"What impassions me . . . expressions."* Letter W22.

40 *(The function . . . brothels.)* Hollis Clayson, *Painted Love: Prostitution in French Art of the Impressionist Era* (New Haven: Yale University Press, 1991).

40 *"Very good . . . pleasure."* Letter 538a.

40 "le maquereau . . . *pimp")*. Gustave Coquiot, *Van Gogh* (Paris: Ollendorff, 1923), pp. 127–128.

42 *Yet why then . . . drinks?* Thanks to Sjraar van Heugten for bringing this to my attention.

44 *Nevertheless . . . 1 franc.* Anne Rivière, ed. *Propos sur l'Art/Émile Bernard,* 2 vols. (Paris: Séguier, 1994), p. 242.

45 *"When you are . . . time,"* Letter 622a.

45 *"Moreover . . . herself."* Letter 625.

45 *"I have an . . . last,"* Letter 559.

45 *"Madame Ginoux . . . Paris."* Coquiot, pp. 187–188.

45 *". . . background pole . . . wood."* Letter 559.

45 *"This pose . . . femininity."* Dorn, p.2

45 *"It is a . . . together."* Letter 643.

46 *"While she was . . . children."* Letter W11.

48 *"I would never . . . independently."* Pierre Weiller, "Nous avons retrouvé le zouave de Van Gogh," *Les Lettres français,* 31 March 1955.

48 *"A painting has . . . raped it."* Ibid.

48 *"have been approved . . . brothel."* Letter 522.

49 *"as many Arlésiennes . . . get them."* Letter 542.

49 *"I should have . . . on it."* Letter 541a; see also Weiller, above.

49 *"Not a single . . . Bel-Ami?"* Letter 590c.

50 *"Roulin seems to . . . tall.* Priou.

50 *"a republican . . . through."* Letter 516.

50 *"none the less . . . liquor."* Letter 514.

50 *Roulin's pride . . . Van Gogh.* Letter 518.

50 *(Here it should . . . aware.)* Letter 572.

50 *"to baptise the . . . family."* Letter W6.

50 *"I do not . . . him."* Letter 520.

50 *"done at a . . . setting."* Letter 525.

51 *"kept for himself."* Ibid.

51 *Then he adapted . . . "Berceuse."* Jon Hulsker, "Van Gogh, Roulin, and the Two Arlésiennes, a Re-examination: Part II," *Burlington Magazine* 134, 1076 (1992): 707–711.

51 *"He is more . . . postman."* Letter 550. In fact, Van Gogh admired Monticelli.

51 "Like to paint . . . background."
Letter 643.

51 "Last week I . . . canvas." Letter 644.

51 "Then one day . . . portrait." Quoted
from Adeline Ravoux-Carrié.

52 "It was somewhat . . . painting." Stein,
pp. 211–19.

54 "never mingled with . . . Valdivielse."
Ibid.

54 "These meals were . . . boarder." Ibid.

54 That fatal last . . . fallen . . ." Ibid.

GIVE US OUR DAILY BREAD

57 "I have wanted . . . people. Letter 404.

57 "I work as hard . . . now." Letter 175.

58 "a better meal . . . afford it. Letter 138.

58 "sick of the . . . for it." Letter 413.

58 "Do you know . . . one." Letter 440.

58 "All I have . . . trunk." Letter 442.

58 "I had a meal . . . paintings." Theo
Waarde, 1888, 703 [546] [F].

60 "his bald head . . . brow.'" Letter 277.

60 "What a mistake . . . infidels."
Letter 520.

62 "It's the same . . . so low." Letter 480.

62 "my blood circulation . . . digesting."
Letter 613.

64 "I don't see . . . that." Theo Waarde,
1889. 806 [607] [F].

64 "He is completely . . . Theo." Van
Gogh-Bonger, introduction.

64 "For me it is . . . to us." Theo Waarde,
1890. 881 [638] [F].

A REMEDY AGAINST SUICIDE

67 "I breakfasted on . . . purpose."
Letter 106.

67 "Every day I take . . . me." Letter W11.

67 "The genius of despair . . . first."
Charles Dickens, The Life and
Adventures of Nicholas Nickelby
(Oxford: Oxford University Press,
1981), pp. 74–75. Thanks to Hans
Luijten for finding this.

68 "I am going . . . painting." Letter 569.

68 "My dear Gauguin . . . evening."
Susan Stein, ed. Van Gogh (New York:
Hugh Lauter Levin Associates/
Macmillan, 1986), p. 126.

69 "Seriously sick . . . alcoholic."
Letter 544a.

69 "that damned dirty . . . steaks."
Letter 480.

69 When his health . . . wine. Letters 486
and B7.

69 "get as much . . . alcohol." Letter 489.

70 "for making a . . . home." Letter 485.

70 "a blue enamel . . . oranges." Letter 489.

70 "in the habit . . . fluid." Letter W4.

70 "23 cups . . . pay for." Letter 546.

70 "Instead of eating . . . alcohol."
Letter 581.

72 "An artist is . . . good." Ibid.

72 "I ever more . . . much." Letter 550.

72 "I so often . . . a sot. . . ." Ibid.

72 "Very often I think . . . boards."
Letter 507.

73 "The frightful superstition . . . bad."
Letter 585.

A NEW HOME IN AUVERS

100 Their correspondence . . . the artist.
Letter 633.

102 "I have seen . . . as I." Letter 635.

104 "Auvers is very . . . North."
Letters 635, 637, and 636.

105 "You know, if . . . so low." Letter 480.

FIELDS OF WHEAT AND
FLOWERING PEAS

136 "I have one . . . like." Letter 636.

140 "a landscape with vines . . . of the
village." Letter W23.

140 "I have a vineyard study . . . to see me."
Letter 641.

SUNDAY LUNCHES WITH
DR. GACHET

172 ". . . the head with . . . place."
Letter 638.

172 "I feel that . . . well." Ibid.

176 "full of black, black, black . . ."
Letter 635.

177 "Sunday has left . . . me. . . ."
Letter 640.

177 "What impassions me . . . portrait,"
Letter LW22.

Bibliography

GENERAL

Faille, J.-B. de la. *The Works of Vincent van Gogh*. New York: Reynal/Morrow, 1970.

Hulsker, Jon. *The New Complete Van Gogh*. Amsterdam: J. M. Meulenhoff, 1996.

Heugten, Sjraar van, and Fieke Pabst. *Van Gogh in nero*. La Grafica Firenze: Centro Di, 1997.

Heugten, Sjraar van. *Vincent van Gogh, Drawings*, 2 vols. Amsterdam: Van Gogh Museum, 1996, 1997.

Rivière, Anne, ed. *Propos sur l'Art/Émile Bernard*, 2 vols. Paris: Séguier, 1994.

Tilborgh, Louis van, and Marije Vellekoop. *Vincent van Gogh Paintings*, vol. 1. Amsterdam: Van Gogh Museum, 1999.

LETTERS

De brieven van Vincent van Gogh, 4 vols., Han van Crimpen and Monique Bernds-Albert, eds., The Hague, 1990.

Verzamelde brieven van Vincent van Gogh, 2 vols., Johanna van Gogh-Bonger, ed., and Introduction, Amsterdam/Antwerp, 1955.

The Complete Letters of Vincent van Gogh, 3 vols., Introduction by V. W. van Gogh, Preface and Introduction by Johanna van Gogh-Bonger.

MONOGRAPHS AND EXHIBITION CATALOGUES

Coquiot, Gustave. *Vincent van Gogh avec 24 reproductions hors texte des oeuvres de Vincent van Gogh*. Paris: Ollendorff, 1923.

Dorn, Roland. *Décoration*. Vincent van Goghs Werkreihe für das gelbe Haus in Arles. Zürich/New York, 1990.

Exh. cat. *Van Gogh à Paris*. Paris, Musée d'Orsay, 1988.

Exh. cat. *Van Gogh en Den Haag*. The Hague, Haags Historisch Museum, 1990.

Exh. cat. *Vincent van Gogh. Drawings*. Otterlo, Museum Kröller-Müller.

Exh. cat. *Vincent van Gogh. Paintings*. Amsterdam, Van Gogh Museum.

Heenk, Elisabeth Nicoline. "Vincent van Gogh's Drawings. An Analysis of Their Production and Uses," thesis. London, Courtauld Institute, 1995.

Kodera, Tsukasa. *Vincent van Gogh: Christianity versus Nature*. Amsterdam/Philadelphia: J. Benjamins, 1990.

Pickvance, Ronald. *Van Gogh in Arles*. New York: Metropolitan Museum of Art/Abrams, 1984.

Pickvance, Ronald. *Van Gogh in Saint-Rémy and Auvers*, New York: Metropolitan Museum of Art, 1986.

Pickvance, Ronald. *Van Gogh et Arles*. Arles: Fabricant, 1989.

Pickvance, Ronald. *Van Gogh*, Martigny: Fondation Pierre Gianadda, 2000.

Stein, Susan, ed. *Van Gogh: A Retrospective*. New York: Hugh Lauter Levin Associates/Macmillan, 1986.

Van der Wolk, Johannes. *De schetsboeken van Vincent van Gogh*. Amsterdam, 1986.

Welsh-Ovcharov, Bogomila. *Vincent van Gogh and the Birth of Cloisonism*. Toronto: Art Gallery of Ontario, 1981.

CAFÉ LIFE

Clayson, Hollis. *Painted Love*. New Haven: Yale University Press, 1991.

Conrad, Barnaby III. *Absinthe: History in a Bottle*, San Francisco: Chronicle Books, 1988.

Delahaye, Marie-Claude, and Noël Benoît. *L'Absinthe, muse des peintres*. Paris: Editions de l'amateur, 1999.

Langle, Henry-Melchior. *Le petit monde des cafés et débits parisiens au XIXe siècle*. Paris: Presses universitaires de France, 1990.

Lefébure, Cristophe. *La France des cafés et bistrots*. Toulouse, 2000.

Lemaire, Gérard Georges, and Martin H. M. Schreiber. *Cafés d'artistes à Paris*. Paris: Plume, 1998.

Welsh-Ovcharov, Bogomila, and Phillip Dennis Cate. *Émile Bernard, 1868–1941*. New Brunswick, N.J.: Jane Voorhees Zimmerli Museum of Art, 1988.

213

Acknowledgments

For Jonathan and Micol, with love

In thanking those without whom this book would not have been possible, I begin with Dominique Jansenns. I will never forget the pleasure I felt when Dominique asked me to write about the Auberge Ravoux.

Much gratitude is owed to "my brother at the stove," *chef de cuisine* Christophe Bony, for his patience, good naturedness, and willingness to reveal the secrets of the auberge kitchen. Thanks also to Marc Schoenstein and to the ever helpful, ever cheerful staff at the auberge. Others in Auvers who generously gave of their time are Madame Claude Millon, Janine Dumurriez, Maurice Giordano, Sandra Becuwe, Jean-Claude Pantelini, and Marie-Claude Delahaye, founder and director of The Absinthe Museum.

I am grateful as well to Caecilia di Montagliari for her kindness, and to Ronald Pickvance for his words of wisdom and his indispensable chronology of Vincent van Gogh's sojourn in Auvers.

Thanks are also owed to Birgitta Ralston, Fred Leeman, Frédéric Lebain, Ann Bramson, Deborah Weiss Geline, Ruth Peltason, Laura Pensiero, Paul Wanderwohl, Lisa Bernhard, Moha Orchid, Philippe Gatto, Marc Bauer, Stephen Schmidt, Cathy Kaufman, Rick Ellis, and at Sotheby's, Tish Roberts and Kevin Tierney.

Particular thanks go to Nydia Leaf, Paul Leaf, and Elena Ghiron, as well as to other family members here and in Italy.

Two dear friends, Clifford A. Wright and Margaret Wolfson, were encouraging while this book was slowly taking shape in my mind. Others I wish to thank are Cathérine Faury, Myriam Hervé-Gil, Isabelle Ehrmann, Philip and Mary Hyman, Barbara K. Wheaton, Naidre Miler, Robert Kaufelt, Vidia Mahadeo, Beret Scangarello, Judy, Rita and Dan Paul, Carolin Young, Carlo Bella, Seigo Nakao, Erevan Morales, Bridget Carzis, and Alba Dwass.

—Alexandra Leaf

Many people have been helpful well beyond the normal scope of duty, in part due to Dominique Janssens's idea for this book. Thanks to Roland Dorn, Hugues Wilhelm, and Bowine Michel, each of whom kindly read and commented upon the manuscript, and thus vastly improved my text.

Valuable assistance and suggestions likewise came from staff members of the Van Gogh Museum, Amsterdam. In particular, Hans Luijten, Sjraar van Heugten, and Sophie Pabst.

Anita Vriend and Monique Hageman were helpful with the gathering of literature and images. Birgitta Ralston's role far exceeded the physical design of the book. Birgitta never lost sight of the idea of the book, and helped considerably in shaping it. Ruth Peltason, my editor, patiently transformed my nearly fluent English into a more natural voice, and always made me feel that she stood at my side.

—Fred Leeman

Index

217